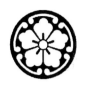

ORCHID
GUIDES

'THERE BEFORE YOU'

ANGKOR OBSERVED

A Travel Anthology of 'Those There Before'

Dawn F. Rooney

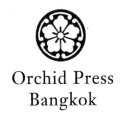

Orchid Press
Bangkok

'THERE BEFORE YOU'
ANGKOR OBSERVED A Travel Anthology of
'Those There Before'
Dawn Rooney

First published: 2001

© Orchid Press 2001

Orchid Press
P. O. Box 19,
Yuttitham Post Office
Bangkok 10907, Thailand

ISBN 974-8304-79-5

DEDICATION

To the spirit of Henri Mouhot who opened the eyes of the West to Angkor

ACKNOWLEDGEMENTS

The following people, in particular, provided continuous support in various ways during the research and writing of this book. My sincere thanks to: Hallvard Kuløy, David Murray, Dr Prasert Prasarttong-Osoth, Jim Rooney and Sarah Rooney.

A NOTE ON SPELLINGS

The original spelling has been retained in quotations, which sometimes differs from that used in the text, either because it is a phonetic interpretation or because it conforms to a romanisation system used by the French.

The Pinyin system for the spelling of Chinese names is used with the Wade Giles spelling in parenthesis of the first appearance of the word. Cross references to the two systems can be found in the index.

The spelling of words in the Khmer language conform to the generally accepted romanisation, which is a foreign pronunciation of the written Sanskrit.

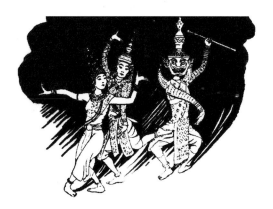

CONTENTS

LIST OF ILLUSTRATIONS

PREFACE

My attraction to Khmer art was instantaneous when I first
visited Angkor in February 1970. I was not prepared for
either the scale or the variety of architectural remains.
I've seen temples in other parts of South and Southeast
Asia – India, Sri Lanka, Indonesia, Burma, Vietnam and
Thailand – but none stir my soul like Angkor. Looking at
the splendid temples for the first time, I felt slightly out of
control of my senses. Massive blocks of grey sandstone
sculpted into sensuous images, walls covered with intri-
cately carved reliefs, causeways, moats, passages, corridors,
galleries, some illuminated by the sun, others hidden in
shadows, all beckoned me to explore them further.

Shortly after that visit, though, Cambodia was inacces-
sible to foreign visitors for nearly two decades due to inter-
nal disturbances and I was unable to return to Angkor.
However, since I was living in Bangkok, I pursued on-the-
site observations through temples in North-eastern Thai-
land, a major provincial centre of the Khmer Empire be-
tween the eleventh and thirteenth centuries. This rich
archaeological source of Khmer history provided the basis
for my book, *Khmer Ceramics*, Singapore (Oxford Univer-
sity Press), 1984.

I returned to Angkor soon after it reopened in 1991
and searched for a guidebook to plan my trip. None was
available. On a subsequent visit I found a photocopy of a
guide written in 1950 but the text was out-of-date, there
were no photographs and the reproduction quality was
poor. So I wrote a proposal for a book to include not only
information on the temples and suggested itineraries, but
also a background of the geography, history, religion, art
and architecture of Angkor. Odyssey Publications in Hong
Kong accepted my proposal enthusiastically and published
my guide, *Angkor: An Introduction to the Temples*, in 1994.
A second edition (expanded and revised) was published
in 1997, followed by a third one in 1999; a fourth edition
is at press.

During research on the guide, I came across numerous firsthand accounts written by explorers to Angkor in the last half of the nineteenth century and early western travellers from the beginning of the twentieth century onwards. Early travellers' impressions of coming upon the great 'Ongkor', as Angkor Wat was called, are vividly written. Most of the accounts are out-of-print and found only in the archives of institutions or specialised libraries, so few people today know about the experiences and impressions of early travellers to Angkor. Thus, the idea to bring together a representative selection of their accounts was born. A portion of the book is devoted to tales of the trials of getting there and the rigours of the journey, which are incomprehensible today when we can fly to Cambodia directly from several international destinations.

Angkor Observed is a personal book that entwines my own reflections from more than fifty trips to Cambodia and living in Thailand for some thirty years with those culled from early travellers. An anthology of this nature can never be complete and the choice of authors and excerpts is necessarily a subjective one. I have, nevertheless, tried to present a balanced view of the accounts and to capture the spirit of adventure, written by those who experienced it. The ultimate qualification for inclusion, however, is that I liked it, for whatever reason.

The excerpts cited span over a century, from 1860 onwards, and bring together, for the first time, selections from those 'There Before You'. The book is divided into nine chapters that can be read in any order depending on your mood or desire. Parts are nostalgic; some bring out the quixotic quest of travel; others depict the hardships of travelling in the tropics; still others reveal the impact of being at the great temples of Angkor. And all show a keen sense of observation, an acute curiosity and a zealous passion for adventurous travel. This book is in celebration of all those who left their memoirs for us to relive their experiences and perceptions of Angkor. Enjoy!

Dawn F. Rooney August 2000
 Bangkok, Thailand

CHAPTER 1

ANGKOR. ITS GLORY AND HISTORY

Let it be said immediately that Angkor, as it stands, ranks as chief wonder of the world today, one of the summits to which human genius has aspired in stone (Sitwell, O., *Escape With Me*, p. 90).

Angkor is no mere expedition to an ancient, abandoned kingdom, besprinkled with grey old ruins. It is an adventure into lost ages: a sort of uncharted voyage of the spirit (Ponder, *Cambodian Glory*, p. 315).

Why did westerners want to go to Angkor? What was their motivation? By the beginning of the twentieth century, 'Going eastward' seemed exotic and exciting. Europeans had heard stories from their ancestors about the Grand Tour on the continent, fashionable in the seventeenth and eighteenth centuries. A pursuit of learning motivated many Europeans who were ripe to seek new adventures further afield than the continent, to travel eastward. Going abroad was an essential part of a young Englishman's education and it was considered to give him polish and sophistication. The following excerpts from early travellers tell about their motivations for going to Angkor.

15

Pierre Loti, a French naval officer who served in the Far East in China, Japan and Korea at the turn of the twentieth century, wanted to see Angkor ever since he was a child. One day, in the attic of his home he was sifting through family memorabilia and read:

The ruins of Angkor! I remember so well a certain evening of April, a little overcast, on which as in a vision they appeared to me. It was in my "museum"—a little room allotted to my childish studies at the top of my parents' house—where I had gathered together a collection of shells, rare-plumaged birds, barbaric arms and ornaments, a multitude of things that spoke to me of distant countries. For at this time it had been quite decided by my parents that I should remain at home and not venture forth into foreign lands as did my elder brother who not long before had died in the far east of Asia.

This evening then, an idle scholar as was my habit, I had shut myself in amongst these disturbing things, for reverie rather than

with the idea of completing my tasks; and I was turning over some old and yellowed papers that had come back from Indo-China with the belongings of my dead brother. A few diaries. Two or three Chinese books. And then a number of I know not what colonial review in which was recounted the discovery of colossal ruins hidden in the depths of the forests of Siam.

There was one picture at which I stopped with a kind of thrill—of great strange towers entwined with exotic branches, the temples of mysterious Angkor! Not for one moment did I doubt but that one day I should see them in reality, through all and notwithstanding all, in spite of prohibitions, in spite of impossibilities.

To think of it better I moved to the window of my museum and gazed, chin in hand, at the outstretched country. Of all the windows in the house this one of mine commanded the most distant prospect. In the foreground were the old roofs of the tranquil neighbourhood; beyond, the hundred-year-old trees of the ramparts, and then, at last, the river by which the ships made their way to the ocean.

And very distinctly at this time there came to me a foreknowledge of a life of travels and adventures, with hours magnificent, even a little fabulous as for some oriental prince; and hours, too, infinitely miserable. In this future of mystery, greatly magnified by my child-ish imagination, I saw myself becoming a kind of legendary hero, an idol with feet of clay, fascinating thousands of my fellow-creatures, worshipped by many, and by some suspected and shunned.

In order that my personality might be more romantic there needed some shadow in the renown I was imagining for myself. What could that shadow well be? Something fantastic—something fearsome? Perhaps a pirate. Yes; it would not greatly have displeased me to be suspected of piracy on seas far distant and scarcely known.

And then there appeared to me my own decline, and, much later, my return to the scenes of my childhood, with heart a weary and whitening hair. My parental home, piously conserved, would have remained unaltered; but here and there, pierced in the walls, hidden doors would lead to a palace of the Arabian nights, filled with the precious stones of Golconda, with all my fantastic booty. And then, for the Bible was at that time my daily reading, I heard murmuring in my brain the verses of Ecclesiastes on the vanity of things.

Tired of the sights of the world and entering again, an old man, the same little museum of my childhood, I was repeating to myself: "I have tried all things; I have been everywhere; I have seen every-thing…" And amongst the many phrases already ringing sadly that came to lull me at my window was one that, I know not why, will remain for ever impressed upon my memory. It was this: "In the depths of the forests of Siam I have seen the star of evening rise over the ruins of Angkor."

A whistle, at once commanding and soft, caused me suddenly to become again the little submissive child that in reality I had not ceased to be. It came from below, from the courtyard with its old walls garlanded with plants. I would have known it amongst a thousand;

it was the usual summons of my father when I was discovered in some small transgression. And I replied, "I am up here, in my museum. Do you want me? Shall I come down?

He should have come into my study and cast his eye over my unfinished lessons.

"Yes, come down at once, little man, and finish your Greek composition, if you want to be free after dinner to go to the circus."

(I used to love the circus; but I was toiling that year under the ferule of a hated professor whom we called the Great Black Monkey, and my over-long tasks were never done.)

Still, I descended to set myself to the composition. The courtyard, that yet was pleasant enough with its old low walls overgrown with roses and jasmine, struck me as narrow, as too enclosed, and the April twilight falling at this hour seemed unwontedly cloudy, even somehow sinister; in my mind I had a vision of blue skies, wide spaces, the open sea—and the forests of Siam, out of which rose from amongst the palms the towers of prodigious Angkor (Loti, Siam, pp. 3-7).

Jennerat de Beerski, a Frenchman whose father and brother both died in Cambodia, was sent on an 'artistic and literary mission' to Angkor in 1919 by Monsieur Albert Sarraut, the Minister of the Colonies. A conversation with a friend, though, stimulated his interest in Angkor:

I well remember passages of a conversation I had with a friend some time before my journey to the Far East, to Angkor.

"Beauty is ever fresh," I was saying: "it is the brightest gem of nature, as boundless as the universe, as changeable as the vague outline of a mist. And yet I believe that every facet of art, the science of beauty, has been examined before or since the beginning of this century. Nothing is left for the traveller who wishes to visit wondrous, remote and unknown regions, the last resting-places of mystery, where so far it has not bee hunted out of its lair by Western civilisation."

My friend looked at me; then he replied:

"What you say is more or less true. No spot of this world of ours keeps entirely virgin in its bosom the startling treasure of an obscure art; but, if no hidden arts are waiting for the enthusiast, some, I assure you, have remained entombed in countries so weird and incomprehensible that mystery reigns there still, baffling all men. I have seen several of these precious regions, and none was more fantastic and remarkable than Angkor."

"Culture is a torrent which flows for all eternity; on some arid soils it leaves no mark; on others it continually effaces what it had fashioned, modelling anew, covering the destruction of a kingdom by the foundations of an empire. Also, above its seething waters,

solitary rocks emerge on which sedentary traditions have established their settled nest; but there it is picturesqueness, not magnificence, which meets us; our intellect is amused, our soul in slumber. Now, if I may develop the simile, torrents sometimes flood a tract of land unexpectedly and return to their beds, leaving behind them the mark of a temporary passage. Culture in the same way has leaps and spasms, invades a wilderness, turns it into a powerful realm, then capriciously retires…The population to which it taught the many secrets of human learning dwindles, falls and is decimated, but there grimly stands in the regrown forests the forgotten and romantic masterpieces of genius."

"In such regions one can reach mystery and grandeur; time has brushed away the pettiness of human nature and has spared the relics that prove its virtues and strength."

"Go to Angkor, my friend, to its ruins and to its dreams" (de Beerski, *Ruins in Cambodia*, pp. 19-20).

At the age of seventeen, Frank Vincent, Jr., the son of a wealthy New England trader, decided to travel and was determined 'to make a systematic tour of the most interesting parts of the world,' an ambitious decision for the frail, young man. He attended Yale University but left shortly after he entered because of illness. Despite his poor health, Vincent travelled for fifteen years and visited Angkor in 1871.

An aura of mystery and intrigue about Angkor prevailed in the West in the early twentieth century. De Beerski contemplates these aspects wandering through the Royal City of Angkor Thom at moonlight:

Mystery, source of thought! Is there any place in the world where you reign with greater force than here?

This I indeed the land of mystery, the land where everything served but to conceal, where leaves cover insects, where trunks hide beasts, where vegetation shelters temples, in their turn enshrining weird idols…(de Beerski, *Angkor, Ruins in Cambodia*, p. 50).

Drawings and photographs of the temples shrouded in jungle circulating through Europe at that time undoubtedly sparked curiosity and interest in going to Angkor. (Plate 1). Grace Thompson Seton was one traveller inspired to go to Angkor in 1938 through such photographs.

Angkor at last! The trail end of a lure that has led me half around the world, has teased my imagination since first photographers gave us the enigmatic faces of the Bayon, colossal, innumerable, smiling remotely amid writhing masses of smothering jungle (Seton, *Poison Arrows*, p. 200).

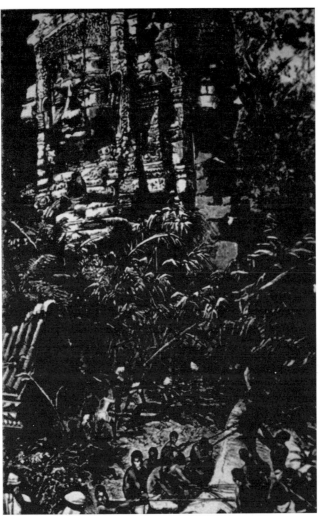

1 *A drawing of the Bayon temple engulfed in jungle (after Delaporte,*
L., Voyage au Cambodge: L'Architecture Khmer, 1880).

Richard Halliburton, an American, heard about Angkor
from an Englishman he met in Cairo who, unlike many
who only talked of the mystique of Angkor, had actually
been there and seen it. Halliburton writes of his
serendipitous meeting, the mystique of Angkor and how
the conversation motivated him to travel abroad and
to see Angkor:

He spoke of it in awesome tones as if it had been a super-human experience. Again and again in India I heard the name linked with superlative adjectives relating to its monstrous size and exquisite detail, yet always encompassed in rumour and obscurity. No one there had seen it – everyone said it was a miracle. Angkor—the murmur of its name grew as I moved eastward. Angkor—tales of its reputed glories were rumbling in my ears at Bangkok. ANGKOR—the wind and the jungle and the vast grey cloud of stone roared at me now as I hurried from the bungalow toward the mile-distant mystery: "Here is the superlative of industry, here the crown of human achievement. Here, here, is Angkor, the first wonder of the world, and the greatest mystery in history" (Halliburton, The Royal Road to Romance, p. 296).

Halliburton was in his final year at Princeton when the urge to travel struck him. He 'wanted to realize my youth while I had it, and yield to temptation before increasing years and responsibilities robbed me of the courage.' After graduating in June 1941, he writes: 'I was at liberty now to unleash the wild impulses within me, and follow wherever the devil led.' With his roommate, Irvine, they set off:

Away went cap and gown; on went the overalls; and off to New York I danced, accompanied by roommate Irvine (whom I had persuaded with little difficulty to betray commerce for adventure), determined to put out to sea as a common ordinary seaman before the mast, to have a conscientious, deliberate fling at all the Romance I had dreamed about as I tramped alone beside Lake Carnegie in the May moonlight (Halliburton, The Royal Road to Romance, p. 5).

Halliburton's parents offered him a deluxe trip around the world as a graduation present but he turned it down:

So we scorned the Olympic and, with only the proceeds from the sale of our dormitory room furnishings in our pockets, struck out to look for work on a freighter (Halliburton, The Royal Road to Romance, p. 5).

In contrast to Halliburton, American James Saxon Childers exhausted his travel funds on a trip around the world, ran out of money before he reached Angkor in 1923 and cabled his father for a loan:

Just ten months ago I left Alabama for no reason except that I was thirty years old and hadn't seen the Orient. Besides, I was tired of my two jobs: writing a daily newspaper column and teaching English literature to college sophomores. I started out to wander around the world. I've been through Japan, Korea, Manchuria to the Siberian border, and south through the rest of China. When I left home, my father assured me that five thousand dollars was not enough to

take me around the world. I was certain he was mistaken, and told him so. He can now have the pleasure of smiling at my ignorance, though the smile will be an expensive, one, for I cabled for a heavy loan.

The money should arrive to-morrow morning. In the afternoon I'll sail for Saigon in Indo-China, and from there set out through the jungle to hazard the mystery in stone that men call the ruins of Angkor (Childers, *From Siam to Suez*, pp. 3-4).

Englishwoman Claudia Parsons also went around the world, a few years after Childers, but unlike him, she had to find temporary employment and even sell her clothes to fund the trip: 'I must apologize for frequent reference to money matters...Costs were the outstanding feature of this venture.' Parsons aptly named her book *Vagabondage*. A model of Angkor Wat that she saw in an exposition in Europe inspired her to go to Angkor (Plate 2):

I saw it first at the Paris Exhibition of 1931, a pavilion built of concrete treated to look like weathered stone. It was the outstanding feature of the exhibition, and at evening was flood-lit with yellow lighting which turned concrete to gold. I had then never heard of Angkor Wat and thought this was just a flight of fancy, a wonder palace built for the occasion, not a copy of a temple long existent in the jungle of French Indo-China.

But within I found photographs and read descriptions that introduced me to the real Angkor and that nest of temples buried with it in jungle. I became familiar with the reliefs and carved motifs that decorated its walls, and that day I formed a vow: Some day...Somehow... (Parsons, *Vagabondage*, p. 127).

2 *A model of Angkor Wat in the Colonial Exposition in Paris, 1931; originally built for the exposition in Marseilles, 1922. (Photograph courtesy of Shirley Ganse.)*

She went to Angkor and was not disappointed: 'Angkor was built to impress the pilgrim, was intended to fulfil his hopes and fortify his beliefs no matter in what century he came' (Parsons, *Vagabondage*, p. 147).

Horace Bleakley, on a trip through Indo-China in 1925-26, included Cambodia simply because he thought: 'To come to Indo-China and not to go to Angkor is equivalent to paying a visit to Egypt without seeing Luxor,' (Bleakley, *A Tour in Southern Asia*, p. 55).

For Patrick Balfour 'the atlas is a notorious seducer. Step by step it leads the traveller on, covetous as a collector, insatiable in his accumulation of geographical experience.' He travelled from London to the east in 1934 and visited Angkor near the end of his six months journey. Balfour's motivation for writing of his travels in the east is set out in the Preface of his book:

Whereas in the past the Grand Tour was undertaken with the avowed educational intention of improving the mind, to-day we travel from a variety of motives, more negative than positive. Travel is primarily an avenue of escape, both actual and spiritual, from the complex liabilities of modern life. But though the pursuit of knowledge may be incidental to this instinct, it remains implicit in every voyage. The field of every traveller's interests is perceptibly widened by what he sees, and, if this book succeeds in stimulating in the reader some fraction of that curiosity to know more of the East which his journey aroused in the writer, it will not have been written in vain (Balfour, *Grand Tour*, p. viii).

Norman Lewis decided to go from Paris to Indo-China in 1950 because of the rapidly occurring changes in the region. He regretted he had not seen China before 1949 when the communists defeated the Nationalist People's Party forcing Chiang Kai-shek to retreat to Taiwan and closing the doors of China to visitors. He did not want to have same regret about Angkor:

In 1949, a curtain which had been raised for the first time hardly more than fifty years ago in China, came down again for a change of scene. Low-grade clerks in air and shipping offices all over the world were given piles of leaflets and told to stamp the word 'suspended' over such place names as Shanghai, Canton and Kunming. Later they used the 'service discontinued' stamp. If you had wanted to go to China it was too late. You would have to content yourself with reading books about it, and that was as much of the old, unregenerate China as you would ever know.

Now that China had passed into the transforming fire, it seemed that the experience of Far-Eastern travel, if ever to be enjoyed, could no longer be safely postponed. What then remained? Which would be the next country to undergo this process of change which was spreading so rapidly across Asia, and which would have to be seen now, or never again in its present form? I thought that Indo-China was the answer, and it was all the more interesting because, compared to the other Far-Eastern countries, so little had been written about it.

In the middle of January 1950, deciding to risk no further delays, I caught an Air France plane at Paris, bound for Saigon (Lewis, *Travels in Indo-China*, p. 17).

Recalling Angkor's past.

The name 'Angkor' derives from the Sanskrit word *nagara* ('holy city') which is *nakhon* in Thai and was probably pronounced *nokor* or *ongkor* in Khmer. Angkor is a confusing name in modern usage because it can refer to a kingdom, a region, an ancient city, or a former capital. It is widely used to identify the area in north-west Cambodia with the greatest concentration of Khmer monuments built during the Angkor Period (AD 802-1432).

The Khmer Empire controlled a large part of modern continental Southeast Asia for over six hundred years, from the beginning of the ninth to the middle of the fifteenth century. At its peak it was the most extensive and powerful force in the region with boundaries extending from the capital at Angkor, in north-western Cambodia, to southern Laos, north-eastern Thailand, the Malay Peninsula, Bagan (in modern Burma) in the west and southern Vietnam in the east (Map 1). Angkor, the administrative, cultural and religious centre, is situated on a fan-shaped plain between the Tonle Sap ('Great Lake') in the south and the Kulen mountain range in the north. Three hills – Phnom ('hill') Bok, Phnom Bakheng and Phnom Krom – frame the Angkorean plain. The Dangrek mountain chain runs east to west across northern Cambodia and provides a natural barrier to Thailand, except one opening in the western part of the range that gives access between the two countries. Siem Reap, capital of the province of the same name and

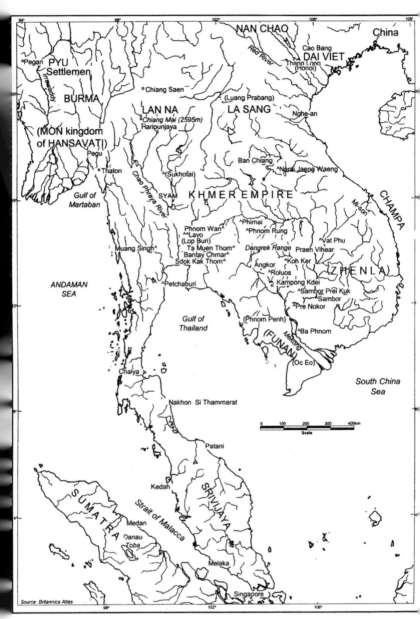

Map 1 *The Khmer Empire at its maximum extent* (c. AD 1200). *(David Snellgrove, Asian Commitment, 2000)*

Map 3 *(right)* *Siem Reap Province showing the location of the ruins of Angkor, by Frank Vincent (1873). (See p. 39.)*

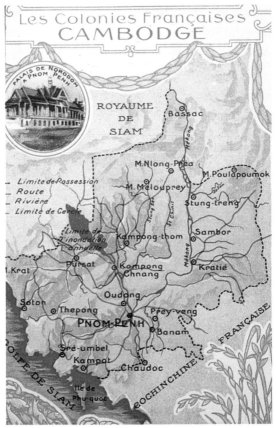

Map 2 A postcard with a map of Cambodia, which was one of
the three French Colonies in Southeast Asia. Les Colonies
Françaises: Cambodge [The French Colonies: Cambodia]; inset,
The palace of King Norodom (reigned 1859–1903). (See p. 37.)

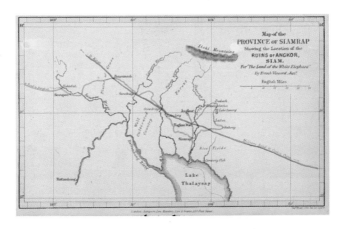

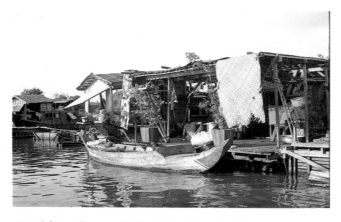

3 A fishing village on the Tonle Sap (Siem Reap).

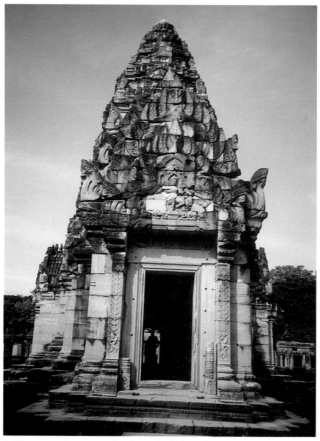

4 The central tower with a lotus-bud shaped superstructure at Phimai, a Khmer temple in north-eastern Thailand (c. first half of the eleventh century). (See p. 36.)

north of the Tonle Sap, is the town closest to the temples and the arrival and departure point for visitors to Angkor (Map 3). Phnom Penh, the capital of Cambodia, is located 350 kilometres (217 miles) south of Siem Reap, and is connected to the Tonle Sap by a river of the same name (Map 2).

The Inland Sea

The vast Tonle Sap dominates the natural water system of Angkor and is the lifeline of the Khmers, supplying fish and providing water for the cultivation of rice. Floating fishing settlements cluster near the mouth of the lake and inhabitants live in boathouses that move seasonally with the fluctuations of the water level (Plate 3). Every year the Tonle Sap River reverses its direction and the great lake more than doubles its size, making it a natural reservoir for six months a year, between May and late October. The phenomenon occurs when the water sent forth by the melting snows from the Himalayas exceeds the capacity of the silted channels of the Mekong River. As the Mekong flows southward through Cambodia to the South China Sea and reaches Phnom Penh, the impact of the overflow forces the Tonle Sap River, a tributary of the Mekong, to reverse its course and feed into the great lake. When this happens, it is so immense the Cambodians call the lake 'the inland sea'. At the end of the rainy season, the river reverses its flow and returns to normal.

Zhou Daguan (Chou Ta-Kuan), a Chinese emissary, who lived at Angkor for nearly a year between 1296 and 1297, wrote about this unique occurrence of nature over seven hundred years ago:

From the fourth to the ninth moon there is rain every afternoon, and the level of the Great Lake may rise seven to eight fathoms. Large trees go under water, with only the tops showing. People living at the water-side leave for the hills. However, from the tenth moon to the third moon of the following year not a drop of rain falls; the Great Lake is navigable only for the smallest craft, and the depth of the water is only three to five feet (Chou Ta-Kuan, *The Customs of Cambodia*, p. 39).

Henri Mouhot, a French naturalist, describes the sur-
real surroundings in January 1860 when the lake was
double its normal size:

*You enter the immense sheet of water called Touli-Sap [Tonle Sap],
as large and full of motion as a sea…The shore is low, and thickly
covered with trees, which are half submerged; and in the distance is
visible an extensive range of mountains whose highest peaks seem
lost in the clouds. The waves glitter in the broad sunshine with a
brilliancy which the eye can scarcely support, and, in many parts of
the lake, nothing is visible all around but water* (Mouhot, *Travels
in the Central Parts of Indo-China,* vol 2., p. 272).

Before Angkor

The historical roots of the Khmer civilization most likely
lie in two early states, known in Chinese chronicles as
Funan and Zhenla (Chenla). Both states were structured
on Indian concepts that reached the shores of the Gulf of
Thailand and western Cambodia sometime between the
third and fifth centuries AD when India was looking to-
wards the sea for new trade routes to replace the lucrative

overland ones with China. Trading ships with accompa-
nying religious leaders travelling from India moved towards
China following the coastline and established ports along
the way in hospitable areas where provisions could be ob-
tained. These ports served as dissemination points for the
spread of Indian ideas in the early cultures of continental
Southeast Asia. As trading ships came further east from
India so did social, cultural and religious ideas. The for-
mal religions of Buddhism and Hinduism were introduced;
Sanskrit was adopted as the official written script at the
court level and the influence from India gradually pen-
etrated the customs, government, law, economics and the
arts of the region.

Funan, located in the lower Mekong Delta and extend-
ing to the southern parts of Cambodia and Vietnam, was
one of these early ports. The name 'Funan' appears in Chi-
nese chronicles and was possibly a Chinese interpretation
of *bnam,* an ancient Khmer word meaning 'mountain'
and sounding like *phnom* ('hill' in modern Khmer). The

early tribal inhabitants of Funan may have belonged to the Mon-Khmer family of languages, which provides a linguistic origin for modern Cambodians.

Civil wars undermined Funan and by the second half of the sixth century, Zhenla, situated further inland on both sides of the Mekong River in southern Laos, gained control of Funan and emerged as a new, independent state. Zhenla extended its territorial boundaries to the border of present-day Vietnam in the north-east and as far as southern China in the north. The fall of Funan and the rise of Zhenla marked the beginning of the pre-Angkor period in Cambodian history.

Zhenla's power weakened and it split into northern and southern territories due to rivalry in the eighth century – upper Zhenla ('of the land') on the upper reaches of the Mekong River in southern and along the northern shore of the Tonle Sap; and Lower Zhenla ('of the water') east of the Tonle Sap.

The zenith of Zhenla, between the sixth and eighth centuries, is known as the pre-Angkor period and remains of temples from this time can still be found in southern Cambodia. Hermann Norden, travelling to Angkor in 1931, gives an account of visiting one of these pre-Angkor sites, a few years after its discovery, guided by the Governor of the Province:

The ruins of these temples mark the trail of the Khmers over Cambodgia and they are come on by chance or by seeking; just as Angkor Vat was found by Mouhot, and as Sambor was found a few years ago by a coolie who tracked game into the forest, and returned running to Kompong Thom, twenty miles away, with the word that he had found another hidden city....

I visited Sambor [Prei Kuk] before Angkor. For guide and host to the old capital which ante-dates Angkor Thom by at least two centuries I had Maes Keth Nal, the governor of the province in which these ruins stand. Of royal blood as all must be who hold high positions in the feudal administration of Cambodgia, Maes Keth Nal has his appointment from the king. The governor is a man of middle age and of much charm. He shows the effect of his years of residence in Paris; he has discarded native dress but he manifests a high pride in his racial heritage. In his home in Kompong Thom, where I met his charming wife and two small daughters, I saw bits of his sculpture. The governor, like most Cambodgians, is gifted in that art.

We motored over the twenty miles that lie between Kompong Thom and old Sambor; the road penetrated a forest that grew denser with every mile. Finally we left the car and proceeded along thorn-grown paths to the stretch of ground partially reclaimed from the jungle where stand the temples to the old Cambodgian gods.

Only partially reclaimed; Sambor is still in a state of wildness, overgrown with vegetation. Three groups of ruins, comprising many edifices, have thus far been uncovered. They show that here, too, was an important city; a capital before the great day of the Khmers, a capital built and abandoned by that ambitious, onward-moving people. Perhaps other capitals were built between Sambor and Angkor Thom; cities that will yet be discovered in the ruin-rich jungles. Great changes took place in the people and in their crafts in the centuries that elapsed between the building of Sambor and the beginning of Angkor Thom. The Sambor temples are of brick; only the door arches and statues are of stone. Not yet had the Khmers learned the art of building with stone; nor is there indication of the influence from southern India.

The work of reclamation goes slowly in Sambor. Both time and money have been wanting. Many of the statues and parts of the buildings are overgrown with the throttling, destroying green. Trees grow through roofs of some of the temples; roots and vines twine and interlace around broken walls and fallen statues. Some of the statues were found fallen to the ground, pulled from their niches by the rope-strong lianas. Other statues were found in the giant ant-hills with which the termites have helped on the work of jungle destruction while they did their own work of creation. A few inscriptions have been deciphered by the archaeologists; enough to prove that Sambor was a Cambodgian capital during the reigns of a part of the Bhava Dynasty, and that it dates from the sixth or seventh century (Norden, *A Wanderer in Indo-China*, pp. 282-3).

The rise and fall of Angkor

The fragmentation of Zhenla enabled Jayavarman II to unite the principalities in Cambodia for the first time. At the beginning of the ninth century he conducted a ritual on Mount Mahendraparvata (Phnom Kulen), 40 kilometres (25 miles) north-east of Angkor Thom installing himself as universal monarch and inaugurating the Angkor Period at the beginning of the ninth century.

Some thirty-nine successive monarchs ruled the Khmer Empire for the next six hundred years. Each one built temples to solidify his power and to honour his ancestors to ensure the continuation of the lineage. The empire reached a peak of territorial control between the elev-

enth and early thirteenth centuries. The supremacy of the empire, though, was often threatened by conflicts with neighbouring kingdoms including the Chams in southern Vietnam, the Siamese in Thailand and the Sailendras in central Java. Frequent battles with these kingdoms depleted the manpower and exhausted the reserves of the Khmers.

Two rulers stand out as remarkable leaders that took the empire to unprecedented levels of cultural and artistic achievement. Suryavarman II ('the sun king') ascended the throne in 1113 and reigned for thirty-seven years. He established relations with China and led successful military campaigns against Champa. He is, though, most renowned as the builder of the monumental temple of Angkor Wat, dedicated to the Hindu god, Vishnu, which is the largest religious stone monument in the world and is acclaimed as the greatest architectural achievement of the Khmers.

After Suryavarman II's death, several obscure and weak rulers followed. The Khmers suffered a disastrous defeat in 1177 when the King of Champa invaded Angkor in a daring and unexpected attack by sea. The fleet sailed from the coast of southern Vietnam to the mouth of the Mekong River in southern Cambodia, up the Tonle Sap River and across the lake. This attack by sea was unprecedented as previous ones were by land from north-western Vietnam. The Chams stormed the capital in a siege that decimated Angkor and left it in ruins.

The Chams ruled Angkor for four years before Jayavarman VII, the last great king of the period, ousted them. He ascended the throne in 1181 when he was over fifty years old and he ruled until his death in c.1219. Jayavarman VII's reign was one of the most opulent periods in Khmer history. He injected Angkor and the people with renewed vitality and supported Mahayana Buddhism, which gave the people hope for a prosperous kingdom and birth to new ideas in art and architecture. He undertook a vigourous building campaign to bring harmony, balance and prosperity to the universe. After building a new capital, the Royal City of Angkor Thom with the majestic

Bayon temple at the centre, he constructed a plethora of monuments throughout the kingdom, the largest and most well-known today are Ta Prohm and Preah Khan.

John Thomson, a Scottish photographer who visited Angkor in 1866, some four hundred years after the demise of Angkor Thom, still saw traces of its former grandeur: 'When the country was in its glory the interior must have been a perfect garden,' he wrote.

The Khmer Empire finally disintegrated in 1432 and gradually moved southward. Several factors contributed to the demise of the empire. Among them were the strengthening of the Kingdom of Ayutthaya in southern Thailand, and the advent of Theravada Buddhism, a new religion that spread from Sri Lanka through the Mon states to Cambodia, which introduced new spiritual beliefs. Angkor never regained its glory, despite a few feeble attempts, and, for the most part, the monuments fell in to disuse and became the prey of nature.

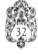 H.W. Ponder conjured up a scenario for the final, prolonged battle between the Khmers and the Thais in the first half of the fifteenth century:

> But if the Siamese story of the final sack of Angkor be true, the last scenes inside those walls must have been an unimaginable maelstrom of slaughter, pillage, and fire…And those gates and causeways must have seen the marching away of long trains of elephants loaded with the spoil of a city so fabulously rich as to be a byword even at the court of China; of chariots full of the fairest of the Khmer woman, spared from death for the pleasure of the victors; and of gangs of prisoners in chains, the pick of the men of all classes, rich and poor, some to be tortured, and some to be the slaves of their conquerors (Ponder, *Cambodian Glory*, p. 69).

Memories of the former Khmer glory faded, even within Cambodia. On an expedition to Angkor in 1866, the French Mekong Exploration Commission noted that:

> The Cambodians themselves know nothing either of their origin or of their history…they have no idea that their forefathers could have constructed the monuments whose ruins cover their country (Carné, *Travels on the Mekong*, p. 10).

The first glimpses of Angkor

Even though Angkor, its history and culture, was not widely known to Cambodians and Westerners in the late nineteenth century, it was never a lost kingdom as it is often described in modern publications. Portuguese, French and Spanish missionaries of the sixteenth and seventeenth centuries, for example, knew of Angkor. Their diaries, however, were confidential documents of the churches of Europe and thus the information contained in them was restricted and not circulated outside the churches. References to Angkor in missionaries' diaries leave no doubt that westerners knew of the ancient ruins at least four hundred years ago but their information was mainly based on hearsay as few of them actually saw the ruins. A French priest wrote:'There are in Cambodia the ruins of an old city which some say was constructed by the Romans or Alexander the Great.' Another one heard of 'An ancient and very celebrated temple situated at a distance of eight days from the place where I live. This temple is called Onco, and it is famous among the gentiles as St Peter's in Rome.'

The earliest surviving account of a European who actually visited Angkor comes from Father Charles-Emile Bouillevaux, a French missionary who served in Cambodia in the middle of the nineteenth century. In 1850, he travelled by boat from Phnom Penh up the Tonle Sap River, across the great lake, overland to Siem Reap and through the jungle to Angkor Wat and explored the great temple for two days, then published his observations several years later. 'Angkor Wat stands solitary and alone in the jungle, in too perfect order to be called a ruin, a relic of a race far ahead of the present in all the arts and sciences,' said D.O. King in a paper read to the Royal Geographical Society in London in 1860 based on his travels to Indo-China in 1857-8 (King, 'Travels in Siam and Cambodia,' pp. 177-82). As tantalizing as this observation appears, it generated little public interest at the time. Two years later a paper written by an explorer and read posthumously at the same venue as King's paper served

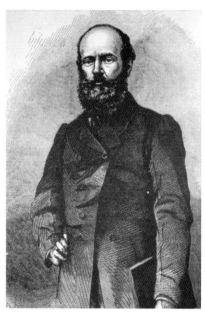

5 *A portrait of Henri Mouhot* (Travels in the Central Parts of Indo-China (Siam), Cambodia, and Laos, During the Years 1858, 1859, and 1860, 1864).

as the catalyst for an awareness of Ang-kor in the West. The paper comprised field notes of the Frenchman Henri Mouhot who travelled to the interior regions of Siam, Cambodia and Laos between 1858 and 1861 (Plate5).

Mouhot's keen observations of the places, people, animals, insects and shells he saw during his travels in Southeast Asia are captured in a detailed, but unfinished, diary that provides the earliest surviving records of previously un-reported areas (Plate 6).

Mouhot, an educated and cultured nineteenth cen-tury gentleman moved from his native home in France to Jersey and married a Scottish woman who was related to the explorer Mungo Park. Some two years later Mouhot set out for the East, leaving his wife behind. Although he tried to obtain funds from both France and England, he left with nothing more than moral support from the Royal Geographical Society in London.

Upon seeing Angkor Wat in 1859 Mouhot writes:

In the province still bearing the name of Ongcor, which is situated eastward of the great lake Touli-Sap, towards the 14th degree of north lat., and 104 long. East of Greenwich, there are, on the banks of the Mekon, and in the ancient kingdom of Tsiampois (Cochin-China), ruins of such grandeur, remains of structures which must have been raised at such an immense cost of labour, that, at the first view, one is filled with profound admiration, and cannot but ask what has become

of this powerful race, so civilised, so enlightened, the authors of these gigantic works? One of these temples—a rival to that of Solomon, and erected by some ancient Michael Angelo —might take an honourable place beside our most beautiful buildings. It is grander than any-thing left to us by Greece or Rome (Mouhot, *Travels in the Central Parts of Indo-China*, vol. 1, pp. 2789).

Mouhot's accompanying drawings showing layouts, enclosures, scale, shrines and galleries of the temples illuminated Angkor in westerners' eyes.

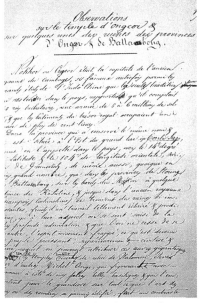

6 *A page from the hand-written diaries of Henri Mouhot on his Observations of the Temples of Angkor (Mouhot, 1864).*

Although Mouhot's diaries stimulated the imagination of the West, they were of secondary importance to Mouhot, who was a naturalist with the primary purpose of going east to acquire new specimens of insects, plants, flowers and shells.

After Angkor, Mouhot explored uncharted territory in north-eastern Siam and surveyed the Mekong River. The interiors of these areas on European maps of the seventeenth and eighteenth centuries were virtually blank until Mouhot provided charts and a map of his travels in the region (Map 4). In November of 1861 Mouhot contracted a fever and died at Luang Prabang in Laos at thirty-five years of age. His two faithful servants, Phrai and Daeng, took his notes to Bangkok which were later sent to his widow and brother in Jersey and, subsequently, were published posthumously in 1864 in French and later translated into English.

Following Mouhot, Dr. Adolf Bastian, an ethnographer from Bremen and President of the German Geographical Society, traveled to Angkor and presented his findings in a paper ('A Visit to the Ruined Cities and Buildings of Cambodia') read to the Royal Geographical Society of London in 1865. Before his departure from Bangkok for Angkor, Bastian had an audience with the second king of Siam who was familiar with Khmer temples through a visit to Phimai, a provincial Khmer capital in north-eastern Thailand. The King told Bastian that he had heard there were similarities in art and architecture of Phimai and Angkor Wat. A resemblance between the two temples is not surprising, as Phimai was a Khmer stronghold in Thailand before Angkor Wat was constructed and continued as a provincial centre after its completion. The lotus-bud shaped central sanctuary at

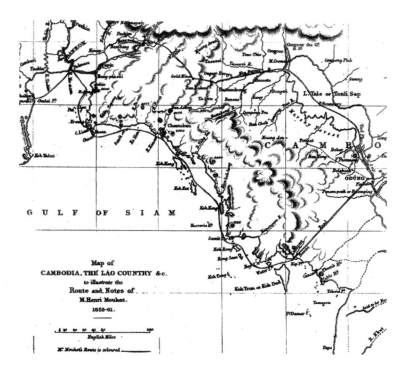

Map 4 The cartouche and part of a map showing the route and notes of Henri Mouhot's journey to Cambodia, the Lao country, etc. in 1859-61 (The Royal Geographical Society, 1862).

Phimai is strikingly similar to the towers of Angkor Wat (Plate 4, p. 26). This architectural innovation by the Khmers is traditionally believed to have made its first appearance at Angkor Wat, built between 1113 and 1150. An inscription, however, refers to a ceremony that took place at Phimai for the dedication of a deity in 1108, so the temple must have been completed by then. If so, Phimai was finished five years before construction on Angkor Wat began and, therefore, may have provided the inspiration for the lotus-bud shaped towers at Angkor Wat.

Bastian noted that at Angkor Wat the 'Magnificent inscriptions on door posts from top to bottom are in perfect preservation.' These inscriptions, carved in stone on the pillars of the cross-shaped galleries of the second level and written in Sanskrit and Khmer, are still visible and in good condition today (Plate 7). The inscriptions provide the basis for knowledge about the temple. Bastian visited many monuments besides Angkor Wat and drew the first surviving map showing the temples at Roluos, south-east of Angkor, a ninth century capital of Jayavarman II. Bastian was also the first to note parallels between Indian and Khmer artistic and architectural concepts.

At about the same time that Father Charles-Emile Bouillevaux, D.O. King, Henri Mouhot, and Adolph Bastian were exploring the ruins of Angkor, the French presence in Cambodia accelerated, through an interest initiated by missionaries who saw its position on the Mekong River as advantageous for trade. In 1863, France signed a Protectorate over Cambodia giving them administrative control of the entire country except Siem Reap and Battambong Provinces, which had been in Siamese hands since 1780 (Map 2, p. 25). Laos and Vietnam also came under French control by the end of the nineteenth century. The three countries were known as Indochina because they were influenced by both India and China.

Thomson, on his way to photograph the ruins of Angkor, arrived in Bangkok in 1866 and was privy to the strained relations that existed between France and Siam following

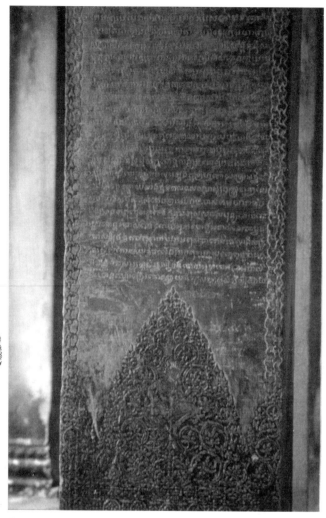

7 An inscription in Sanskrit and Khmer on a stone pillar in the central aisle of the second level of Angkor Wat (early twelfth century).

the signing of the Protectorate. During an obligatory audience with the Siamese King Mongkut (Rama IV) to obtain permission to travel beyond Bangkok, Thomson was presented with a letter instructing him to make known Siam's displeasure with the agreement as he travelled throughout the region. In an extract from the letter the King wrote:

I beg to take from you a promise that you should state everywhere verbally or in books, (&) newspaper public papers that those provinces of Battambong and Ongkor or Nakhon Siam belonged to Siam continually for 84 years ago—Not interrupted by Cambodian Princes or Cochin China, the fortification of those places were constructed by Siamese government 33 years ago, the Cambodian rulers can not claim in those provinces as they have ceded to Siamese authority 84 years ago. Signed, S.P.P.M. Mongkut, on 5476ᵗʰ day of reign, Royal Residence, Grand Palace, Bangkok, 13ᵗʰ May, 1866 (Thomson, 'Notes of a Journey through Siam to the Ruins of Cambodia').

Angkor was returned to Cambodia in a treaty between Siam and France signed in 1907.

The Mekong Exploration Commission, set out in 1866 to find a navigable route that could be used for trade along the Mekong River from Saigon to China. The expedition, led by Commander Ernest-Marc-Louis de Gonzague Doudart de Lagrée, was delayed in Bangkok by getting permission to travel onwards, so de Lagrée decided to take the six members of his group to Angkor where they spent a week systematically recording their observations and surveying the area. Findings of the expedition were subsequently published by two members of the team: Francis Garnier, the second in charge of the expedition, and Louis Delaporte, the artist attached to the mission. Garnier's work was published in 1873 in *Voyage d'Exploration en Indo-Chine, Effectué Pendant Années 1866, 1867 & 1868* and Delaporte's engravings of the ruins of Angkor appeared in 1880 in *Voyage au Cambodge: L'Architecture Khmer*. Delaporte's drawings showed the ruins as they saw them, engulfed by trees, roots and other jungle foliage. Vincent travelled in 1871-2 from Bangkok to Siem Reap and drew a fairly accurate map of Angkor and the environs and gave details of his journey (Map 3, p. 25):

The total distance we travelled from Bangkok was 275 miles; of this 30 miles was by canal in boats, 30 miles on the Bang pa Kong river in boats, and the remainder—215 miles—was performed upon horses and elephants, in bullock-carts, and on foot; the greater part of the journey, however, was accomplished on horseback. The time consumed in making this trip was seventeen days (Vincent, *The Land of the White Elephant*, pp. 207-8).

By the beginning of the twentieth century, the French

had established the Ecole Française d'Extrême Orient (EFEO) with headquarters in Hanoi. Its purpose was to study the history, language and archaeology of ancient sites in Indo-China. They undertook a systematic study of Angkor and began a programme to preserve the monuments. They worked steadily for nearly three-quarters of a century, except for a few years during the Second World War.

Angkor today

Today, Angkor, Cambodia's historic treasure and the premier ancient site in Southeast Asia, commands international awareness. Two major factors abetted this interest: first, the re-opening of Cambodia to tourism following the signing of a Peace Treaty in Paris in 1991, and, second, the inclusion of Angkor on the United Nations Educational Scientific and Cultural Organisation (UNESCO) World Heritage List in November 1992. The latter accolade was awarded in recognition that Angkor is one of the world's most valuable cultural heritages, a national symbol of Cambodia and its people and of concern to all mankind.

Most importantly, modern Cambodians are developing an awareness and appreciation of their rich past. Today, the towers of Angkor Wat emblazon the national flag, and an increasing number of Cambodians are visiting the temples at Angkor and honouring them as historic sites (Plate 10, p. 40). Photographs of wedding parties are taken at temples such as Banteay Srei and Angkor Wat. Family outings to the recently opened Kulen National Park are popular. International organizations are helping to educate Cambodians about their national heritage and history. Hopefully this trend of disseminating cultural knowledge to the modern nation will continue and future generations will hold children in their arms and tell them about their Khmer ancestors and the glory of Angkor.

CHAPTER 2

THE EXPLORER'S TRAIL

*Camping at night beneath forest-trees, or on the open arid
plains; halting at short intervals to repair our carts with the
materials which the jungle afforded (for there was not a single
nail in these vehicles), or to exchange them for others at the
various settlements on the route; we thus spent over a month
in lumbering across the country, and, as may be imagined,
had to endure some hardships from want of proper food, the
bulk of our supplies having been lost or damaged in the storm
when we quitted Kabin. At 'Ban-Ong-ta Krong' I had a sharp
attack of jungle fever, which left me so utterly prostrate that I
had to hire a small bullock-cart to take me on* (Thomson,
The Straits of Malacca, Siam and Indo-China, p.128).

The arduous journey

The overland journey made by explorers in the last half of
the nineteenth century from Thailand to Cambodia
through uncharted territory was just plain rough and tough.
The excerpt above is from the diaries of John Thomson
and his party on their way to Siem Reap in January 1866.
It gives a glimpse into the hardships of getting to the ruins
at that time. For the rare westerner who wanted to go to
Angkor, it was obligatory to obtain a letter that served as a
passport from the King of Siam before proceeding as the
north-western provinces of Siem Reap and Battambong
were not ceded to France when they signed the Protector-
ate over Cambodia in 1863. So, upon arrival in Bangkok,
a westerner began the lengthy process of setting up an au-
dience with the king as soon as possible. Thomson spent
six months in Thailand before he was able to proceed over-
land to Cambodia where he wanted to photograph the
temples of Angkor. And, even then, the route he pro-
posed was not approved, so he followed one similar to
Mouhot, who had made the passage six years earlier:

*We had first intended to sail down the Gulf of Siam to Chantaboon,
and thence to cross over the forest-clad mountains of that province
to Battabong. But the Siamese Government declined to grant a pass-*

port for that route, which they reported as dangerous and impracticable. We were therefore reduced to the necessity of making a tedious, and, so far as health was concerned, more dangerous journey by the creeks and rivers, and across the hot plains and marshes of the south-eastern provinces of the interior (Thomson, *The Straits of Malacca, Siam and Indo-China*, p. 118).

Mouhot made an entry in his diary telling of an encounter with nine wild elephants in the depths of the jungle along this route. Read on to find out what happens:

When we reached the station where we were to pass the first night, our servants lighted a fire to cook their rice, as well as scare away the wild beasts; but, notwithstanding this, we remarked that our oxen, dogs, and monkey showed signs of great fear, and, almost immediately afterwards, we heard a roaring like that of a lion. We seized our guns, which were loaded, and waited in readiness.

Fresh roarings, proceeding from a very short distance off, completed the terror of our animals; and we ourselves could not help feeling uneasy. I proposed to go and meet the enemy, which was agreed to, and we accordingly plunged into that part of the forest whence the sound came. Although familiar with these terrible creatures, we felt far from comfortable; but before long we came upon recent tracks which were quite unmistakeable, and soon, in a small clearing in the forest, perceived nine elephants, the leader being a male of enormous size, standing right in front of us.

On our approach he set up a roar more frightful than ever, and the whole herd advanced slowly towards us. We remained in a stooping position, half hidden behind the trees, which were too tall for us to climb. I was in the act of taking aim at the forehead of the leader, the only vulnerable part, but an Annamite who stood beside me, and who was an old hunter, knocked up my rifle, and begged me not to fire; "for," said he, "if you kill or wound one of the elephants we are lost; and even if we should succeed in escaping, the oxen, the wagons, and all their contents would be overwhelmed by the fury of these animals. If there were but two or three, we might hope to kill them; but nine, of whom five are very large, are too many; and it will be more prudent to retreat." At this moment, Father Guilloux, who had not much confidence in his powers of locomotion, fired his gun in the air to frighten the elephants; and this plan fortunately succeeded: the herd stopped in astonishment for an instant, then turned round, and marched into the forest (Mouhot, *Travels in Siam, Cambodia and Laos*, vol. 1, pp. 266-9).

Vincent and his party of eight, which included an American missionary and the United States Consul, made the rigourous journey from Bangkok to Siem Reap in seventeen days in 1871. Vincent writes about the troublesome mosquitoes:

We noticed that all the natives slept within curtains, and that the huge buffalo-cows were corralled in small swampy enclosures, in which they wallowed, covering themselves with mud and water as a protection against the stinging pests. At night we entered the nettings we were so careful not to leave behind, but no such thing as 'balmy sleep' could be obtained; there seemed to be quite as many mosquitoes within as without the curtains. They made a buzzing as of a thousand bees; the air was literally thick and heavy with them. The only respite we had from their attacks was when completely enveloped in our blankets; but this was simply 'from the frying-pan into the fire,' for the action nearly suffocated us. In the morning the General said he counted fifty of the merciless insects which were hanging on the inner side of his curtains, in a semi-torpid state, after the night's sanguinary foray; and my face was so red and swollen as scarcely to be recognizable by my companions (Vincent, *The Land of the White Elephant*, p. 176).

Anna Leonowens was not an explorer but she travelled overland (at least purportedly) from Bangkok to Siem Reap at an early date. And she is the only female I have read about making this journey before 1900. Anna was a teacher of English to the children of King Mongkut of Thailand from 1862 until 1867. She published her memoirs of that period in 1870. A second book followed and three films based on her life in Siam have been made. The authenticity of the most recent one, 'Anna and the King' by Fox Movies starring Chow Yun-Fat as the King and Jodie Foster as Anna, is so controversial that the Board of Censors banned it from being shown in Thailand.

Leonowen's verbose account of her trip overland from Bangkok to Siem Reap follows:

Our journey from Bangkok to Kabin derived its memorable interest from those features and feelings which join to compose the characteristic romance of Eastern travel by unhackneyed ways,—the wild freedom of the plain, the tortuous, suspicious mountain trace, the tangled jungle, the bewildering wastes and glooms of an unexplored region, with their suggestions of peril and adventure, and especially that glorious participation in the enlargement and liberty of an Eastern wanderer's life which these afford. Once you begin to feel that, you will be happy, whether on an elephant or in a buffalo-cart,— the very privations and perils including a charm of excitement all unknown to the formal European tourist.

The rainbow mists of morning still lay low on the plain, as yet unlifted by the breeze that, laden with odor and song, gently rocked the higher branches in the forest, as our elephants pressed on, heavily but almost noisely, over a parti-coloured carpet of wild-flowers.

Strange birds darted from bough to bough among the wild myrtles and limes, and great green and golden lizards gleamed through the shrubbery as we approached Siemrâp.

The more extensive and remarkable ruins of Cambodia seem concentrated in this part of the country, though they are by no means confined to it, but are found widely scattered over the neighboring territories.

From Sisuphon we diverged in a northeasterly direction, and at evening found ourselves in the quaint, antique town of Phanomsôk, half ruined and deserted, where the remains of a magnificent palace can still be traced.

The country between Cambodia and Siam is an inclined plane falling off to the sea, beginning from the Khoa Don Rèke, or highlands of Korat, which constitutes the first platform of the terraces that gradually ascend to the mountain chain of Laos, and thence to the stupendous Himalayas.

Khoa Don Rèke ("the Mountain which Bears on the Shoulders," the Cambodian Atlas) includes in its domain the Dong Phya Fai ("Forest of the Lord of Fire"), whence many tributary streams flow into the beautiful Pachim River.

At sunrise next morning we resumed our journey, and after a long day of toiling through treacherous marshes and tangled brushwood came at sunset upon an object whose presence there was a wonder, and its past a puzzle—a ridge or embankment of ten or twelve feet elevation, which, to our astonishment, ran high and dry through the swampy lowlands. In the heart of an interminable forest it stretches along one side of the tangled trail, in some places walling it in, at others crossing it at right angles; now suddenly diving into the depths of the forest, now reappearing afar off, as if to mock our cautious progress, and invite us to follow it. The eye, wistfully pursuing its eccentric sweep, suddenly loses it in impenetrable shadows. There is not a vestige of any other ruin near it, and the long lines it here and there shows, ghostly white in the moonlight, seem like spectral strands of sand.

Our guides tell us this isolated ridge was once the great highway of ancient Cambodia, that it can be traced from the neighbourhood of Nohk Burree to Naghkon Watt, and thence to the very heart of Cochin China; and one assures us that no man has ever seen the end of it.

So on we went, winding our devious ways over pathless ground, now diving into shady valleys, now mounting to sunny eminences where the breeze blew free and the eye could range far and wide, but not to find aught that was human. Gradually the flowering shrubs forsook us, and dark forest trees pressed grimly around, as we traversed the noble stone bridges that those grand old Cambodians loved to build over comparatively insignificant streams. The moon, touching with fantastic light the crumbling arches and imparting a charm of illusion to the scene, the clear spangled sky, the startling voices of the night, and the influence of the unknown, the mysterious, and the weird, overcame us like a dream. Truly there is naught of the

commonplace or vulgar in this land of ruins and legends, and the foretaste of the wonders we were about to behold met our view of the great bridges.

Tapan Hin ("the Stone Bridge") and the finer and more artistic Taphan Thevadah ("the Angel's Bridge") are both imposing works. Arches, still resting firmly on their foundations, buttressed by fifty great pillars of stone, support a structure about five hundred feet long and eight broad. The road-bed of these bridges is formed of immense blocks or beams of stone, laid one upon another, and so adjusted that their very weight serves to keep the arches firm.

In a clearing in the forest, near a rivulet called by the Cambodians Stieng Sinn ("Sufficient to our Need"), we encamped; and, having rested and supped, again followed our guides over the foaming stream, and re-crossed the Stone Bridge on foot, marvelling at the work of a race of whose existence the Western nations know nothing, who have no name in history, yet who built in a style surpassing in boldness of conception, grandeur of proportions, and delicacy of design, the best works of the modern world—stupendous, beautiful, enduring!

The material is mostly freestone, but a flinty conglomerate appears wherever the work is exposed to the action of the water.

Formerly a fine balustrade crowned the bridge on both sides, but it has been broken down. The ornamental parts of these massive structures seem to have been the only portions the invading vandals of the time could destroy.

The remains of the balustrade show that it consisted of a series of long quarry stones, on the ridges of which caryatidian pillars, representing the seven-headed serpent, supported other slabs grooved along the rim to receive semi-convex stones with arabesque sculptures, affording a hint of ancient Cambodian art.

On the left bank we found the remains of a staircase leading down to the water, not far from a spot where a temple formerly stood.

Next morning we crossed the Taphan Teph, or Heavenly Bridge—like the Tapan Hin and Taphan Thevadah a work of almost superhuman magnitude and solidity.

Leaving the bridges, our native pilots turned off from the ancient causeway to grope through narrow miry paths in the jungle.

On the afternoon of the same day we arrived at another stone bridge, over the Paleng River. This, according to our guides, was abandoned by the builders, because the country was invaded by the hostile hordes who destroyed Naghkoin Watt. Slowly crumbling among the wild plantains and the pagan lotuses and lilies, these bridges seem to constitute the sole memorial, in the midst of that enchanting desolation, of a once proud and populous capital.

From the Paleng River, limpid and cheerful, a day's journey brought us to the town of Siemrâp; and, after an unnecessary delay of several hours, we started with lighter pockets for the ruins of Naghkon Watt. (Leonowens, The English Governess at the Siamese Court, pp.221-3).

Thomson proposed that Leonowens did not visit Angkor at all, that she used his photographs and plagiarized Mouhot's text. Reading her account, Thomson thought that she had travelled along the same route as he did a few years earlier. If so, though, he was puzzled because he:

Could not make out…how her elephants could have "pressed on heavily, but almost noiselessly, over a parti-coloured carpet of flowers." As to parti-coloured carpets, the convolvulus and other flowers, found in these regions, are of remarkably beautiful kinds, but it is on account of their extreme rarity that they are most highly prized. For my own part, I should have expected a longer and more detailed account of her journey from a lady who observes so accurately and describes so well. Can it be possible that it was she, after all, who aided in compiling M. Mouhot's posthumous narrative, where some of the passages which treat of the Cambodian ruins read like extracts from Mrs. Leonowen's own valuable work (Thomson, *The Straits of Malacca, Siam and Indo-China*, p. 129).

The above excerpt is only one of several that convinced Thomson of Leonowen's extraction of another's work to embellish her own. He sights other errors and concludes his degradation of Leonowen's authenticity in her account with this note:

We regret, however, to discover this authoress, when she describes the Cambodian ruins, falling into a number of grave errors which might, some of them, have been avoided had she studied my photographs more carefully when she did me the honour of selecting them to illustrate her work (Thomson, *The Straits of Malacca, Siam and Indo-China*, p. 130).

Harold Elvin, who bicycled to Angkor from India in 1961, also sensed an error in Leonowen's account of the route she took to Angkor: 'After reading Anna's horse-ride to Angkor I had expected hills the whole way. I suspect now she took a boat and came up through the Elephant or Cardamon Mountains,' (Elvin, *Avenue to the Door of the Dead*, p. 260).

Siem Reap – stepping stone to Angkor

Siem Reap ('the defeat of the Siamese'), the provincial capital, is approximately six kilometres (four miles) from the ruins of Angkor, and was the largest centre of civilization the explorers had seen since leaving Bangkok. It must have been a welcome respite from the arduous travel

through dense, pathless jungle. Upon arrival in Siem Reap, early travellers presented their credentials to the presiding officer. Francis Garnier, a member of the Mekong Exploration Commission, described Siem Reap in 1866 a 'new Angkor, a big market town that sits astride the banks of the river…'. The rare appearance of a foreigner was reason for the finest of celebrations – special food, music, dancing – and the festivities were an eclectic mélange of traditions from the East and West. Rarely was an invitation declined but Frank Vincent was too exhausted when he arrived in Siem Reap in 1871 to dine with the governor. Apparently accepting the foreigner's plight, the governor accommodated Vincent and his party by sending to them:

A very nice Siamese (though served in European style) dinner upon a silver tray; there was soup in a large blue China tureen, a great dish of boiled rice, and a variety of stewed meats and condiments in small bowls; knives and forks were provided and a table and chairs brought, a cloth laid, and upon it (mirabile visu!) *a 'reg'lar down-east' tallow-dip was placed, the wick being quite two-thirds of its size, and it burning at about the rate of an inch a minute* (Vincent, *The Land of the White Elephant*, pp. 201-2).

Thomson and his party were received by the governor 'with great courtesy', upon their arrival in Siem Reap, where they stayed for three days. But in contrast to Vincent's opinion, he thought 'The old town of Siamrap is in a very ruinous state.'

Elephants and oxen

Arrangements for transportation on this leg of the journey were made through local officials in Siem Reap. The common modes of travel were either pony, oxen cart (or 'buffalo-chariot' as some early writers called it), or elephant. Thomson set off for Angkor Wat by pony.

On the third morning of our stay we mounted our ponies, and passed out of the city gates on the road for Nakhon Wat, and the ancient capital of the Cambodian empire. One hour's gentle canter through a grand old forest brought us to the vicinity of the temple, and here we found our progress materially arrested by huge blocks of freestone, which were now half buried in the soil. A few minutes more, and we came upon a broad flight of stone steps, guarded by colossal stone lions, one of which had been overthrown, and lay among the de-

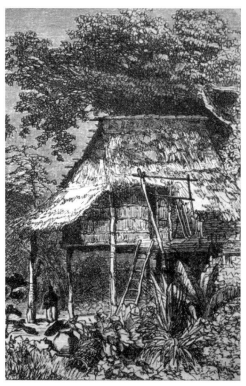

8 *Accommadation for the explorer (Delaporte, 1880)*

bris. *My pony cleared this obstacle, and then with a series of scrambling leaps brought me to the long cruciform terrace which is carried on arches across the moat. This moat is a wide one, and has been banked with strong retaining walls of iron-conglomerate. The view from the stone platform far surpassed my expectations. The vast proportions of the temple filled me with a feeling of profound awe, such as I experienced some years afterwards when sailing beneath the shade of the gigantic precipices of the Upper Yang-tsze.*

The secret of my emotion lay in the extreme contrast between Nakhon Wat—rising with all the power which magnitude of proportions can give, a sculptured giant pyramid amid forests and jungle-clad plains—and the grass-thatched huts, the rude primitive structures which are all the present inhabitants have either wish or ability to set up (Thomson, *The Straits of Malacca, Siam and Indo-China,* pp. 135-6).

Loti, like Leonowens, was not an explorer but he followed in their footsteps as he was the earliest traveller to go to Angkor at the turn of the century who left a record of his journey. Loti went from Siem Reap to Angkor Wat by oxen cart, a journey that took over two hours:

On leaving Siem-Reap our ox-carts turn away from the river and follow another sandy road which plunges right into the forest. And then suddenly there is an end to the tall green palms above our heads; for all this vegetation of coconut and areca palms is confined to the banks of the river. We make our way now under foliage that is similar to that of our own climate, only the trees that bear it would be a little giantlike compared with ours. In spite of so much shade the heat, as the sun climbs the sky, becomes every minute more oppressive. Following the ill-defined road through the high forest trees and impenetrable bush, our carts jog along in time with the trotting of the oxen between two banks of thicket or bracken. And the prudent monkeys cling to the highest of branches.

When, at the end of some two hours travelling through the forest in this fashion, we were beginning, what with the jolting and the rocking and the heat, to feel ourselves overtaken by somnolence, the fabulous town itself was suddenly reavealed to our eyes.

Before us there is gradually unfolded an extent of open space; first of all a marsh overgrown with grasses and water-lilies than a wide stretch of water which liberates us at last from the forest, in the dense covering of which we had been travelling; and further on, beyond the stagnant waters, a number of towers, in the form of tiaras, towers of grey-coloured stone, immense dead towers, outlined against the pale luminosity of the sky. Yes! I recognise them at once. They are indeed the towers of the old picture which had troubled me once upon a time, on an April evening, in my little museum. I am in the presence of mysterious Angkor! (Loti, Siam, pp. 53-5).

Vincent took a ride in a 'bullock-cart' but found it incompatible with his size:

The body of this vehicle looks very much like a huge barrel; it is made of bamboo covered with leaves, but so narrow is it that one has to sit cross-legged, and so low is it that when thus sitting it is impossible to wear one's hat. Upon a small seat which projects out before, the driver sits; he drives the oxen by means of a small rope passed through their nostrils, and uses a goad (a sharp nail fastened to the extremity of a stout stick) upon their humps instead of a lash. The bullocks usually bear strings of wooden clapper-bells around their necks, and when trotting fast their jingling sound reminds one somewhat of the sleigh-bells in winter at home. Upon a good, level road this mode of conveyance is not disagreeable, but little of the country through which one is riding can, however, be seen (Vincent, The Land of the White Elephant, pp. 200-201).

The oxen carts used by villagers today living in the Angkor region have changed little from those used by Loti and Vincent (Plate 11). And the framework and type of wheel on these carts is the same as in ancient times as depicted in a carving at the Bayon temple of the thirteenth century (Plate 9).

13 A travel brochure of Dollar Steamship Lines offering cruises around the world including tours to Angkor, Siam and Malaya (c. 1940s). (See p. 56.)

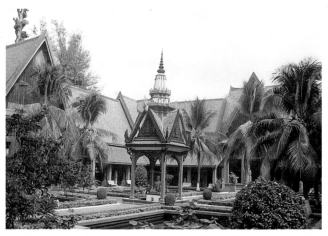

14 The National Museum of Cambodia, Phnom Penh. (See p. 62.)

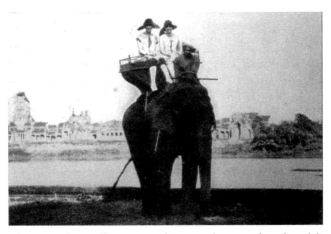

15 Two early travellers wearing elegant sun hats seated in a howdah on an elephant in front of the west entrance at Angkor Wat (c. 1920s).

ions or rest as in a chair, placing the feet upon the animal's neck. In some parts of Siam, a young elephant may be purchased for as little as twenty ticals (about $12). The animals which we had from time to time travelled two, or two and a half miles an hour, but they could not make more than twenty miles a day, nor could they carry more than four hundred pounds' weight upon their backs (Vincent, *The Land of the White Elephant*, pp. 194-5).

Thomson gives his impression of what it's like atop the back of an elephant:

The elevated position, the straight course one shapes through forest and jungle, and the commanding view one obtains of the surrounding scenery, have at first a rare charm; but after a time we feel that it would be a decided relief could we stay the regular gyration of the head, and seek another axis of motion than the small of the back. So we form some excuse, and descend to 'terra firma;' but even then the motion still goes on, or appears to go on any rate, for some time (Thomson, The Strait of Malacca, Siam and Indo-China, p. 135).

Garnier relates a hair-raising experience on an elephant that happened while he was travelling from Siem Reap to the ruins of Angkor in 1866:

On the morning of 24 June, we took leave of the hospitable governor to make a camp closer to the ruins. Each of us was perched on an elephant and, being mostly little accustomed to this means of transportation, we were more concerned with avoiding the hard jolts of our saddles than with enjoying the sights of the forest into which we entered or the relative freshness of the morning at which we set off. For my part, I mounted a young female which, fearful and sensitive

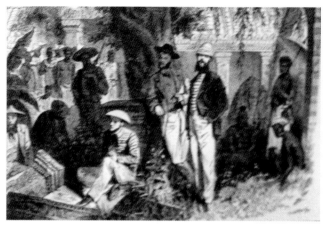

16 Members of the Mekong Exploration Commission (Delaporte, 1880).

as goes with this age and sex, suddenly took fright at the sight of I know not which bizarrely shaped tree trunk and launched into a gallop across the forest, endangering the howdah *and its occupants. Her* mahout [driver and tender of the elephant] *only managed to stop her by driving two or three inches of the curbed back iron which serves the elephant drivers as a spur, into her head. I took some time to recover from the rude jolts which I received from my highly strung animal* (Garnier, *The French in Indo-China*, pp. 10-11).

The joy of seeing the temples of Angkor seems to out-weigh the hardships of travel according to the accounts of the explorers. The Governor of Siem Reap provided Vincent and his party with three elephants to travel to Angkor Wat and he writes his thrill of getting there at last:

We started for the ruins of Angkor, three and a half miles distant, to the north. We took but little baggage with us, being rather impatient now that we were nearing the main object of the expedition—the ultima Thule *of our desires and hopes—and so we passed quickly and silently along a narrow but good road cut through the dense, riant forest, until, in about an hour's time, on suddenly emerging from the woods, we saw a little way off to the right, across a pond filled with lotus plants, a long row of columned galleries, and be-yond—high above the beautiful cocoa and areca palms—three or four immense pagodas, built of a dark-grey stone. And my heart almost bounded into my mouth as the Cambodian driver, turning towards the* howdah *said, with a bright flash of the eye and a proud turn of the lip, "Naghon Wat"; for we were then at the very por-tals of the famous old 'City of Monasteries,' and not far distant was* Angkorthom—Angkor the Great (Vincent, *The Land of the White Elephant*, p. 208).

CHAPTER 3

TO ANGKOR, THE WATER WAY

How often we in America have felt that intangible thrill that is Asia—the East that is East—where no amount of Western understanding seems quite able to fathom the depths of her mysterious peoples and customs (Dollar Steamship Lines & American Mail Line Brochure).

Across the seas to Cambodia

By the first decade of the twentieth century travel to Cambodia was more organized and travel agents were putting together packaged tours to the region. Travelling by sea from Europe or America to Saigon (Ho Chi Minh City), in southern Vietnam was developing. Later, cruises offered tours to Angkor. Also, the number of travellers increased steadily as did the diversity of nationalities. Delays were, nevertheless, frequent, primitive conditions still prevailed in some places and preparations for the journey and planning for an extended stay in a foreign country had to be made. Taking the right provisions for enduring the tropical climate and for coping with the myriad of lizards and insects, leeches and other health hazards were just some of the considerations necessary for a venture eastward from the West. A guide, published in 1906, offers some general suggestions for cruising to the Eastern seas. The recommendations are particularly amusing in light of the casual dress that prevails amongst tourists to Asia today:

In the first place it must be remembered that it is quite unnecessary to discard all European clothing. Most of it is certainly too heavily made and too close in texture for tropical wear, but there are occasions and localities where much of it becomes necessary...For the actual tropics however, a special outfit of light washing material is needed, and the principal items therein should comprise, for gentlemen, a number of white or grey linen or cotton suits, consisting of trousers and coats

only. The so-called patrol coats, which do away with the necessity for wearing the uncomfortable starched collar, are much in vogue in the East and can certainly be recommended. Ladies also should choose their travelling wardrobe with a view to lightness and simplicity, as the hot weather renders the laundryman an ever present necessity, and delicate fabrics and laces wear out quickly under the rather rough handling they receive at the hands of native washermen….

Footwear, if it can be avoided, should not be purchased in the East, the manufacturers in this respect being far below the European standard. The most suitable shoes for the tropics are those made of white canvas, with leather soles (Plate, *A Cruise Through Eastern Seas*, pp. 3-4).

By the mid-1940s Dollar Steamship Lines offered tours from the United States to the Orient in luxurious ocean-going liners. A passenger could embark on a President Liner at Los Angeles or San Francisco, cross the Pacific Ocean to Honolulu and go on to Japan, Shanghai and Hong Kong. To get to Angkor you took a local steamer from Hong Kong to Singapore and then a train and car to Angkor. A trip to Angkor features in the cruise brochure (Plate 13, p. 52):

The Oriental beauty and color that we may store up from such a trip will unroll like a necklace of memories as the adventure of life goes on through the years. The thrill of discovering the age-old lost Kingdom of Angkor at sunset, a vast city of crumbling rock, half concealed by the cruel tentacles of the jungle is a pinnacle experience (*Dollar Steamship Lines & American Mail Line Brochure*).

The brochure stresses: 'And yet, though Angkor be in the middle of dense jungles, we have comfortable and modern hotels at our disposal and fine motor cars to drive about this interesting country.'

Up the Mekong by steamship

One thing that makes a visit to Angkor an event of unusual significance—preparing you to enter into the state of mind proper to such an experience—is the immense difficulty of getting there (Maugham, *The Gentleman in the Parlour*, p. 208).

After reaching Saigon (Ho Chi Minh City) by sea from the west, a typical journey to Angkor began on one of the French-owned steamers belonging to the Compagnie des Messageries Fluvials de Cochinchine going up the river to Phnom Penh. Steamer trunks of fine leather carrying the

spiritual state. One showed one's determination to go native for a couple of hours after dinner and one was expected to flop down quite unconcernedly wherever there happened to be a vacant mat.

The actual smoking, a tedious process, brought no reward it seemed, unless persevered with. I was promised that with six pipes I could expect to be reasonably sick, which was as far as a beginner got on the first few occasions. However the smell of the stale smoke-impregnated compartment of a 'workman's special' was enough for me. It was another convention that one stretched oneself out on a mat while the blob of opium was toasted over a spirit lamp before being transferred to the bowl of the yard-long pipe. These preparatory rites were performed by a corps of uniformly ill-favoured young Cambodian ladies, whose looks Madame excused by saying that all the pretty ones had recently been abducted by some ex-bandits newly formed into a patriotic army. Valas smoked three pipes and was ready to move. No one seemed in the slightest affected by their indulgences, despite the fact that two civil servants and a very high ranking officer in the same room had smoked fifteen pipes and said that they would smoke thirty before leaving. Apart from the sheepish good-fellowship of shared weakness, there was nothing in their manner—I met the officer later on duty—that seemed in any way other than normal.

Valas was highly suspicious of the quality of the opium, and asked whether it was contraband rubbish from Siam. The original wrapper, marked with the government stamp, had to be found to convince him (Lewis, A Dragon Apparent, pp. 198-200).

On the subject of drugs, Gorer thought the Khmers were 'an opium-soaked community.' Read on:

Opium is, however, absolutely necessary for the comprehension of their art. Khmer art has always seemed strange and alien to European commentators; and this strangeness in analysis is caused by the fact that Khmer art is extremely sensual and completely sexless. In the square mile of Khmer sculpture at Angkor there is not a single sexual figure or group; the very rare nude figures have no genitals... the chaste Khmer figures are extremely voluptuous, carved and adorned with an obvious appreciation of human beauty but with no desire. And this peculiar attitude is, I am sure, the result of opium (Gorer, Bali & Angkor, pp. 178-180).

Nearly thirty years later, Sitwell visited Angkor and in reference to Gorer's theory that the Khmers were 'an opium-soaked community' writes: 'This conviction which grows upon one with every walk over the causeway into Angkor Wat becomes a certainty when we see the obsessive and megalomanic Bayon' (Sitwell, S., The Red Chapels of Banteai Srei, p. 48).

A Cambodian guide told Seton in 1938 a local legend

century. Here is a description of one:

Madame Shum's is Pnom-Penh's leading opium den, or salon de désintoxication as they are now, with a kind of prim irony, re-named. The salon was a great bamboo shack among the trees, its empty window-apertures glowing feebly with death-bed light. In these romantic surroundings the raffish élite of Pnom-Penh meet together at night over the sociable sucking of opium pipes.

We were received by Madame herself, who possessed all the calm dignity of her social position. There was evidently a certain snob-value in being on calling terms with the head of the house, compara-ble to the privilege of being allowed to address a well-known head-waiter by his Christian name. The rank and file of patrons were dealt with by underlings, but the socially prominent always made a point of calling at the administrative headquarters to present their compliments to Madame. We were served with highballs on the veranda while Madame showed us the latest portrait of her son, who was studying medicine in France, and of her daughter, an ex-tremely beautiful girl of seventeen who was at college in Saigon. They were by different French fathers, she mentioned. Valas pro-duced the formal banter the occasion demanded, including mild, chivalrous overtures to Madame herself and a request for the daugh-ter's hand.

One went to Madame Shum's, Valas said, first because it was the thing to do, and secondly because you met all kinds of business and other contacts there. We did in fact run into one man who hoped we might be induced to buy a certain American car from him. He had imported this car with a particular client in mind, a wealthy Chinese who, since it was the only one of its kind in Indo-China and loaded with chromiumed accessories, was expected to jump at the chance. Before seeing it the Chinese had asked all the questions covering the essentials. Was it fitted with radio?—Yes. Press button hood-operations?—Yes. Parking and pass-lights?—Yes. Two-tone horn?—Yes. Air-conditioning?—No, but it could be fitted. Only at the last moment when the man was sure the sale was in the bag had he turned up with a tape-measure. He was sorry, it was too small; several centimetres shorter than a Buick he had been offered. Thus have the provincial Chinese of Pnom-Penh, separated from the main-springs of their culture, turned away from the curious and exquisite, and embraced the standards of taste which are impressed by fashion, by glitter and by sheer size.

As a concession to the atmosphere at Madame Shum's patrons were supposed to remove their clothing and put on a sarong. At first one felt childish and self-conscious, like a timid experimenter, perhaps, in a nudist colony. But among all these corpulent officials, these chiefs-of-staff and under-secretaries padding to their pleasures down the creaking corridors, the feeling soon passed. It was nothing more than a casual encounter of elks in semi-regalia. There seemed to be no desire for privacy. The sarong was the badge of a temporary inward and

air galleries surrounding an inner courtyard that combines French Colonial features with a Khmer-style façade (Plate 14, p. 52).

Garstin visited the museum in 1928 and writes of the variety of the collection:

It [Phnom Penh] possesses one oasis, one unique and grateful spot, the Khmer Museum. This is under the loving care of M. George Groslier, probably the greatest living authority on Angkor and to whom the revival of native handicrafts is largely due. The collection is housed in a building of Cambodian style, with the roof turned up at the ends in the form of an inverted arc and tipped with horns. Here are Brahmanic and Buddhist statues, bas-reliefs and ornaments of many epochs, fetched from many places, Angkor, Sambor, Phnom-Kulen, Kompong Speu. Sivaist trinities in stone, Khmer lions, Garudas and Nagas, Buddhas and Taras. Here are scores of little bronze images, monks, sacred dancers, chariot buckles, bells, daggers, beaten silver cups, and rings with enormous jewels. Here also are glittering dresses, ferocious fanged masks with crowns like spires for actors, silks of barbaric but entrancing colours, pots and jars of earthenware, black lacquer boxes shaped like toads, royal palanquins and saddlery (Garstin, The Dragon and the Lotus, pp. 248-9).

Osbert Sitwell recognized the importance of the collection but thought the figures, removed from their context and standing in isolation, were rather cold and despondent:

The museum constitutes the chief interest of the town, for it houses the principal collection of bronzes in Cambodia; one far finer than any existing either in Saigon or Angkor. In these galleries the traveller begins to realise for the first time both the extent of Angkor, and its esthetic status, before ruin overtook it. Room after room is filled with these calm, bronze figures, with large, curiously shaped ears, and, playing round their mouths, that smile which so distinguishes them, and seems to have risen up to their lips at some overtone from a world so distant that only their ears are attuned to catch the sound. But these beautiful images, removed from their surroundings, dead for so many centuries to all human contact, have become mournful, like the dry and dusty relics of Egypt; even their smile has grown infinitely sad, and they can only be regarded now as so many disbanded heralds of that tremendous glory that stands recovered from the assaults of the forest...Lovely and, even, sublime as they were, they fail in the memory to attain to that same brightness, to that same incisive poignance as another altogether more transient and trivial impression of Phnom Penh (Sitwell, O., Escape With Me, p. 76).

On the seamier side of life in Phom Penh, opium dens operated in abundance in the first half of the twentieth

one day, when I've saved up a stock of exclamation-marks.

All day we pushed against the broad flood, through a land so flat and along banks so low it seems as though a six-foot tidal-wave would drown the whole country. Here and there along the banks were fish-traps, canoes drawn up, thatched roofs showing among bamboos and kapoks, and perhaps a buffalo cooling its ugly hide in the stream, nostrils alone visible. Freight-junks drifted down under idle sails, also mats of floating weed with mauve flowers. Now and again canoes accosted us and passengers, mainly women, came aboard hauling their luggage with them, mat bundles, boxes, and live hens either crushed into baskets like cabbages or tied up in bouquets by the legs. In Indo-China nobody seems to be able to step across the road without taking his hen with him. As there is little camaraderie in a hen and there can be no market for so common an article, I presume the idea is that travel will enlarge its mind.

Sunset turned the sky into one of great flawless fire opal, night came over the wide savannahs wearing the young moon like a jewel, but bringing little respite from the heat. I spent a second night in the long chair, waking to see the gilt horns of Phnom-Penh's pagodas lifting over the tree-tops, flashing back at the new-risen sun. It was as though a herd of golden bulls stood at rest in a magic wood (Carstin, *The Dragon and the Lotus*, pp. 243-6).

Sojourn at Phnom Penh

Phnom Penh, the capital of Cambodia, is a flat, sprawling town, situated at the juncture of four rivers – the Tonle Sap, Upper and Lower Mekong and Bassac – was founded in the late fourteenth century. The French built wide boulevards framed by rows of stately trees reminiscent of Paris, elegant villas with wrought iron balconies and gardens with exotic, tropical flowers, a Christian church and esplanades along the waterfront. It was considered the grand dame of French colonial cities in Indochina. Travellers arriving from Saigon stayed in Phnom Penh for at least one night and day, before continuing their journey to Angkor. A typical day in port included a leisurely visit to the National Museum. Its extensive collection of Khmer stone and bronze art was a prelude to Angkor. Seeing the sensuous images of male and female deities and guardians, the intricately carved scenes from Hindu mythology, the serenity of the Buddha figures and much more whetted one's appetite. The museum is a stately, square-shaped building with open-

19

Because for the traveller who likes to 'see comfortably and write dangerously' (if need be) there was nothing so pleasant as river travel. Over and above other advantages it gives the lonely traveller a chance of meeting with others and joining them in excursions which would be difficult alone, except possibly by the spending of much money, a thing I was greatly concerned to avoid!(Wheatcroft, Siam and Cambodia, p. 51).

Horace Garstin left Saigon for Phnom Penh by boat in 1927, the day after Chinese New Year celebrations still going on:

Stokers on the berthed steamers were letting off slap-bangs; crackers popped all over the town. First one or two, desultory sniping, then fusillade upon fusillade. Saigon might have been a beleaguered city. The Chinese saluted the new moon with rockets, she lying on her back, low down over the glare of the town like some wan and listless goddess. The rockets soared and dropped, fiery daffodils curving gracefully across the stars.

Garstin's account continues, written in a personal and often humourous style:

We left the brightly lit cafés astern and headed seawards to find the main stream of the Mekhong. On the lower deck men and women were laying out their mats for the night, among stacks of green coconuts, crates of hens, bales and baskets. Lower still, a naked Malay cast logs into the furnaces. In the glow of the flames his wet body shone red. Down in that flamelit pit he seemed a devil stoking fires for the damned. My cabin fan had broken down, so I camped in a long chair on deck for the night.

We ran on and on through the flat dark country. The native steersmen must have had eyes like cats, for mine are good enough, yet the river-banks were invisible to me. Stars bent in a bright arch from low horizon to low horizon; we might have been at sea. Occasionally the glow of a cigar and a ghostly shape on the bridge betokened that the captain (in pyjamas) had risen from bed to see his charge round a corner. The last things I remember that night were the Cross very faint in the south, the Dipper tilted over Siam, and Orion twinkling brightly down on me through a split in the awning.

I spent the next day sweltering in pyjamas, walking in and out of the shower-bath. Pyjamas constituted the captain's only wear, also. He was the sole white member of the crew and never left the bridge, sleeping, eating and being in the wheel-house. The native steward, having only me to wait on, lay on his back all day in the shade of the deck-house and read a book with much expression and at the top of his voice. It sounded a most exciting work, composed almost entirely of ejaculations. "Ah-ha!" I would hear from the other side of the deck-house. "Ah! Oh! Ai-ee! Ooh! Oo-ah!" Then a short garbled sentence followed by another burst of Oo-ahs and Ai-ees. I must try one myself

tions of a sleeping car, but by boldly leaving open the door one can still see the huge tropic stars.

But a net must be demanded unless one is to look like a severe case of measles the next day. Undoubtedly the mosquito population of the Mekong delta is more dense than in any other region.

And the next day, instead of bumping along in the heat after an early start at six, one lies slothfully in bed and has coffee. From the river the land seems never dull. Watching it slip by is not an intellectual pursuit, but it amuses. There are houses on slender legs shouldering one another, there are coco palms with naked babies peering from behind the boles just like pictures one has seen—and a picture must be the ultimate test of naturalness. And there are the fascinating water-weeds with leaves like calla lilies which break off from the land in patches like islands and go floating gaily down the current. Those lilies seem the largest crop, yet statistics on crops neglect to mention them. The green of them vibrates like a jewel on the surface of the smooth red water (Candee, *New Journeys in Old Asia*, pp. 117-8).

Bleakley travelled on a new steamer about the same time as Candee:

The Jules Rueff, in which I made the journey from Saigon, is the latest and most modern of the fleet belonging to the Compagnie des Messageries Fluviales. It bears some resemblance to one of Cook's steamers on the Nile, having a double tier of cabins and a wide promenade deck with a large dining-saloon forward. The meals are good, and the Chinese stewards capable and attentive. One lunches at eleven and dines at seven o'clock. The petit déjeuner can be ordered when one chooses. The voyage lasts for three nights and three days, for a whole day is spent at Phnom Penh where one must change steamships.

Parts of the river were very beautiful—especially when one passed some tributary that branched off through the paddy fields between high walls of waving palm trees and feathery bamboo, one of the many mysterious little waterways that wander from the main stream like a backwater on the Thames; or, just upon the close of day, when one came to a tiny cover, encompassed all around by a thick belt of forest, where crowds of naked urchins were sporting in the water, their wet skins gleaming like copper in the setting sun, their laughter tinkling merrily across the river in the warm still air. The sunsets are gorgeous on the Mekong, when the sky is ablaze with crimson flames, bathing the stream with the radiance of its reflection until it looks like a river of blood...

At 5:30 on the following morning the Jules Rueff reached the quay at Phnom Penh, thirty-two hours after leaving Saigon...(Bleakley), *A Tour in Southern Asia*, pp. 55-9).

Rachael Wheatcroft, an English artist and writer who visited Angkor at the end of the 1920s, found the boat journey most agreeable:

After the heat and noise of the French city of Saigon, the deck of a river steamer is a refuge of cool repose. And after the night on board, one awakens to a tropic country and already appreciative of such strange customs as morning coffee at seven, and tiffin at eleven with a long siesta to follow.

We awoke at Mytho the first stop, Mytho which seemed only a pierful of chattering Annamites, baskets of green cocoanuts, bananas, pineapples—all against a park-like background of tropic trees splashed with bougainvillea. From there on, one floats all through the fragrant day on a wide, wide river of yellow water, while gradually wise, mild nature changes the itinerant traveller into a tropic idler. We were in another world. We were among European tourists who were intriguing even as travellers. There was, for instance, a Boston maid of austereness who decorated the world by the big splash of colour which was her gown. There was a splendid beauty so evidently an ex-diva that one could see a music-hall around her and hear the rustle of programmes. She held a sad husband by the leash of delicate health. He was tall, loose-hung, dejected and rich. He had made a famous slip in honesty. That this had saddened him was the rare and interesting point in his commercial character.

And there was Priscilla, full of charming inconsistencies. Like a neat wren, only always in white. Puritan by every visible evidence. And pretty with the neatness of a porcelain figurine. She had the hardihood to travel alone to Angkor, and was chummy with the Diva and her husband.

Besides these, were two French priests. Lest the words conjure up a picture of the usual "corbeau," examine them. One was insignificant. The biggest wore a long yellow beard frizzing down to a point almost as far as a layman's lower waistcoat button. It wagged as he talked in manner Shakesperian. He was fat as Santa Claus is fat, and red of face and bald of pate—tonsured by nature's barber. His dress was not a soutane at all but a long black garment in the Chinese shape fastening across the chest, and on his head a white cork helmet. Such is the dress of the thousands of priests to whom the French have delivered the souls of the natives throughout French Indo-China.

All these folk and many more were going to the great world wonder of Angkor (Candee, Angkor The Magnificent, pp. 47-8).

In the following passage Candee tells something about life on board the steamer, gives a birds-eye view of villages in Cambodia and warns of the mosquitoes:

But the trip by boat—ah, that has charm and repose—even though that repose is tricked by a thousand mosquitoes. There are deck chairs where one lounges at night and looks at the holes pricked in the sky that let the glory of Heaven shine through, there is the soft sound of parted water, and there are glimpses of potential friend-ships as other passengers flit through the twilight spaces of the deck. Reluctantly one goes to bed in the cabin no bigger than two sec-

appropriate clothing and accessories for upper class Europeans travelling to the Orient lined the aisles of their cabins. Attractively designed luggage labels on the trunks served not only as destination indicators but also as status markers for the traveller. A label featuring the Grand Hotel d'Angkor, the premier accommodation in Siem Reap, was surely was one of the most coveted of the period (Plate 12, p. 51).

The *Official Guide to Eastern Asia* issued by the Imperial Government Railways of Japan in 1917 makes several suggestions and precautions for going by steamer from Saigon to Phnom Penh:

Most of the travel being by steamer, passengers should provide themselves with books or some other means of diversion. Since, according to the French custom, only two meals are served a day, those who are not used to this custom should carry some food with them. On the river, during December and January, there is always a cool breeze, and it is rather cold at night. Some covering is, therefore, necessary. The steamer usually carries many deck passengers, who loiter around the cabins day and night, often making annoying noises that disturb one's sleep. Cabin passengers, unfortunately, must be prepared to endure it. On reaching the great lake (Grand Lac), one has to transfer to Chinese sampans, which go further up the Siem-reap. On landing, one has to ride on ox-cars, which run through mud and dust. One must, therefore, be dressed accordingly. It is also advisable not to take any very large luggage, but camera enthusiasts should be provided with as many films as possible, for E. of Saigon they are unobtainable, and the beautiful scenery of the surroundings will constantly be appealing to one's desire to record it. Angkor is also a very good hunting region, and those who are fond of this sport should be sure to take guns with them. The only language spoken is French. Travellers will not be able to make themselves understood in any other language. Those who cannot speak French should be accompanied by a guide.

While stopping at Angkor, one is in forests cut off from the modern world. For this reason it is necessary to provide oneself with medicine. It will be malaria. For the journey a white cotton suit will do, but until one returns to Saigon there will be no chance of having it washed (*Official Guide to Eastern Asia*, p. 195).

Accounts of the passage from Saigon to Phnom Penh abound with romantic tales of lingering journeys on the river and of friendships and alliances formed. Helen Churchill-Candee writes about some of her fellow passengers travelling by steamer along this route in the mid-1920s:

about the carvings and reached an explanation for their nature as Gorer:

As you will note, Madame, this myth supplies innumerable motifs for the Angkor sculptures, the Devas and Assouras (demi-gods and demons) the Apsaras and Devatas, flower-decked sylphs and nymphs enigmatically smiling, human in shape but not human in posture nor expression—drugged dreams fixed into stone. It can be nothing else. Opium must have been the inspiration of the Khmer sculptors, (Seton, Poison Arrows, p. 207).

Across the lake – a surreal experience

The long, slow way is the overture to the Angkor drama, the quiet preparation of the mind for overpowering scenes (Candee, Angkor The Magnificent, p. 46).

After a night's rest in a Phnom Penh hotel, the following morning passengers boarded a small boat for their continuing journey to Angkor which took them up the Tonle Sap River and across the lake. Access by this route was, and still is, seasonal and dependent on the water level. When it is to low, the boats cannot navigate the river to reach a suitable docking point. So the lake is traversed at the time of year when the water volume doubles or sometimes even triples its level in other seasons. Read De Beerski's dramatic account of the oppressive heat and the blackness of the night when he crossed the lake in the early 1920s:

The Tonle-Sap is too clear, too great, too noisy to allow your becoming sorrowful; it is more impressive and wilder than our lakes; imparting the same impression of beauty, it seems fiercer and more uncertain. The numerous craft sailing its waters do not convey an idea of security like our barges and rowing-boats, but seem to be in dread of tempests and storms. The lake and the firmament shine like molten gold, giving dazzling richness to all things around

But the heat is frightful and numbing; you lie coiled in the corner of your boat where shadow is densest, continually craving for drink to cool your parched, burning throat. To cross this lake in a barque is like crossing the Styx before entering hell...crossing a river of red-hot lead...

Night on the Tonle-Sap is as frightful as day; the lessened heat is still too crushing to allow you to sleep and always gives an impression of something impending. The warmth, weighing on your chest, pervades everything and weakens everything. A smell fills your nostrils; not the smell of closed flowers that makes summer nights so perfumed, not the smell of nature at rest when all is quiet...it is

more like the smell brought by the wind from battle-fields after a deadly slaughter, a smell that makes your head ache, created by rotting flesh, by pools of stagnant blood. It stinks at intervals as if a corpse swam alongside. A dog on the far shore howls to the unseen moon—sound to stop the bravest in the depths of a wood; the long, even yell resounds piercingly in the stillness. Real fear creeps into your veins, born of dampness and of darkness, born of the mists of the forest, caused by all that is black, all that is ghastly, the same fear through which armies fly, confronted by no enemies; in fact, greater than the fear of death, the terror of stealth. At last, worn out, you sleep, and in the morning when you awake you understand the source of your horror: you had become feverish under the sun's rays, and at night you had been floating among a lot of decomposed fish, for this is the period when they are captured in thousands and when the fishermen throw away their entrails. You laugh at your mistake and look outside, at the hour when the lake is in all its glory (de Beerski, Angkor, Ruins in Cambodia, pp. 24-5).

Candee gives a lively description of her passage by boat along the same route as de Beerski in the mid-1920s:

We move off gaily, dropping the fine-railed gangplank into the river, and start on the last étape of the journey, which is taken on the Tonlé Sap, a river which here joins the Mékong. So we leave the poetic river which starts as a chilly brook on the frozen uplands of Tibet to widen into a flood of many deltas slipping through tropic savannahs into the China Sea.

The stars and the sound of water chained me late to the deck. Night is the time to be abroad. A native woman of extreme loveliness was in a deck chair, a lap-dog by her side. Over her dark hair a scarf of chiffon, which blew across the large eyes and frequent smile. On her feet shoes of sophistication; on her person the Annamite dress, but of soft French gauzes. She rested in the chair, as perfumed and languorous as a worn flower—until, alas, a sharp whistle came from the French captain's cabin. She obeyed the call like one accustomed.

When finally I went to bed, Blake was snapping his torch light over the prostrate crowd of deck passengers and letting it linger on the women.

Priscilla's cabin was next to mine, both opening out to the hot night with only a narrow strip of deck between us and the rail. She, being a true Puritan, had her door shut, but I nearly stepped on a bundle before it. It was the Hindu manservant she had chosen in place of a lady's maid, lying like a dog fast asleep on a mat before her door. How worshipful are the ways of inconsistency.

The Messageries Fluviales assured us we would dine in Angkor the next night. We did nothing of the kind. Instead we stayed on board far longer, as a chrysalis stays in its case, quietly accepting a transformation of the soul. We were gradually loosening the adhesive that bound us to a world of commonplace, we were listening to

a long overture or intermezzo which prepared us for the strange world of the ancient Khmer. A pity 'tis the day is coming when the pilgrim will be whizzed in motor cars from Saigon even unto Angkor, and thus will arrive with mind dizzy instead of with mind calm, with thoughts of modern inventions and not of intrigue.

While the Mékong flows away for Northern adventures, the Tonlé Sap turns gently and changes from a flat, muddy line into an opalescent lake, a lake so wide that land is lost. Through the greater part of the day one watches white herons along the shore, big buffaloes cooling by the banks of the farms, so deep in water that only their muzzles and branching black horns are seen. Palms everywhere— and palms mean poetry to the Occidental.

Then all at once the lake, Tonlé Sap. The unrippled spread of it is broken only by our big, white boat chugging along with scarce perceptible speed. The water gets low in January and should a high-spirited and impatient boat ram well into the mud, there'd be no help for it until the wet season came to float it off. They say that before the rain begins to fall the Grand Lac becomes only a grand mudflat.

Thus the captain proceeded with caution through the shallow opal flux, while outside his door the pretty lady of Asia, with accessories of Paris, played with her lap-dog and smiled entrancingly on all whom she could catch up with a glance.

At twilight life grew so calm that we lost all sense and were mere spirits floating in an exquisitely coloured ether. Then dinner came and illusion went by the board.

It was a slow and sleepy evening. The boat had abandoned shore stops when it entered the lake. Instead it stopped at odd hours in mid-water at the strange cry of a boatman who stood off in the dark in a tiny sampan with a single faint light. Precarious passings over the rail of the lower deck took place, persons getting off, persons getting on. All mysterious, when there seemed no place to have come from, no place to go to except a far waste of water.

One open sampan received from the steamer an Annamite woman and her baby. The mother spread her square of matting on the little boat's floor and nested the child. Sad anxiety and patience under difficulty—Mary's flight into Egypt repeated in Cambodia.

The sampan waited for another passenger. He came bustling, vociferating, important. It was the big priest with the beard of Jove. He was helped safely into the sampan, he tripped heavily over the covering mother and babe without consideration and possessed himself of the only comfortable rest. Then the little boat vanished.

At last a new star on the night, a lamp fixed high for mariners. The journey's end! Little lights on the water, voices, sounds of rowers. The boat stopped, we missed the engine's thump.

The sampans stole alongside, not showing they were there until over the rail, on to the deck, leaped dozens of dark men, half naked, headed by a superb creature clad in khaki, who dominated and commanded all. He shouted in Cambodian to the two executive coolies

and directed in French to the voyagers.

We were a silent crowd, half asleep, and we were a timorous one. It looked foolhardy to exchange present safety for a tippy sampan manned by howling savages at midnight on a wide sheet of unknown water. The Diva baulked, and effectively threw her beautiful plump person onto the bosom of a husband who took the assault with limp arms and a face of disillusion.

The orange-yellow Boston maid took the lead with youth's spirited agility, while the brown man in khaki hurled unknown Cambodian curses at his sweating henchmen tugging at the baggage, and passed to the task of directing us, the sacred goods of the Messageries Fluviales.

He straightened his great figure for a mental effort and addressed the timid petulant huddlers, which we had become.

"Une zong-bong pour les touristes,
 Une zong-bong pour les bag-ages."

Very staccato, very imperative.

We slipped away in the perilous dark on the "zong-bong" for an unguessable haven, our faith pinned to the light of the feeble lantern we had seen from the steamboat, for the only man who could instruct or spread confidence was on another boat with "les bagages."

We had to learn that one lives a year of sensations between the steamer and the ultimate stop. The overloaded sampans were sculled across the waters it seemed for hours, with no sign of land. Constellations above reflected in the lake and no sky line showed a break between sky and flood. The burning stars seemed the nearest heaven.

When a change came it was not land we met but a forest of spreading trees having water as their element instead of earth. Through their branches we saw the stars, below them the same bright sparks were sprinkled, and from the foliage came the music of birds that call at night.

On and on through this endless enchantment. We no longer feared. Beauty was all there was in the world and it was ours. The stalwart boys who stood high at bow and stern propelling with long oars began to croon snatches of native songs with deep, sweet voices.

Out on the warm silence spread a melody familiar. "Marching through Georgia!" Yes, the song of the Civil War in America.

"Hurrah, hurrah, we shout the jubilee,
 Hurrah, hurrah, the flag that makes us free!
 And thus we swell the chorus
 From Atlanta to the sea—"

There the air stopped, wandered off into bars of strange notes. Then it returned to the refrain—not the words of course. Strange. Does it mean that the boy caught it from a tourists or is it a musical accident of coincidence?

He stopped it as we casually reached a shore. We had forgotten there was a shore or any element save water. In a moment the Diva was screaming for her twelve pieces of luggage, Priscilla, the competent, was selecting hers with the Hindu, and we were being packed

*away in motor cars. Incredible! Motor cars at the end of three days'
and nights' journey up a wild tropic river into the jungle! Faithful,
ubiquitous Henry Ford await us"* (Candee, *Angkor The Magnificent*, pp. 55-61).

Maugham writes more about the difficulties of getting to
Angkor from Phnom Penh:

*For once you have reached Phnom-Penh—itself a place sufficiently
off the beaten track—you must take a steamer and go a long way up
a dull and sluggish river, a tributary of the Mehkong, till you reach a
wide lake; you change into another steamer, flat-bottomed, for there
is no great depth, and in this you travel all night; then you pass
through a narrow defile and come to another great stretch of placid
water. It is night again when you reach the end of it. Then you get
into a sampan and are rowed among clumps of mangroves up a
tortuous channel. The moon is full and the trees on the banks are
sharply outlined against the night and you seem to traverse not a
real country but the fantastic land of the silhouettist. At last you
come to a bedraggled little village of watermen, whose dwellings are
houseboats, and landing you drive down by the river side through
plantations of cocoanut, betel and plantain, and the river is now a
shallow little stream (like the country stream in which on Sundays in
your childhood you used to catch minnows and put them in a jam-
pot) till at length, looming gigantic and black in the moonshine, you
see the great towers of Angkor Wat* (Maugham, *The Gentleman in
the Parlour*, p. 208).

Siem Reap grows up

Siem Reap, which the explorer's described as 'unimpor-
tant' and a 'sleepy' place, had grown in size and status by
the 1920s according to travellers' accounts, although the
village-like atmosphere remained and it fascinated
travellers (Plate 17). Wheatcroft, who went to Siam and
Cambodia in 1928 to paint and sketch, included a delicate,
fine-lined sketch of a village in Siem Reap with her notes
(Plate 18):

*From the modern Cambodian point of view Siém Réap is quite an
important place and a headquarters of French officialdom. It is pictur-
esque, too, which, from the traveller's point of view, is even better. An
attractive wooden bridge spans the stream leading to the main shop-
ping street. The stilt-borne wooden houses turn their varied backs to
the water* (Wheatcroft, *Siam and Cambodia*, pp. 77-8).

Parsons arrived in Siem Reap in 1941 and wrote her

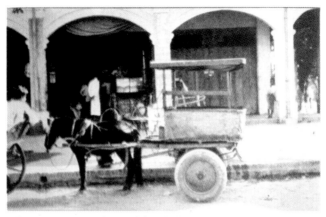

17 A pony cart in front of the market in Siem Reap (Borland, B., Passports For Asia, 1933).

impressions:

Angkor Siemreap was a native village to which had been added a residency, a post-office, a couple of hotels and some flower-beds. There was also a zoo belonging to the larger hotel. In the wake of these additions came shops selling a number of unlikely things and a wooden music-hall with nightly attractions.

These were on one side of the river. On the other side was a more native life, and obviously the Siemreap river had been the main street before the roads were made. The village spread some distance along its banks, and a large water-wheel, like a paddle of a river steamer, stood ready to do manual labour for any one who untied its chains

It was very beautiful, this village along the river... (Parsons, *Vagabondage*, p. 142; (Plate 20 p. 77).

Grand style

By the mid-1920s guest bungalows and hotels in Siem Reap were built that provided suitable accommodation for western travellers. The fashionable place to stay was the Grand Hotel d'Angkor, which opened in 1929 and was managed by the French. It was where all royalty, stars and sophisticated travellers stayed when they visited Angkor (Plate 19). Ponder writes about his stay at the Grand in 1936:

In the last year or so two European hotels have opened up in Siem Reap...One is a modest building. The other [The Grand Hotel d'Angkor] is an immense and dazzling white concrete palace that

18 A drawing of a village in Siem Reap by Rachel Wheatcroft in her book Siam and Cambodia: in Pen and Pastel with Excursions in China and Burmah, 1928.

would look more at home on the Cote d'Azur…It would be hard to imagine a pleasanter place than the cool, lofty dining room. There is an appropriate touch of magic about the place too…though your footsteps echo eerily in the long, spacious lounge that is so cool and welcoming as you enter from the blazing sunshine outside, there is nothing in the least depressing about it (Ponder, Cambodian Glory, p. 148).

Christopher Pym spent three weeks in 1957 travelling 724 kilometres (450 miles) in Cambodia. At the end of his journey he stayed at the Grand Hotel d'Angkor in

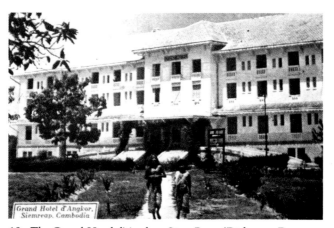

19. The Grand Hotel d'Angkor, Siem Reap (Dickason, D., Wondrous Angkor, 1937).

Siem Reap. His stay at this luxurious hotel was planned in advance and to ensure he had enough funds left at the end of his journey to pay the bill he sent a money-order to the hotel in advance:

This was civilization once more. He [the manager] *called one of his minions to find me a room. The room was on the wrong side of the hotel—that is the wrong side for seeing Angkor Wat. By opening the door and opening the door of the room opposite, and opening the veranda doors of the room opposite, I could see several miles out across the rain-forest. High above the trees hovered the five towers of Angkor Wat. I turned the clock back three years to 1954, when I saw Angkor Wat for the first time from this same hotel. My host on that occasion had been a Siamese Prince. Champagne corks popped, and the toast all round was 'Angkor the Great'. This had been my introduction to Angkor, but I could never forget that it was also my introduction to Cambodia* (Pym, *The Road to Angkor*, pp. 179-80).

The Hotel des Ruines, built across the road from the western entrance to Angkor Wat, was also part of the Grand Hotel group and, of course, managed by the French. A luggage label of the period includes photographs of the two hotels with the façade of Angkor Wat in the background (Plate 21 p. 77). When Lewis stayed at the Hotel des Ruines in the 1950s, it was considered the annex of the Grand Hotel in Siem Reap:

The Grand Hotel des Ruines had had several lean years. It was said that one or two of the guests had been kidnapped. The necessity, until a few months before, of an armed escort, must have provided an element of drama not altogether unsuitable in a visit to Angkor. Now the visitors were beginning to come again, arriving in chartered planes from Siam, signing their names in the register which was coated as soon as opened with a layer of small, exhauster flies falling continually from the ceiling. Perking up, the management arranged conducted tours to the ruins. In the morning the hotel car went to Angkor Thom, in the afternoon it covered what was called the Little Circuit. The next morning it would be Angkor Thom again and in the afternoon Angkor Vat. You had to stay three days to be taken finally on a tour of the Grand Circuit. Naturally in the circumstances the hotel wanted to keep its guests as long as possible. And even Baedeker would not have found three days unreasonable for the visit to Angkor (Lewis, *A Dragon Apparent*, p. 221).

Bleakley found the hotel most pleasurable:

No one can desire a more comfortable dwelling-place than the Bunga-

low at Angkor—the only hotel in the East against which I have never heard the slightest hostile criticism. Considering that it is in the heart of the jungle, more than four hundred miles by road from Saigon, the organization and equipment of the little hostelry are wonderful (Bleakley, *A Tour in Southern Asia*, p. 90).

Epilogue

Even though the Grand Hotel des Ruines was revamped several times including several changes of name, a one-story, bungalow-type accommodation remained in that location until the late 1970s when it was destroyed by the Khmer Rouge. I stayed in the Auberge des Temples on my first visit to Angkor and have searched for traces of it on subsequent trips but even the foundation is gone. Today small cafes and open-air stalls selling souvenirs occupy the space of the favourite hotel of early travellers to Angkor.

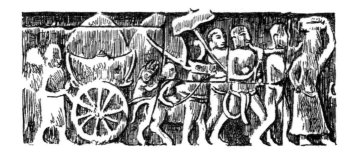

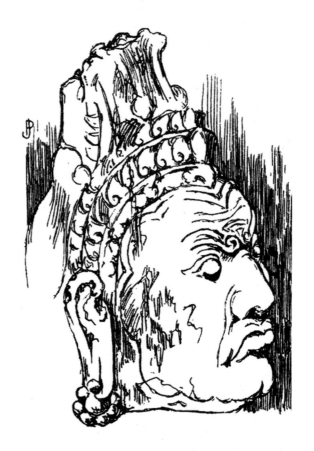

CHAPTER 4

THE ALTERNATIVE ROUTES

Stella Benson claimed:

*to be the first tourist in the world's history to reach Angkor
entirely by land in a car. Were it not for the hope of seeing
Angkor, no one would ever motor from Saigon to Pnom-penh,*
she wrote in 1925 (Benson, *The Little World*, p. 279).

By road and train from Singapore

From the mid-1920s onward, getting to Cambodia by road
and train from several different points was possible. But,
like the water route, conditions could still be difficult and
were often unpredictable. With the development of travel
by road and train, Singapore became a departure point for
going to Angkor. But as Geoffrey Gorer discovered in 1936,
'Even now with improved transport Angkor is still some-
thing of a pilgrimage' (Gorer, *Bali & Angkor*, p. 239). By
combining modes of transport such as car and train, it was
technically possible to get to Angkor from Singapore. In
1942, Marjorie Appleton serendipitously met the man-
ager of a travel agency in Singapore who convinced her to
go to Angkor by car and train with a party leaving that
very afternoon. She accepted and describes her experience
and the diversity of her travelling companions:

*"Waal, I hadn't featured myself driving along this road," declared
Mr. Wilbur B. Hogan of Tacoma, Washington State. "I hadn't
featured myself doing this trip, but they up and asked me and I
figgered I shouldn't likely be this way again..."*

*Dr. Beeching, too, had come on the suggestion of a travel agency.
Only Mr. Weiner had deliberately planned his visit to Angkor.*

*Mr. Weiner was an Austrian. No! He was a German, he said with
haste, and inadvertently letting slip, as he thus corrected himself, the
only hint he ever gave that a German passport might not necessarily
mean a German heart.*

*Mr. Wiener never joined in any conversation which might seem
to be remotely related to politics. Dr. Beeching and Mr. Wilbur B.
Hogan liked to comment now and then on general world topics. At
such times Mr. Wiener appeared not to have heard them. Possibly
he had not. Possibly he was thinking of the ancient kingdoms of the*

Khmer—the ruins of whose glory we had come to see. Although none of us made remarks, so far as I remember, which were either original or portentous, the two Americans and I myself did like to give free expression to our opinions if we were so minded. Was it that Mr. Wiener had no opinions? His function was, it seemed, to recapitulate for us the information which he extracted from his history books. The one from which he gained most of his information seems to have been "Wondrous Angkor," by Dickason; and indeed we had cause to be grateful to him for later he did make the dead stones of Angkor live for us.

For this Viennese, the journey was a realization of an ambition. For years he had dreamed of seeing Angkor. He had read so much about the vanished cities that he was ready to find his way about them before he reached them, and he was therefore tacitly voted generalissimo.

Mr. Wiener was soaked in history. Mr. Hogan's only interest was in the birds we saw, and the trees and flowers, of which latter there were few enough. Dr. Beeching was imbued with the philosophies of the East, and spoke of the temples of Japan and China and the Religious customs of those countries. Obviously not much interested in Christianity, he referred to its nine hundred sects only to call attention to the fact of there being as great variations also in the religions of the Far East (Appleton, East of Singapore, pp. 148-9).

Parsons went to Angkor from Singapore by train and bus in 1937:

Singapore treated it in the light of an everyday excursion, booked me a Second Class railway journey from Penang to the frontier of French Indo-China, and a bus journey from the frontier to Angkor Siemreap. It engaged a room at the Station Hotel at Bangkok where I would have to wait a day for a train connection. In fact it turned a daydream into a concrete plan (Parsons, Vagabondage, p. 127).

She writes about the view through the windows of the train:

There were no towns. There were clusters of huts, neat structures of palm leaf and bamboo, not without reason built high off the ground on stilts. They were therefore dry, though the owners sometimes waded waist-high to get to them. There were no forms of communication other than waterways and this railway. And there seemed to be nothing solidly founded except this railway embankment, the stations, and great welts of rock rising to almost mountain height suddenly out of the flatness. These rocks occurred singly and at intervals like giant milestones measuring the route to Angkor, or else like the phallic symbols that, on a smaller scale, ornament the terraces of Angkor's temples.

Strange, unreasonable country! (Parsons, Vagabondage, p. 131).

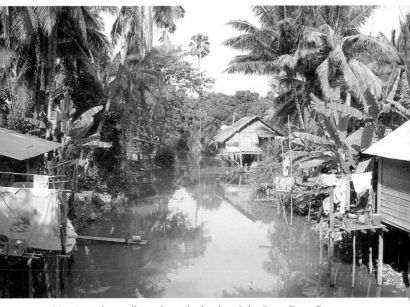

20 A modern village along the banks of the Siem Reap River.
(See p. 70.)

21 A luggage label of the Grand Hotel d'Angkor and the Hotel des
Ruines, a Grand hotel in Siem Reap; background, the façade of the
western entrance to Angkor Wat and the two Grand hotels (1930).
(See p. 72.)

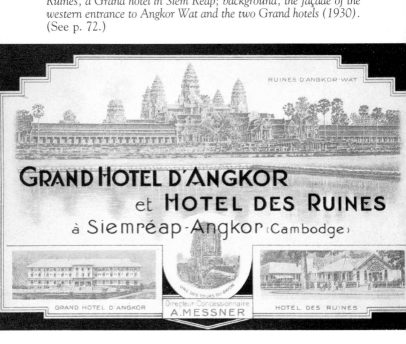

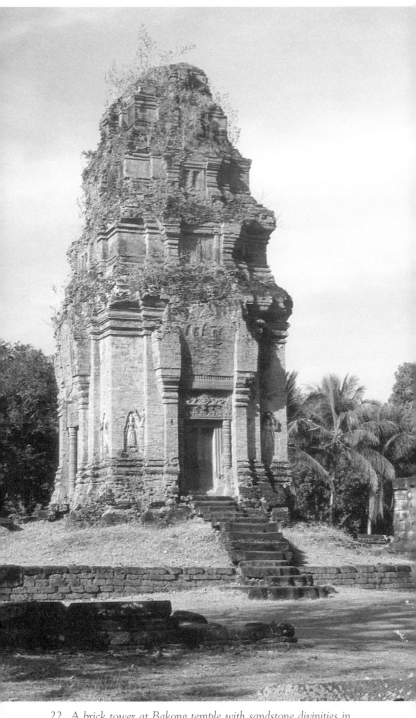

22 A brick tower at Bakong temple with sandstone divinities in niches enhanced with stucco, Roluos (AD 881). (See p. 98.)

CHAPTER 4: THE ALTERNATIVE ROUTES

The bumpy way to Angkor

Beatrice Borland encountered problems when she tried to go by car from Bangkok to Angkor via Sisophon and Battambang provinces in the early 1930s:

The sensible way to go to Siam is via Sisophon, but as usual, things were not functioning just right. Though it was the dry season the road was under water—therefore quite impassable. We had to back-track to Phnom Penh and take an extra day going around the south side of the Tonlé Sap, via Battambang (Borland, *Passports For Asia*, p. 86).

Santha Rama Rau, his wife, and daughter followed the same route as Borland but in reverse direction, travelling from Siem Reap to Bangkok by road. And they had a frightful trip:

Near the end of February 1949, we decided to leave Cambodia and go on to Siam. We did, after some discussion, take the military convoy to the Siamese frontier in spite of the possibilities of attack, because otherwise we would have had to return to Saïgon and go from there. For the previous few days we had been hearing the disturbing sound of gunfire in the forest around Siem-reap...

The military convoy took us from Siemreap to Sisophon which was about fifty kilometers from the Siamese frontier. The ride was entirely without incident, though every bridge had to be examined for mines and the roads along the wooded sections were patrolled by foreign-legion troops. As there was no way of getting from Sisophon to Poipet on the Siamese frontier except in a private car, the head of the Sureté there offered to drive us in his jeep. Poipet had the friendly seedy look of all frontier towns, and from there we again hitched a ride with the Sureté man across the frontier to Aran Pradet, in Siam.

As we drove through Poipet we saw that one section of the town had been burned down. "The work of the Izaracks," the Sureté man said. Later he said, "Forgive me for going slowly, this road is usually mined." He pointed to an overturned car on the side of the road, "One sees that quite often." We passed acres of burned rice fields, "Again the Izaracks. This used to be rich rice country, now the peasants have had to leave (Rau, *East of Home*, pp. 178-9).

A scenic trip from Vietnam

Lewis takes the reader on a colourful journey through the countryside as he makes his way from Vietnam to Cambodia by road in 1951. He compares a village in Vietnam with one in Cambodia and the people as well as seen through his eyes along the road:

The Land-Rover bounded westwards over the road to Cambodia. It was the only road of any length in the country open to unescorted, day-time traffic, although it had been closed for a fortnight before the day we left, 'owing to damage caused by the weather.' We plunged through a bland and smiling landscape, animated by doll-like Vietnamese figures, and mud-caked buffaloes that ambled across the road, lowering their heads as if to charge, when it was too late. Children dangled lines from bridges, while their elders, gathered in sociable groups, groped for fish, waist-deep in liquid mud. The kites, floating over the villages, were pale ideographs against a deeper sky. There were miles of deserted rubber plantations.

It was better, said the driver, not to stop between the towers, and his method was to accelerate to about 65 m.p.h. until a tower was about two hundred yards away. He would then relax speed until we were past, and about the same distance on the other side. This confidence in the towers seemed not altogether well-founded. The papers had recently published an account of an attack by one of the garrisons on a car straggling behind a convoy in which the driver was shot dead and a lady passenger's finger was almost bitten off in an attempt to rob her of a ring. We frequently found that ditches had been dug across the road by Viet-Minh sympathizers, and subsequently filled in with loose earth. A series of such semi-obstacles taken at full-throttle was a fun-fair sensation, even in the Land-Rover. At one point we passed a newly burned-out car from which a tracery of smoke still arose.

Cambodia. It was a place-name always accompanied in my imagination by tinkling, percussive music. Although the Vietnamese had been encroaching for centuries upon Cambodian land, there were signs of a true physical frontier at the present border. We came to a wide river; on one side was Cochin-China—which had once been Cambodia too—with the neat, busy Vietnamese, the mosaic of rice-fields and the plantations. Across the river was the Cambodia of present times, and what, too, must have been some early frontier of the ancient Khmer state, since everything changed immediately. It was not only the people, but the flora and the fauna. A cultural Great-Divide; a separation of continents. On one bank of the river were ordinary forest trees, which, as amateurs of natural history, the Vietnamese would spare, if not compelled to clear them for rice-fields or plantations. The other bank bore sparse clumps of coconut palms—the first I had seen in my travels—and beyond them, a foretaste of the withered plains of India.

The bamboos and underbrush had gone, and with them the dark-winged, purposeful butterflies of the Vietnamese forests. Here only trivial fritillaries fluttered over the white prairie grass. Great pied kingfishers as well as the large and small blue varieties encrusted the edges of yellow pools and ditches that served no economic purpose. There were no rice-fields. Cambodians lounged inertly about the rare villages that were no more than a few squalid African huts. In one village some women with dirty, handsome faces were pouring

earth into some of the worst holes in this terrible road, while a group of bonzes stood by, watching them with saintly detachment. The trim pajamas of the Vietnamese had given way to the dreary weeds of India; a drab, sarong-like skirt, pulled in the men's case into the shape of breeches by bringing the waist-sash through the legs. There might be, in addition to this, a jacket of some dingy material and a rag wound round the head as a turban. It was curious to reflect that under the barrack-room discipline of their spirits, the aboriginal Mois—when left alone—were the best dressed and best housed people in Indo-China. After them came the Vietnamese, in their brisk, work-a-day turnout—you never saw a ragged one—and their flower-decked shacks. And last of all were these descendants of the great Khmer civilization, who quite clearly didn't care in the slightest how they lived or dressed.

But the Cambodians had one enormous advantage over the others. There were no plantations to be seen on this side of the river. So far, the Grendel of Colonial capitalism had been kept at bay. The Cambodians are practising Buddhists, and every man, including the King, must spend a year of his life as a mendicant novice in a Buddhist monastery. And the strength of this second of the world religions lies in the fact that it has produced a tradition, a permanent state of mind, which makes its followers neither adept as exploiters nor amenable to exploitation. The Cambodians, like the Burmese, the Laotians and others, no doubt, of the South-East Asiatic peoples, are, by their own design, poor, but supremely happy. In these rich and comparatively underpopulated countries there is no struggle for existence, and this provides the ideal atmosphere for the practice of the gentle faith in which their people have been reared.

The Vietnamese, whose Buddhism is diluted almost to the point of non-existence, has a competitive soul, is a respecter of work for its own sake, and strives to increase and multiply. As he will work hard for himself, he can be made to work hard for others, and is therefore the prey of the exploiter. There are a few uneasily conducted plantations in Cambodia, and while I was there, in fact, there was a serious revolt in one of them. But Cambodia has no surplus population and no proletariat. Every man can have as much land as he can cultivate. As far as I know no Cambodian has ever been shipped in the hulks to end his life toiling in some depopulated South-Seas island (Lewis, A Dragon Apparent, pp 192-4).

The track from southern Laos

Hermann Norden entered Cambodia in 1931 from yet another direction. He drove from the town of Pak-Se in southern Laos, 'passing through forests cut by streams and ravines, with many traces of big game'. Of the journey he writes:

The roads down from Laos were very bad; they worked havoc with our tyres, Phong patched and plugged, but at best the journey was a matter of short rides and long stops in road and village. Whenever we were stalled, shouting children swarmed around the car and climbed on the running road. I could not talk with them except by pantomime. My small vocabulary gleaned in Laos was of no use in Cambodgia. The older people were less friendly, too, than the Laotians whom they resemble except for sturdier build. I noted that they sat on their heels, Hindu fashion, not like the Laotians with posteriors flat on the ground and with legs folded. The sarongs of the Cambodgian women were fastened high above their breasts. All wore the black velvet turbans with which I had become familiar in the country of the Chams, their kin in civilisation but always their enemies.

We made slow progress from Stung Treng to Kompong Cham over a road that led through forest and ricefields, and past vats which were reminiscent of Hindu architecture. The yellow robes of the many monks were reminders that Buddhism exists here side by side with Brahminism; side by side, and intermingled.

At Kompong Cham I abandoned Phong and the car to wait for the arrival of new tyres, ordered by telegram long before. I climbed on a motor bus which was bound for Siem-reap, the administrative centre of Cambodgia, and would pass through my immediate objective, Kompong Thom. The bus was crowded with passengers; sixty inside, twenty on top; almost as many women as men. I noted that these travelling women wore bright dresses and flowered head-shawls like the peasants of southern Europe instead of the sarongs and turbans I had seen in the villages and along the roads. I found a seat beside the driver, and was permitted to toot the horn to frighten the cattle that courted death by getting in our way. There were many to be thus frightened. Cattle even more than rice account for Cambodgia's wealth.

Slight and brief was this contact with the people it was better than nothing, and I was glad of the riddled tyres that had brought it about. I was passing through Cambodgia with tourist swiftness as is likely to happen at the end of a long journey. Besides, one goes to Cambodgia to look at the long-lost newly-found temples, and however long the layman may stay, he sees little else. The traveller's only interest in the Cambodgian of to-day is likely to be a feeble effort to trace a resemblance between him and the builders of the great temples. One sees modern Cambodgia dimly, because one looks through the purple haze of its past. Perhaps Henri Mouhot was the last European to see a Cambodgian merely as a Cambodgian, and Mouhot only before he had caught his first glimpse of the domes of Angkor Vat—that discovery which turned the imagination of the Western world toward the Khmers in their splendour and their mystery (Norden, A Wanderer in Indo-China, pp. 276-7).

The Phnom Penh – Siem Reap link

Casey told of French plans to build a road linking Phnom Penh to Siem Reap in his book published in 1933, although the construction of the road was underway in the 1920s and, at least, passable by 1925.

A road extended from Angkor to the east for more than one hundred miles, linking up the capital with the northern cities. Traces of the highway have been found, and plans are already under way for its restoration, so that tourists may roll at eighty kilometres an hour through a district where now the hardy explorer pushes through mile upon mile of bamboo in constant danger of his life and unending fear of the tiger and wild elephant (Casey, Four Faces of Siva: The Detective Story of a Vanished Race, p. 64).

The advent of the road enabled visitors to reach Angkor year round, even when the level of the water in the lake was too low for the passage of boats. Garstin describes a hair-raising journey he took along the road in 1927:

When I set out for Angkor the dry season was on and I had to go overland and am, alas! unable to boast that I have floated over tree-tops. I went north in a brand-new mail bus carrying first-class passengers only. My white companion was a nervous French youth bound back to his station in the hinterlands, our driver a smiling Filipino. We ran out of Phnom-Penh just as the keeper was snuffing the candle in King Norodom's fanciful lighthouse and for the next hour or so my hair stood so continuously on end that I feared it would stop there. We had halted at an outlying hamlet to shed a postcard when, with a roar and a derisive fanfare of the horn, a third-class bus charged past, enveloping us in dust—closely followed by a second.

*Our driver wiped the grit from his eyes and the smile from his face and muttering what I took to be Filipino expletives, advanced his spark and trod on the juice.******!! The idea of common third-class rattle-traps casting dust in the teeth of his first-class mail-carrier!*****!! He'd show 'em! We tore in pursuit, plunged into a swirling dust-storm, saw a shadowy vehicle rocking madly ahead of us, closed on it, raced it wing to wing, two wheels in the gutter, two wheels skimming the abyss, saw the big thing loom over us like an exaggerated turkey-crate—native passengers' heads sticking out of every crack, all yelling at once—then with a bound that flung one backwards against the cushions, we had scraped past and were tearing up on the heels of the next, blinded and choked with dust (Garstin, The Dragon and the Lotus, pp. 52-3).*

Garstin's journey continues:

*We crossed the river and went racing away across a flat, bare coun-
try, baked dry as a brick. The sun rose up in pitiless strength, the
road before us became a ribbon of dazzling white, that behind us
was hidden in a hanging dust-cloud. Heat haze simmered over the
face of the land, trees quivered; outlines vibrated and multiplied; the
horizon rippled as though swept by encroaching seas. Seen through
that trembling haze the world appeared unstable and illusionary,
one vast mirage which might at any moment utterly dissolve...*

*We plunged into forests and raced one, hour upon hour. The
river air, sucked in behind the windscreen, was a red-hot blast, scorch-
ing the sun. In one place the timber was afire, crackling like distant
musketry, sweeping the road with dense and choking clouds, but the
Filipino plunged into them without falter, his merry eyes impervious
to smoke, dust or dazzle. On and on down a long forest avenue we
swept, swung hard over to the left and came to a halt beside a gentle
river flowing through a green tunnel of gracious trees. Bamboo wa-
ter-wheels turned in the slow current; women stood knee-deep in the
stream washing bright-coloured clothing. In the gardens were little
white bungalows brilliant in their mantles of Bougainvillea. After
the heat and aching glare of the plains it seemed a corner of paradise.
This was Siem Reap, residence of the Cambodian provincial governor.*

*Half an hour and we were away again, racing down more jungle
roads. But journey's end was near. The Filipino nudged my elbow
and pointed. I caught my breath. Far ahead the five great lotus-bud
towers of Angkor Vat soared triumphantly above the tree-tops, rosy
in the evening sky* (Garstin, *The Dragon and the Lotus*, pp. 255-7).

The ancient Khmer highway

Alan Brodrick also travelled by road to Angkor in the same
decade as Garstin but from a different direction. After vis-
iting the ancient capital of Luang Prabang in northern
Laos, he went southward by road to Kompong Thom, east
of the Great Lake in Cambodia. From there he took the
so-called 'new road' which followed one built by the
Khmers, to Siem Reap, crossing an ancient bridge along
the way:

*Fifty-five miles this side of Siem-Reap, on the Angkor road, you
cross the Spean Prapto's bridge of laterite blocks put up by the Khmers
a thousand years ago. It is nearly two hundred feet long and fifty
wide. On either side, forming parapets, are long serpents' bodies
rearing up, at the bridge's entrance, to seven-headed hoods. As the
Khmers knew no arch, their corbelled supports must be very close
together and the Spean Prapto's has no less than twenty-one of them.*

Most of the old Khmer bridges now form solid walls, or barrages, so blocked are the interstices between the upholding piles. Nearby, just to the right after you cross the bridge is the track running off through over thirty miles of rich hunting country to the ruins of Beng Mealea.

On either side of you are rice-lawns or forest often flooded by the waters of the Great Lake. You cross the Roluos river. Northwards the tracks lead to the ruined sanctuary of Prasat Chao Srei. You can follow the Roluos down to the old Khmer town of Roluos where, in A.D. 893, King Yacovarman dedicated four towers to the memory and the spirits of his father, his mother and his maternal grandparents (Brodrick, Little Vehicle, pp. 120-1).

The 'Grand Circuit' and the 'Petit Circut'

By the second decade of the twentieth century, the French had completed a road network known as the 'Grand Circuit' and the 'Petit Circuit', giving access to the temples by car. Franck followed the circuits and describes the ease of visiting the temples in 1926:

To visit Angkor is no longer a proof of prowess, except of the Ford-endurance needed to make the circuit of ruins covering forty kilometres of throttling forest-jungle. Even as recently as the beginning of the present century visitors had to scramble through the wilderness about Angkor as best they could. To-day there is a network of good roads, French even to their sign-boards, to all the important ruins, with so few ox-carts or other native traffic on them now that they are almost as commonplace as our national highways—until suddenly they burst out again upon some other mammoth ruin (Franck, East of Siam, p. 46).

Ponder 'did' the circuit ten years after Franck:

For the main road had been extended to Siem Réap and Angkor, joining two loops, the 'Grand Circuit' and 'Petit Circuit' which now linked up Angkor Wat, Angkor Thom, and a number of the biggest neighbouring groups. And as an inevitable result, nine out of ten of these conscientious sightseers assumed that the only ruins on the map were those that time and guide permitted them to see. The one-day 'schedule' was a truly remarkable achievement; and I have often wondered whether the ghosts of Mouhot or de Lagrée, or even of poor disgruntled Father Bouillevaux ever made an excursion from Paradise to join these parties on their breathless tours...or whether, so doing, they would feel that their sacrifices had been worth while, if it was only for such as these that they were made?...But even so: there is no reason why it should affect the pleasure of our party, as they set out after breakfast to do the Grand Circuit! (Ponder, Cambodian Glory, pp. 141-2).

The pioneer persists

Despite the completion of a network of roads linking the temples, travellers in the first half of the twentieth century continued to visit the ruins in types of transportation used by the explorers. Perhaps it was the novelty of riding on an elephant or in an ox cart that fascinated them. Surely it was not the comfort. On another tour of the ruins Franck and his party travelled by elephant rather than car:

A shower-bath, lunch, and a nap, and I was off again, for a three-hour elephant ride. There are two of these great beasts attached to the sala, but like the goat-cart at the zoo they are now rather curiosities than useful means of transportation. Akin to all holders of sinecures, they stood before the door lazily swinging their trunks and watching with cunning little eyes the Fords that have taken nearly all their work away from them. The American ladies mounted one of them, Mr. Piffton-Smith and I the other. The mother of Lady So-and-so would not risk her precious life in such an adventure, and how her husband persuaded her to let him undergo this terrifying experience is a domestic secret to which I have no key.

I shall forevermore think of the elephant as a synonym for caution, for slowness and docility too, for that matter. The cornacs, as the French call what we know as mahouts, drove these pacific monsters more easily than we do a horse, nay, as easily as one can drive an automobile, except that nothing would induce them to move faster than two miles an hour. Like domesticated man, there was nothing whatever wild about them, and with every step up the only hillock in all the region the prudent beasts felt every stone before trusting their weight to it, until they seemed to personify the precautious mother of a Lady whom we had left behind. Little by little we dominated the immense sea of absolutely flat forest. Here where once there were innumerable palaces gleaming in the sunshine, little more was visible above the endless spread of vegetation than the block of Bayon and the five towers of AngkorVat. The view across the vast forest-jungle left even that great temple like a needle lost in a haystack, so tiny was it in its immense setting in the midst of what looked like an endless and a trackless wilderness.

So terrifying was this experience of rising a hundred feet or two above sea-level on these cautious monsters that poor Mr. P.-S. had to be helped down at the summit like an infant, and only the impossibility of covering on foot the mile or two back to the sala induced him to mount again....Then we went slowly, more than slowly, back, and across the mammoth bridge over the moat for a circuit of AngkorVat. It was as if, knowing they could not compete in speed with the Fords that have replaced their fellows, the beasts had no intention of trying; or it may be that there is an elephant union. That would even better account for their skill in wasting time at every movement, making their journey the shortest possible within

the three hours allotted us. The foundation of AngkorVat and the bridge leading to it are raised two or three meters above the ground, to facilitate mounting and dismounting from the elephants that were once the only beasts of burden in this region. But there was no time to dismount and mount now; the hour of the tiger would indeed have come before the lethargic animals took up their funereal march again. As we crept slowly round the temple, the elephants tore large branches from some of the tropical trees high above our heads, and munched them as languidly as a plumber eating his lunch on some one else's time (Franck, *East of Siam*, pp. 71-2).

Childers is another traveller who visited the ruins by elephant after the completion of the roads:

"Angkor Thom," said Rollo on the second morning of my visit, as he made signs for me to mount one of the two elephants he had hired to take us to "The Great Capital," the deserted city that lies one mile from the temple. We could have gone in automobiles, but Rollo insisted I ride as rulers had ridden, and because of his insistence I climbed to the howdah where I watched the mahout kick the elephant and strike it with an iron hook until at last the great beast heaved itself toward Angkor Thom (Childers, *From Siam to Suez*, p. 11).

And Bleakley travelled by ox cart to see the ruins:

One does not travel to the other side of the world to ride in an automobile. Even in 1915, you could ride in an automobile in Kalamazoo or Keokuk or Kokomo, Indiana. To ride in a Cambodian buffalo-chariot you must go to Cambodia (Bleakley, *Tour in Southeast Asia*, p. 30).

Routes less travelled

Halliburton used several modes of transport to reach Cambodia. The types were not unique, but his trip was certainly not a typical one. He departed from Bangkok as a deck passenger (actually, though, a French merchant invited Halliburton to share his first-class cabin) on a 'little ex-yacht' that followed the coastline of the Gulf of Thailand and along the way they encountered a frightful storm. He learned in Bangkok that he could shorten his journey by almost half if he disembarked at Kampot on the southern coast of Cambodia and traveled by 'motor-bus' to Phnom Penh on the Mekong River:

Disembarking at the little port, I spent a night on the beach, and the next day covered one hundred and forty miles in a motor-bus over

magnificent rock roads, through continual alternations of dense jungles and neat villages. This put me in Phnom Penh just in time to meet a steamer from Saigon sailing up the river to Angkor (Halliburton, *The Royal Road to Romance*, pp. 291-5).

A Swiss businessman living in Thailand actually walked across the border into Cambodia in January 1966. From the town of Aranyaprathet in Thailand he crossed the border into Cambodia, arriving in the town of Poipet. At the checkpoint on the Cambodian side, a guard holding a gun and standing in front of a wooden hut signaled to him to enter the hut for a passport check and then gestured him onward without delay.

Harold Elvin and his friend, Ramesh Desai, bicycled 4,800 kilometres (3,000 miles) from Madras in India to Angkor in 1961. They crossed the border into Cambodia from Aranyaprathet in Thailand, then bicycled to Siem Reap. They travelled on three British pounds a week between them for the entire trip, but had no regrets about the hardships endured and concluded: 'Angkor: you give all who love creation the sublime shot in the arm,' (Elvin, *Avenue to the Door of the Dead*, p. 206).

Finally, by 1950 air travel was possible and in the 1960s Air France flew directly from Bangkok to Siem Reap, circling the temple of Angkor Wat just before landing, which was a spectacular beginning for a visit to Angkor. I was one of the lucky ones who saw Angkor Wat from the air.

Tips for travellers

Several travellers' accounts to Angkor included practical advice culled from their experiences. I've selected two of my favourites. Harry Franck's advice on coping with the tropical climate follows:

Every living being, European or native, retired immediately after the eleven o'clock dejuener and did not rise again until two or three in the afternoon. To think of doing anything else was all but impossible, to say nothing of actually doing it. Not even the Cambodians, used to this climate at least for centuries, seemed able to endure those burning hours out of doors. For all my tropical experience I soon found that the only way to bear life during that atrocious period was to revert to the reputed costume of Adam before the unfor-

tunate apple episode, turn the electric fan squarely upon my recumbent form inside the mosquito-net, and succumb to the fond hope of perhaps getting a nap (Franck, *East of Siam*, pp. 54-5).

And in 'Hints to Trippers' Geoffrey Gorer offers the following suggestion:

In Cambodia the sun is stronger than in the Dutch East Indies, and there is no shade on the ruins: a sun helmet (or double terai) and an early rising are essential (Gorer, *Bali & Angkor*, p. 240).

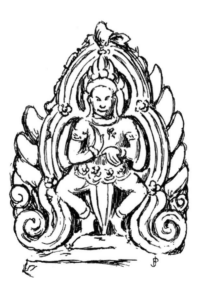

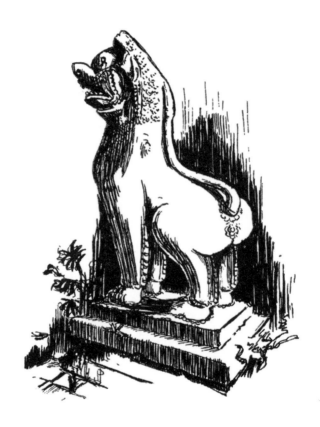

CHAPTER 5

FIRST IMPRESSIONS AND EARLY ANGKOR

Angkor is still little known to the world at large, though it is perhaps the greatest collection of ruins on earth....Its monuments still tell a story of luxury of its royal and military life; its carvings give an inventory of its riches, from jewels to dancing-girls. The least observing must soon realize that this was once the heart of a magnificent kingdom; and what an immense city it was—and is (Franck, *East of Siam*, p. 47).

Dazzling Angkor

Early travellers wrote descriptive prose capturing their impressions of the first view of Angkor, a sight that is always unforgettable. I've seen the magnificent temple over fifty times and the first glimpse never ceases to thrill me. Read on to get a flavour of how some felt on coming face to face with the temples of Angkor:

I shall not forget my first glimpse of Angkor. On a tree-bordered road which appeared to be taking us ever deeper into the forest, we rounded a bend and at a little distance beyond the thick greenery, there rose up before us the aspiring white cones of Angkor Wat. They were white lacy cones covered, as the bright sunlight clearly showed, with delicate tracery. I know that I gave an involuntary 'Oh!' of awed astonishment (Appleton, *East of Singapore*, p. 151).

She continues her reflections on Angkor:

But in the beholder, unversed in these or any other matters either technical or erudite, Angkor awakens a sense of incredulous wonder and the quickly following thought that since so much remains, how much must have vanished; and since so much has vanished, how impermanent are the works of man! (Appleton, *East of Singapore*, pp. 154-5).

The eye avoids the great Wat. The back is toward it and one will not turn. It stands there like a waiting lover, and you will not meet until you can meet alone that none may see the excess of emotion.

The moment has come, one is isolated in the shade of a big tree by the moat. And what the lifted eyes absorb is a world of green enthroned on which is the wondrous temple with towers uplifted to the centre of a rainbow which arches over all against a grey cloud

curtain. It is not real. It is too theatric. The low sun leaves the long first galleries in shadow, but bathes in red gold the central towers. It is not real. It is too theatric (Candee, *New Journeys in Old Asia*, p. 125).

Angkor is no mere expedition to an ancient, abandoned kingdom, besprinkled with grey old ruins. It is an adventure into lost ages: a sort of uncharted voyage of the spirit (Ponder, *Cambodian Glory*, p. 315).

One place in all the world contains within itself an approximation of body and soul which only those know who are balanced on the borderline at the moment of death. And that place is Angkor. For at Angkor you leave all the gold leaf, all the beggary that fattens on religion, all the confusion of human wants behind. Two day's toll to eternity are paid by poor, shortlived man, for a glimpse over eternity, and there within the stillness of a peace no hermit ever knew, one finds the unrouged loveliness of art triumphant over time and disintegrating sun and wind. And the soul that never knew itself before because of the clamor of false priests and crude conventions, finds itself alone—released, but not disembodied, revitalized but not made mortal again……Angkor always remaining the grand finale of emotional experience (Greenbie, *The Romantic East*, pp. 156-7).

Many years afterwards, riding out of the moist greenness of Siem-Reap—that little Cambodian village which is the gateway of Angkor—I beheld the towers of Angkor-Wat thrusting up in the rain like guttered candles; and after so long a time of dreaming I felt I was merely gazing at an enlargement of the picture that had begun its thrilling tyranny in my boyhood…I was installed in the sala, or government bungalow, separated by only a road and a wide moat from Angkor-Wat itself.

The rain had ceased, the sky was grey, overcast with a burnished haze: a reflection that seemed to run fluid from the west where the clouds were smoky gold. It was like some weird crepuscular light. In it Angkor-Wat was fabulous and pagan. The moat, drinking in the sunset, was tawny metal while the towers of the temple, great irregular tiaras crowning those bewildering terraces, seemed chased in old gold upon the rain-coloured sky.

As I watched, the light died from it, swiftly, like the last breath from a living thing, and then it was dead stone, its towers ghosts that haunted the dusk.

In the roadway, a bullock cart creaked by; gleaming half-naked figures seemed to glide past with spectral litheness. Across the way, the broken obelisks of Angkor-Wat stood dark beneath a single ascending star (Hervey, *Travels in French Indo-China*, pp. 57-8).

Our Mecca was very near now. For five miles or so we traveled along a winding road through the forest, into whose depths keyed up with anticipation, and uncertain how the first sight of Angkor might reveal itself, we peered right and left, expecting to see we knew not what.

And then, suddenly, the forest opened out. Far ahead, rising like strange, lovely giant blossoms from among their own foliage, there appeared above the vague green tree-tops of the jungle that stretched away into the distance, a group of colossal grey-gold lotus-buds; mysterious and strangely delicate despite their immense size, shimmering in the golden haze that illumined the thousand exquisite pinnacles combined in each magically perfect whole: the towers that the natives believe were built not by man, but by the Gods—the crowning glory of the sanctuary of Angkor Wat (Ponder, Cambodian Glory, pp. 31-2).

Numerous novels written by Somerset Maugham were set in Asia, yet he was so overwhelmed when he first saw Angkor that he was at a loss for words to put his impressions into writing:

I have never seen anything in the world more wonderful than the temples of Angkor, but I do not know how on earth I am going to set down in black and white such an account of them as will give even the most sensitive reader more than a confused and shadowy impression of their grandeur. Of course to the artist in words, who takes pleasure in the sound of them and their look on the page, it would be an opportunity in a thousand. What a chance for prose pompous and sensual, varied, solemn and harmonious; and what a delight to such a one it would be to reproduce in his long phrases the long lines of the buildings, in the balance of his paragraphs to express their symmetry, and in the opulence of his vocabulary their rich decoration! It would be enchanting to find the apt word and by putting it in its right place give the same rhythm to the sentence as he had seen in the massed grey stones; and it would be a triumph to hit upon the unusual, the revealing epithet that translated into another beauty the colour, the form and the strangeness of what he alone had had the gift to see.

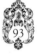

Alas, I have not the smallest talent for this sort of thing,... (Maugham, A Gentleman in the Parlour, pp. 208-9).

The appeal of the jungle

The jungle environment is one of Angkor's most unique and appealing features to westerners (Plate 23). 'Sometimes it seems as though Angkor ruined were more powerful to thrill, more subtle to charm than Angkor in its brilliant perfection could have been', (Candee, Angkor The Magnificent, p. 148). When the jungle invades a temple you see nature and stone cohabitating, in both positive and negative ways. The roots of a giant tree cascade over the roof of a stone gallery with such weight and intensity that

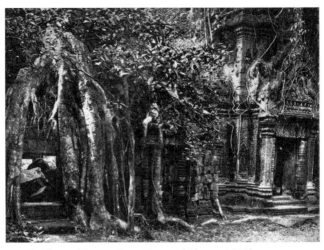

23 *Ta Phrom* (Casey, Four Faces of Shiva, 1929).

the wall supporting the roof has collapsed; some roots spread with enough force to pry apart the sandstone blocks of a wall; other roots stabilize a wall. So we see nature and man feeding on one another. In a strange way they have become friends, supporting, protecting each other and simply growing old together. Today, as the trees and stones are in their golden years of life they have reached a crossroads as conservators grapple with the duality of nature – to remove the trees or leave them. Meanwhile, the jungle continues its relentless crush on the stones and provides a timeless changing mélange of nature and man.

Wheatcroft expounds on the union of jungle and stone at Angkor:

Gorgeous as are the temples; it is their setting above all which makes Angkor unique....

Ficus, as everywhere, were various and many. Many ruins half destroyed by boring roots in their young eagerness for life are now held together only by their grip as they grow through and on them. In one of the outlying temples—Greater Angkor covers an immense tract of jungle—were the biggest trees I have seen at all, the upper part of their roots consisting of buttresses such as are common to many tropical trees, but of enormous size, and the roots themselves running for yards along the surface of the ground, thick as a well-grown oak—the very image of the python of childish nightmares! (Wheatcroft, *Siam and Cambodia*, p. 65).

De Beerski was:

Overtaken by the poetry of nature, I no more think of man. All kinds of trees grow vigorously and fill space in the most pleasing disorder; nothing here is mastered by another force; all is free in the splendid freedom of nature in its virginal state. Banyans stretch their long branches overhead, covered with dark green leaves that form a trembling curtain under which you step; other branches are entwined with them, and innumerable trunks stop your view everywhere. You believe you are in a green prison with no openings, but as you walk the prison goes forward with you, and truly, as everything here, you do what you like. No eyes look at you, except perhaps the unknown ones of the trees, but they are as untroublesome as invisible, and should they magically show themselves they would probably appear full of goodness and sympathy (de Beerski, Angkor, Ruins in Cambodia, p. 58).

Seeing the dilapidated temples enshrouded in jungle made Garnier feel sad:

Mixed with the admiration that one feels for this artistic richness spread out there with so much profusion there is a profound feeling of sadness. Is it the sight of these decrowned and crumbling towers which seem to wait for a last effort of time to buy the monument in their debris? Is it regret at being unable to penetrate this grandiose enigma which rises up suddenly before us, evoking an entire civilization, a whole people, a disappeared past? Is it the fear that this *magnificent masterpiece of human genius cannot deliver the secret that it hides before its destruction is complete? In fact, almost everywhere there are archways opening up, peristyles that totter, columns leaning over and several lying on the ground broken, long, trailing shards of moss indicating along the interior walls the destructive work of the rain: low reliefs, sculptures, inscriptions are effaced and disappear under this rust which gnaws at them. In the courtyards, on the faces of the bases, on the roofs and even on the surface of the towers, a vigorous vegetation makes its way across the gaps between the stones. Plants become gigantic trees little by little; their forceful roots, like a wedge that always advances further, separate, shatter and overturn the enormous blocks which seem to defy all human efforts. It is in vain that a few monks, dedicated to the sanctuary, try to fight against this invasion by nature of a work of man: the former wins with speed (Garnier, The French in Indo-China, pp. 22-3).*

Childers ponders the jungle at Angkor in 1932:

Today the jungle is taking back its own, crumbling and swallowing proud buildings erected by proud men. Seeds dropped by birds have grown into trees and their roots have split the heads of the ancient gods. Other trees send their roots above ground and over all barriers more than a hundred feet to wrap about blocks of stone and tear them from their moorings. Myriads of small plants, the jungle's in-

fantry, advance in almost solid formation. A thousand years the jungle has waited, watching the aspiration of man. Then man died. The living jungle crawled in to blot out the scar of civilization (Childers, *From Siam to Suez*, p. 12).

A sole dissenter

Later, Childers reveals why he did not like the temples of Angkor in a letter written to his friend:

Dear Octavus Roy Cohen: You asked me to write to you about the ruins of Angkor. I'm sorry you did; for I've been in Angkor a week, yet can find out nothing about it. At night I prowl through the temple and in the day I ride elephants through the town, but the stones are only stones and I hear nothing.

In Athens I can see Socrates in his ragged old coat, forever talking, forever making his soul as good as possible. In Rome I hear the tramp of the legions and Cato shout, "Delenda est." In Paris I see Villon staggering, staggering just a little as he searches for the snows of yesteryear. In the streets of London, Doctor Johnson shambles along with Boswell at his side. I hear him say: "Sir, when a man is tired of London, he is tired of life." But Angkor is silent. The lips of the four-faced god are mute; even the spirit of his devotees has gone into the awful jungle.

I would not have you feel that Angkor prompted me to ask Cleopatra's famous question: "Is this the mighty ocean? Is this all?" In a way, I have not been disappointed in Angkor, but the place has not set me on fire; I have not felt as I did when looking at the Great Wall of China, or at the Parthenon, or at the Forum: Genghis Khan never stormed these gates, Phidias never worshipped in this temple, Caesar never walked these streets...

I am writing you this letter, Roy, in the modern hotel built by the French at Angkor. I have just returned from wandering through the temple alone. Far back in the inner sanctum, I heard the liquid notes of the bamboo xylophone, played in the native village, join with the low chant of the Buddhist priests and come softly over the lake. The great temple stretched away from me, its stones silver in the moonlight, its shadows hiding the brooding souls of millions of men dead for centuries...Long I sat listening to the xylophone and to the chanting. Long I peered at the ancient stones. And yet when I left the temple at midnight, the souls of the builders were still hidden in shadows (Childers, *From Siam to Suez*, pp. 5-13).

The novelty of monkeys

Not surprisingly, the many monkeys at Angkor were a novelty and impressed travellers. Imagine a westerner venturing eastward for the first time in the early decades of the twentieth century who finally arrives at Angkor after an

arduous journey and finds monkeys scampering about the jungle. Franck comments on the monkeys while visiting the ruins on horseback in the early morning. The year was 1926:

Monkeys dashed from branch to branch, scores of monkeys, though not one had we seen during the official trips by Ford. Evidently they keep out of the way of tourists, perhaps because they cannot endure their inane chatter. But now they played by the dozen about the ruins, as freely as if they recognized in me a close relative, and indulged in a pantomime, worthy of any stage, that was plainly an imitation of the workmen among the remains of Angkor-Thom. A Cambodian legend assures us that monkeys formerly talked like men, until the men made slaves of them and forced them to work. The monkeys did not like this, and as they are timid but intelligent they simply ceased to talk like us and pretended not to understand, so that from that time forth they have lived in peace, gathering nothing except for their dinners, and gamboling among the trees to their hearts' content (Franck, *East of Siam*, p. 73).

Roluos

Clustered around the modern village of Roluos, approximately sixteen kilometres (ten miles) south-east of Siem Reap, are remains of some of the earliest temples in the area. Amongst the most intact and finest examples of early Angkor Period art are the ninth century temples of Preah Ko, Bakong and Lolei (Plate 24), which are similar in form and decoration. The area known as Roluos today is the site of an ancient centre of Khmer civilization, Hariharalaya ('the abode of Hari-Hara'). Some seventy years after Jayavarman II established his capital on Mount Kulen in AD 802 inaugurating the Khmer Empire and the Angkor Period, he moved the capital to Hariharlaya and ruled until his death.

A typical tower of the Roluos group is built of brick and stands on a low pedestal with sandstone lintels, doorframes, pillars and sculpture. The decoration on corner niches is enhanced in stucco. The towers are oriented to the east, with false doors on the other three sides (Plate 22, p. 78). The intricately carved motifs of floral elements intertwined with fanciful, mythical creatures on the false doors are a hallmark of Khmer art. Columns, lintels and sculpted guardian figures set in decorative niches were carved from

24 *Lolei Lintel (de Beerski, P.J.*, Angkor, Ruins in Cambodia, 1923).

sandstone (Plate 25). A wall bisected on two or more sides by a gate originally enclosed each temple. I've only found one account of Roluos and it comes from de Lagrée, a member of the Mekong Exploration Commission who surveyed the temples in 1866. His notes were published in Garnier's book. He writes of the difficulties of earning the confidence of the natives to get them to tell him the locations of the temples. Read on:

It was not without the greatest trouble that M. de Lagrée obtained from the locals the necessary information to enable him to reach all these ruins. In spite of the authority of his position, his knowledge of the Cambodian language, the gentleness and the simplicity of his manners, he did not always manage to overcome the resistance of the inhabitants and to have them take him to the places in the forest which harbor monuments of some importance. Local traditions preserved the memory of their existence and the name of these monu-

25 *Drawings: (left) a female divinity in a niche at Lolei temple, Roluos (AD 893); a male guardian in a niche at Preah Ko temple, Roluos (AD 879) (de Beerski, 1923).*

ments, however, but nobody admitted knowing the way to them, or knowing it, nobody wanted to serve as guide. Amidst these forests, where there are no reference points, the vague indications of the elders of the country are of no value and one can pass a hundred times within a few meters of the most considerable ruins without being aware of their existence, thanks to the impenetrable curtain that the tropical vegetation extends everywhere before the eyes.

Besides the superstitious fears which the locals feel when penetrating the depths of the forests, which according to them are haunted by spirits that are easily irritated, their repugnance sometimes also has self-interested motives. It is not only in Cambodia that ruins are believed to conceal treasures and, moreover, the Khmer ruins really have contained some. Disturbed and plundered as they have been during the long wars that they have depopulated this unlucky region for centuries and which have led to its final subjection to Siam, one can still hope to find some of the copper statues or metal ornaments which were previously so numerous in all the sanctuaries. The Cambodian who knows the localities in the forest where they are ruins

thus often keeps his secret to himself and is especially wary of guiding a European whose ability to find treasures is thought to be very great (Garnier, *Travels in Cambodia*, pp. 29-32).

Bakheng

It is a testimony to the love of symmetry and balance which evolved its style...in pure simplicity of rectangles its beauty is achieved. It is a pyramid mounting in terraces, five of them...Below Bak-Keng lies all the world of mystery, the world

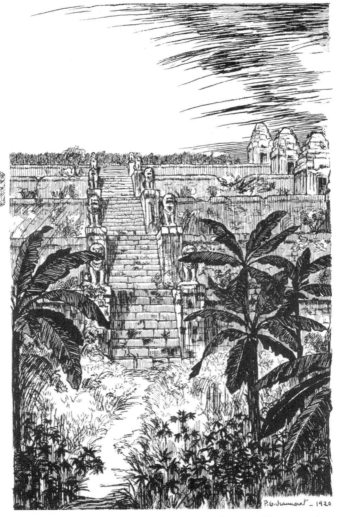

26 A drawing of the eastern entrance to Phnom Bakheng temple, Angkor (late ninth – early tenth centuries) (de Beerski, 1923).

of the Khmer, more mysterious than ever under its cover of impenetrable verdure (Candee, *Angkor The Magnificent*, pp. 217-18).

The capital was moved from Roluos sometime in the late ninth century to the area known today as Angkor, probably for better resources. There is also evidence that the area was occupied in the prehistoric period. King Yasovarman I ascended the throne in AD 889 and set about

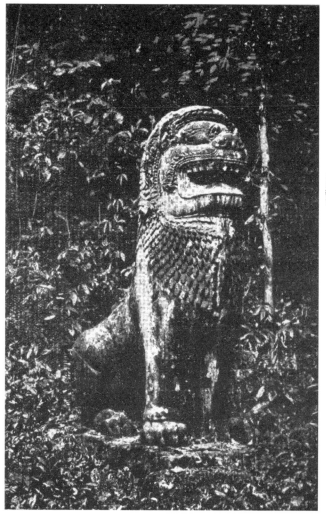

27 A lion at Bakheng (Casey, 1929).

overseeing the completion of a vast reservoir in the east
and building a new town called Yasodharapura, known as
'the first Angkor' and his state temple, Phnom Bakheng.
The original boundaries of the city are barely distinguish-
able today but archaeologists have determined that
Yasodharapura was surrounded by an earthen bank and
enclosed an area of approximately sixteen square
kilometres (six square miles) making it larger than
Angkor Thom.

Mouhot thought Bakheng was 'one of the preludes to
this civilization as Ongkor-Wat must later have been its
crowning glory'. The temple of Bakheng seemed mysteri-
ous to most early travellers. 'Every haunted corner of
Angkor shares in the general mystery of the Khmers. And
here the shadows seem to lie a little deeper, for this hill is
like nothing else in the district' (Casey, *Four Faces of
Siva*, p. 129).

Phnom Bakheng is an imposing temple situated on top
of a natural rock hill (Plates 26, 27):

*It is difficult to believe, at first, that the steep stone cliff ahead of
you is, for once, a natural feature of the landscape, and not one of
those mountains of masonry to which Angkor so soon accustoms
you...the feat of building a flight of wide stone steps up each of its
four sides, and a huge temple on the top, is a feat superhuman enough
to tax the credulity of the ordinary mortal* (Ponder, *Cambodian
Glory*, p. 72).

Bakheng is an earthly representation of the mythical
Mount Meru, the home of the thirty-three Hindu gods.
As such, it was important that the layout of the temple
reflect elements of the mountain as nearly as possible.
Bakheng, therefore, is highly symbolical. The topmost level
is accentuated with five towers, one in each corner around
a central sanctuary, symbolizing the five peaks of Mount
Meru. The top rises from a square pyramidal base of six
descending tiers with stairways on the axes to give the
perspective of climbing a mountain. The width of the stair-
ways is decreased as the height is increased to add to the
visual perspective. The ground level, plus six tiers and the
top level equal seven and represent the seven heavens of
the Hindu god Indra in mythology. Originally 108 brick

28 A watercolour of the eastern entrance at Phnom Bakheng, Angkor
(late ninth – early tenth centuries) with the towers of Angkor Wat in
the background by Rachel Wheatcroft, 1928. (See p. 107)

29 Baksei Chamkrong temple, Angkor (middle of the tenth century). (See p. 108.)

30 *Eastern entrance to Banteay Srei temple, Angkor* (AD 967).
(See p. 109.)

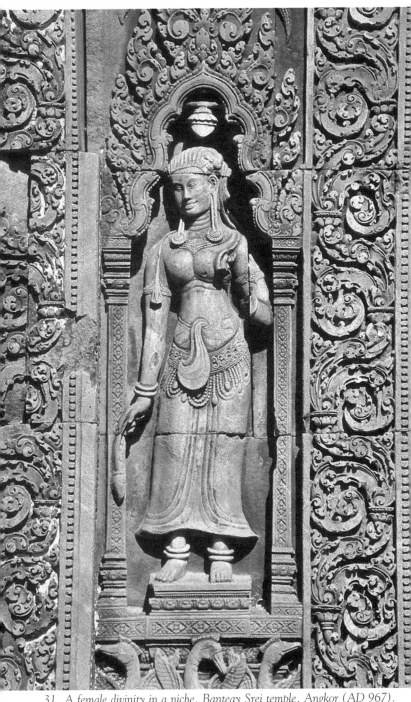

31 *A female divinity in a niche, Banteay Srei temple, Angkor (AD 967).*
(See p. 110.)

and stone towers (many have collapsed) were spaced around the tiers, possibly symbolizing the four lunar phases with twenty-seven days in each phase.

Hervey ventured to Bakheng at night and writes an eerie account of his adventure:

One midnight I ascended to the phallic altar of Phnom-Bakheng. All about me, below the hill, the great Cambodian forest stretched away like some strange black sea hushed beneath the starry sky. Behind the roofless temple, on a block of stone, was a phallus; and suddenly, as I came upon that blunt, dark symbol, it seemed to open an unexplored dimension of Khmer history.

I had a new picture of Angkor—Angkor in the shadow of the lingam.

Even the legend of the king who married a cobra's daughter, thereby starting the Cambodian race, had a phallic aspect, I realized. Indeed, the entire growth of Indo-China had its inspiration in the visible symbol of procreation (Hervey, *King Cobra*, pp. 89-90).

The only view from afar of the five towers of Angkor Wat is at Bakheng and this scene is beautifully captured in a watercolour by Wheatcroft (Plate 28, p. 103). You first see them walking up the path cut through the jungle on the south side of the hilly jungle that wends its way to the top. Turn a corner, look to the south and the five towers of Angkor Wat stand in full view. The thrill of this scene is timeless. Appleton saw the towers one late afternoon in 1942:

The fairy turrets of the great Wat far below were half hidden by the forest, but gleaming in the sun's low beams. Nothing was to be seen of all the rest of Angkor. It was swallowed up in the trees. What was very clear, however, was how the invading army of jungle had marched down from the blue north; trampled the Angkorean cities under its mighty feet and climbed to their topmost towers. To the south was a watery land. In the north the tree-covered mountains were a deep blue in the evening light (Appleton, *East of Singapore*, p. 155).

Going to and from the hilltop temple of Bakheng by elephant was popular with early travellers. Wheatcroft descended by elephant, but, apparently, it wasn't such an agreeable ride: 'Coming down from the top of Phnom Bakeng I had my first elephant ride, and much the most uncomfortable I ever remember, on one of those always uncomfortable beasts!' (Wheatcroft, *Siam and Cambodia*, p. 67). This mode of transport is now reinstated at Angkor

and you can ascend Phnom Bakheng sitting in a *howdah* on the back of an elephant. Special boarding stages with steps have been built for ease of getting on and off the elephant.

Ironically, Bakheng featured again in Khmer history, some 1,000 years after it was constructed, as a strategically placed structure when it was used for surveillance during the civil unrest in Cambodia in the past few decades. From the top of the hill, you can see Highway Six to the south, which extends all the way to the capital of Phnom Penh. Because of its height and position overlooking the highway the top of Bakheng was used for observing movement along the road and environs. A radio tower installed on the central sanctuary remains and is still in use. A military encampment was set up on the top level and the north-west tower on that level was used for storing mortar shells.

Baksei Chamkrong

This little temple with its four square tiers of laterite, crowned by a brick sanctuary, might serve for a model in miniature of some of its giant neighbours, and is almost as perfect as the day it was built (Ponder, *Cambodian Glory*, p. 62).

Baksei Chamkrong, a tenth century Hindu temple, stands small, yet majestic, at the foot of the Bakheng hill (Plate 29, p. 104). It's easily overlooked by visitors today because it is set back, away from the main road and also because the imposing southern gate of Angkor Thom, just in front, consumes your attention. Baksei Chamkrong, though, is a spectacle of beauty with the early morning sun shining on its eastern façade. The balanced proportions and the scale of this temple give it a masterpiece status in the realm of Khmer architecture. The single brick tower is set on a pyramid base of laterite. Sandstone lintels and doorframes are of fine quality, both in material and workmanship. The name 'Baksei Chamkrong' means 'the bird who shelters under its wings' and derives from a legend about a king who fled during an attack on Angkor and was saved from being caught by the enemy when a large bird swooped down and spread its wings to shelter him. Baksei

Chamkrong is built of brick and laterite with sandstone decoration. According to an inscription on the door-frame, the temple was dedicated to Shiva and originally housed a golden image of the Hindu god.

Banteay Srei (Plate 30, p. 105)

> Among all the gems of architecture that were found submerged in the jungle-ocean of the Angkor region, there is one of entirely different character from the rest. All the others take the beholder's breath away by their sheer stupendous size, before he has even time to realize their beauty…But Banteai Srei, the 'citadel of women'…is an exquisite miniature; a fairy palace in the heart of an immense and mysterious forest; the very thing that Grimm delighted to imagine, and that every child's heart has yearned after, but which maturer years has sadly proved too lovely to be true. And here it is, in the Cambodian forest at Banteai Srei, carved not out of the stuff that dreams are made of, but of solid sandstone (Ponder, Cambodian Glory, p. 254).

The temple of Banteay Srei ('citadel of the women') was built in AD 967 by a Brahmin of royal descent who was spiritual teacher to King Jayavarman V. It is renowned for its pinkish sandstone, intricate carving that covers the walls like tapestry and the small size of the buildings. The doors of the central towers are narrow and barely one and a half metres (five feet) in height. The enchanting temple is nearly everyone's favorite site. 'If Angkor is the crown of Khmer art, Banteay Srei is that crown's jewel' (Elvin, Avenue to the Door of the Dead, p. 284). French archaeologists called it a 'precious gem' and 'a jewel in Khmer art'. With its use of woodcarving techniques applied to stone and intricate decoration, some describe the temple as being closer in architecture, to Indian models than any other temple at Angkor. Satcheverell Sitwell thought it even had an aromatic scent: 'One can almost breathe the sandalwood in that first moment.' (Sitwell, S., Great Temples of the East, p. 77). He mentions it again in another book: 'At Banteai Srei it is sufficient but to shut one's eyes and open them again in order to see that the true affinity is Indian' (Sitwell, S., The Red Chapels of Banteai Srei, p. 73).

A tapestry-like background of foliage covers the walls

of the structures in the central group. The architecture is distinguished by triple superimposed frontons with relief narrative scenes carved in the tympanums, terminal motifs on the frames of the arches, and standing male and female divinities in niches. These figures are exquisite in their execution, posture, dress and ornamentation (Plate 31, p. 106).

Gorer is one of the few people who do not see any beauty in the temple of Banteay Srei:

> Considered as architecture the little temple of Banteai Srei, built some miles out of Angkor nearly two centuries later, is completely absurd. It consists of five silly buildings, three with towers and two with curved roofs placed in a line on a rudimentary platform. The forms are those of the towers and "libraries" of Angkor Wat, but they are completely non-functional; the doorways are so low that you have to bend double to enter. In their golden sandstone they seem less like buildings than like gigantic cruets carved by some Brobdingnagian Benvenuto Cellini. And that somewhat over-rated metal worker would have had good reason to be proud of the sculpture which covers every inch of this absurd miniature; on a tiny scale the pediments, the decorated panels, the statues in their niches, the baby guardian demons are as beautiful as any of the Renaissance decoration they so strangely resemble; the golden stone is worked like the most precious metal. The Khmer sculptors a little before the kingdom was destroyed had discovered all that anybody could know about the technique of carving in stone; but they had completely forgotten what to do with the carvings (Gorer, *Bali & Angkor*, pp. 209-10).

The temple was discovered by a French naval officer in 1914, cleared ten years later and restored by anastylosis, a process learned from the Dutch who used it to restore the temple of Borobudur on the island of Indonesia. Plate 32 is a photograph of Banteay Srei taken before restoration, which took place between 1931 and 1937. Archaeological work on Banteay Srei was accelerated following the theft of several important pieces of sculpture and lintels by a European expedition meticulously planned by a young Frenchman, Andre Malraux, in 1923. The stolen pieces were confiscated by the police, Malraux was placed under house arrest in Phnom Penh and later released after a trial. His misdeed, apparently, was not soon forgotten. The Swiss businessman, mentioned earlier, who walked across the

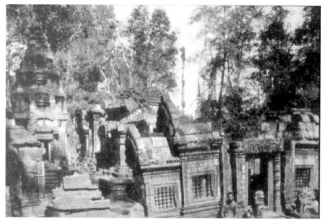

32 *Banteay Srei temple before restoration (pre-1931) (Wales, H.G. Quaritch,* Towards Angkor: In the Footsteps of the Indian Invaders, *1937).*

border from Thailand into Cambodia in 1966 noticed, inside the hut where he was summoned for a passport check, a sign: 'Malraux banned from entering the country,' a reference to a theft of artifacts that took place forty-three years earlier.

At least two visitors between 1939 and 1941 mentioned the difficulties of wild elephants at Banteay Srei. Parsons writes:

While I was at Angkor no driver could be persuaded to visit a distant temple, Bantei Srei, because of wild elephants in this locality whose trace happened to cross the road leading to the temple (Parsons, *Vagabondage,* p. 144).

And Mona Gardner recalls her encounter with the wild elephants:

The Director of Reconstruction called for me one morning before the dawn was very strong to show me the jewel of all Angkor, the little gem-like shrine of Banteai Srei some twenty miles out in the jungle from the mammoth wat of Angkor. Two wagon tracks in sand was the road, and so close were the trees and creepers that the path ahead did not seem a road but just a crease in the green. In that new translucent light of the early morning, the jungle was like an undiscovered continent where sound and song had not yet found their place. Each glistening frond and leaf had a wet newness and the little puffs of breeze were nebulous and unformed. It was a startling and happy feeling, this being projected silently—rocketed almost—into this shimmering void from a very old and tired world where the coffee pots were being rattled and yesterday's brioche put

on breakfast trays. Walking seemed a little unnatural when we left the car and started along a grassy footpath.

The thin grey-eyed Director was brooding over the progress of which in a year could only be measured by inches, and over a government that appropriated a handful of coins to build up what centuries have torn down. He detached himself from his reverie long enough to say:

"We have elephant trouble at Banteai Srei...The herds are used to wandering there, and they do not stop when we build the walls...We have such a little money we cannot cut the jungle far enough..."

"Er...you mean wild...?"

"Well, shall we say awkward?...They lean against walls we have rebuilt, knock over pedestals...Last week they knocked over a tourist gentleman..." The Director attached himself to his reverie again.

I realized that I would rather have looked at picture postcards of the shrine and I was about to tell the Director so—then we were there.

The path turned at right angles and we looked full at a delicate façade and small pink towers. It was all on a miniature scale and the trees cramped in on it, yet looking at it gave the same sensation as stepping off a cliff which you think is only a curb. I had to look and look to convince myself that this thing of pink granite was not a mirage. I couldn't believe that things of the spirit like fervour, scissions and longing, could be put into stone and still be things of the spirit.

This is the quintessence of Angkor. It is the art of those perfectly conceived masses at the Thom, the Bayon, the wat, and Prakan, but distilled to a finer, subtler point. The little terraces and galleries of Banteai Srei might have been made by lapidaries, and the chisels that cut here have been more like needles to make such lace out of stone.

Suddenly, near-by, there was a dull crash and a confused rumble of heavy things falling. In a moment the temple attendant came hurrying towards us. He bowed his head in humility before he spoke.

"A big one, Sire, has just gone out the window of the front wall!"

"The wall we re-built last month?"

"Yes, Sire!" the Cambodian said with a wry smile. "The same spot!" This elephant came in at the breach of the wall...When he put his head in the window to go out he got stuck. He pushed and took the wall with him..."

"You see," the Director said slowly, like a man who is used to pain, "the work of half a year is gone, and we must wait for next year's budget to ask for the money to put those stones up. It is hard to know that perhaps, in my life-time, I will not see the complete beauty of Banteai Srei."

His big sensitive fingers seemed wistful as they caressed a stone lotus (Gardner, Menacing Sun, pp. 79-81).

Finally, two excerpts from travellers who had the privilege

of seeing Banteay Srei with Frenchmen who are re-
nowned for their dedication and work on the preserva-
tion of the temples of Angkor. Brodrick and a
Hungarian, Baron Korvin, were guided around Banteay
Srei in 1940 by Maurice Glaize, the Keeper of Angkor:

*The group of Shivaite sanctuaries which the modern Cambodians call
Banteay Srei, lies enclosed in jungle and some twenty-two miles to the
north-east of Angkor Vat. The trip is only possible in the dry season—
the elaborate drainage works, canals, dykes and sluices of the Khmers
have long since perished—and even before the rains fall, the sandy
tracks are full of potholes where you may crack the spring-plates of the
best-slung car.*

*You swing and sway and crunch farther and farther into the realm
of trees. The jungle dwellers, perched at the top of their front-door
ladders, stare with amazement.*

*Then, when you have settled down to a day of Oceania, and are
surprised only by the monkeys (for few other beasts will you see
unless you go hunting and not always then), suddenly either the
jungle breaks to a clearing revealing some huge, imperishable build-
ing, so immense as to dwarf you, or, rather slowly, you perceive still
clutched and clawed and tangled by the great trees and merging into
the green haze, a temple or a tower or a shrine magnified by its
monstrous growth of living limbs and branches.*

It is like finding medieval India in Samoa...

*Most of the Khmer monuments are of a dull elephant-grey blotched
with huge splashes of black lichen. The colour of the ruins is for all
the world that of the old Irish castles of the west. The coloured
pictures of the Cambodian palaces and temples lend far too vivid a
tint to the stones which are, indeed, best seen, or at least, best ad-
mired, by brilliant moonlight.*

*But the shrines of Banteay Srei are pink. They are rosy jewels,
unique in Cambodia. In their casket of forest they are startling.*

*The sanctuaries are on a small scale. In fact, so low, that you
must bend to enter some of the portals. But so perfect, so cunning
and so glorious are the harmony and proportion that Banteay will
strike you as more imposing than almost any other man-made thing
you will see in Cambodia. For one visitor and pilgrim, at least,
Banteay Srei is the culmination of a Cambodian journey. The vi-
sion of these shrines is one haunting my visual memory at times of
depression and of exultation. The picture I possess within myself of
Banteay Srei is among the few I hope I shall carry, undimmed, with
me into the shades....*

*Banteay-Srei is now world famous for its admirable carvings in
high relief. There are scenes from legend. There are pediments and
portals whose exuberant decoration is mainly ornamental. Many of
the details in their sharpness, their crispness and their delicacy, re-
mind you of chiseled bronze. It is difficult to believe that such defini-*

tion and clarity can have survived for nearly one thousand years. And the shrines are carved in sandstone.

It is here that we have for the first time in Cambodia scenes with bas-relief figures decorating the pediments above the doors. In its superb carving and sculpture old Içvarapura rivals anything in Mother India. But although the design and plan are wholly Indian, the spirit of the place is the spirit of the more alien world of Indonesia....

Alone, in its setting of forest, Banteay Srei glows cool under the heat. Great butterflies like black velvet swoop and flutter about the shrines.

After a day with this marvel, so far from men that you can often hear and glimpse the herds of elephant crashing carefully through the jungle, as we moved away and daylight began to fail and the shrines shrank into their groves, a great flock of emerald parrots shot through the sky, turned and whirled and settled on the eaves, the corbels and the lintels of the sanctuary—brilliant, scintillating jewels.

And then we ate in the jungle and we drank iced champagne, good champagne, for champagne was both good and cheap in Indo-China. You could get a bottle of Charles Heidsieck for six piastres (sixty francs), or, in the days before the last war, about seven shillings and sixpence.

And how did we drink it iced in the heart of the Angkorian forest? We did not carry an ice-box with us. No, we just shoved the two bottles into a pail, filled up the pail with petrol, let the fly-wheel of the car rip and put the bucket next to the wheel until the petrol was all evaporated and the bottles were frozen so that the wine chinked and tinkled with ice-chips...And we did not spill a drop. Nice, old corks coming out as compact and smooth and polished as a piece of jade (Brodrick, *Little Vehicle*, pp. 187-91).

Santha Rama Rau went to Banteay Srei with Henri Marchal in 1951:

One day Henri Marchal said that he was going to a distant temple in the jungle, Banteay Srei, one of the most beautiful of the buildings. He had some special work to do there, and would we like to come along. Very excited at this unexpected opportunity we set off with M. Marchal, fifty soldiers and a truck of arms and ammunition. Banteay Srei was about thirty kilometers from Siem-reap and, under the prevalent conditions of fighting and ambushes in the jungle, was usually inaccessible to tourists.

It was a trip that took all day, but by some muddle food had not been brought for the soldiers, so on our way there we stopped at a village and the soldiers went in to negotiate for food. It turned out that a short while before the entire village had been made to evacuate and the place had been burned down because the villagers had harbored some rebels....

When we reached Banteay Srei our soldier escort asked us, as usual, how long we planned to stay in the temple because if one stayed longer than an hour or, in remote places, an hour and a half,

that gave the Cambodians time to send word to the nearest guerillas who could return to attack the party at the temple. M. Marchal's wrinkled, charming face shone with delight as he led us into the temple. He said, "In this temple I can tell you the history of each stone. Banteay Srei was scattered all over the jungle and we recon-structed it block by block. Here," he said, flinging his hand out, "is the result, in miniature, a perfect temple, small and infinitely fine in workmanship. It is a carved jewel."

He gave us time to admire it. "It is," he said, "a Citadelle des Femmes of the tenth century, dedicated to the worship of Shiva and his wife Parvati." He bowed slightly to me, "Do I pronounce your Hindu names correctly?"

The temple is rose-colored, and glows with its own light against the dark-green night of the jungle that entirely surrounds. It was, as M. Marchal said, entirely perfect (Rau, East of Home, pp. 171-2).

Ta Keo

Some ancient Khmer must have gone to Babylon. There he must have been overcome with the beauty of its hanging gar-dens and he must have returned to reproduce them. I saw one in all its beauty, on the road which curves around Prah Khan. It is not named a garden, however, but it is known as the temple of Ta Keo (Candee, Angkor The Magnificent, pp. 228-9).

Ta Keo ('tower of glass'), a majestic and imposing temple-mountain of the late tenth century located east of Angkor Thom, might have been one of the grandest temples at Angkor, had it been completed (Plate 33). Perhaps work on the temple was stopped because the king died or some historians believe that lightning struck the temple, an in-auspicious act of nature. The massive blocks of stone soar to a height of twenty-two metres (seventy-two feet) towards the sky. The upper level stands dramatically on three tiers of diminishing size with stairways on each side. The central sanctuary with porches in each cardinal direction dominates the layout. The undecorated interior draws your eye to the immense size of the sandstone blocks and compels you to wonder how the Khmers manoeuvred the stones into position at such a height. The temple is unique for the use of rare greenish-grey sandstone and the absence of decoration. The lack of carved reliefs, so prominent in other temples at Angkor, gives Ta Keo a simplicity and an elegance of

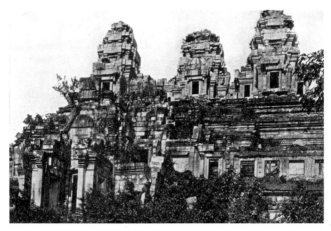

33 Ta Keo temple, Angkor (late tenth – early eleventh centuries) (Casey, 1929).

design. Of these features, in 1929 Casey writes:

Adjacent to them [two smaller temples] *the majestic ziggurat of Ta Keo, most enigmatic of the minor fanes, stepping up toward the sun with a dignity and power suggestive of Angkor Vat. It is dripping with green and crowned with trees, but is still supreme over the forest. Its rocky masses, rising above the tops of the coconut palms, convey the impression that it only recently emerged from some cavern underground, carrying the forest with it in its rocketing ascent.*

It prefigures the final temple of Angkor in more than its size, for it has a chastity of design that sets it apart from the school of thought represented in the Bayon. It is built of a rock much harder than that which is found in the other temples of the district—a material that did not lend itself readily to sculpturing, of which the incomplete chisel-marks of the builders present plentiful evidence.

These same chisel-marks were given an entirely different interpretation when the early investigators began the classification of the Angkorean ruins. The archaeologists who first saw the unfinished work took it for granted that the temple itself was incomplete at the time when the Khmers departed. A translation of its inscriptions later tended to show that it was in existence in the middle of the tenth century.

Ta Keo's lack of ornament makes it distinctive among the works of the Khmers, who were so prodigal of decoration. But its very simplicity gives it architectural importance. Its basic design—the three-stage pyramid surmounted by five towers—is precisely that of Angkor Vat. Its plan shows the development of a new spirit in the people, the growth of good taste… (Casey, *Four Faces of Siva*, pp. 181-2).

Baphuon

'North of the Golden Tower [Bayon]...rises the Tower of Bronze [Baphuon], higher even than the Golden Tower: a truly astonishing spectacle, with more than ten chambers at its base,' wrote Zhou Daguan in AD 1296 (*The Customs of Cambodia*, p. 2). The massive Baphuon temple must have been a spectacular sight at the end of the thirteenth century. However, when Hervey saw it in 1927 the temple was in a poor state:

The Baphuon, *splendorous temple rising like a stricken fortress from courts held in green bondage. There is something tragic and solitary about the Baphuon. Tragedy in the remains of a stone approach that lies matted in grass on the eastern side; in the refuse-filled windows that stare like sightless eyes; and an almost heroic anguish in the receding terraces that tumble into its roofless chambers* (Hervey, *King Cobra*, p. 83).

A photograph of the late 1930s shows what it looked like at that time (Plate 34). Today, the central sanctuary has collapsed and its grandeur is hardly recognizable because of its state of disrepair. The EFEO were working on the Baphuon when they were forced to leave Cambodia in 1972 because of internal disturbances. They have now resumed their conservation work at the Baphuon. The temple is closed to the public and the estimated completion date is 2004.

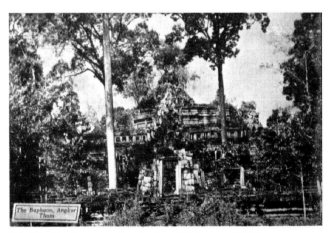

34 *The Baphuon temple, Angkor (Dickason, 1937).*

The Baphuon, a Hindu temple dedicated to the god Shiva, was built in the middle of the eleventh century. It was a temple mountain that was an earthly representation of the mythical Hindu Mount Meru. The temple is approached from the east by a long, elevated causeway that is supported by round columns. Originally a central tower shrine with four porches crowned the peak of the mountain which stood on a sandstone base of five diminishing platforms. Sandstone galleries surrounded the first to third levels. The temple is well-known for its bas-relief tiles with vignettes enacting episodes from the Hindu epics, the Ramayana or the Mahabharata, scenes of daily life or hunting scenes and one regrets these are not viewable today. Candee, though, saw them in 1924 and marvelled at their beauty:

It has been maltreated, and so little of orderly beauty remains that many slight it. But to the real lover of the ruins it is a book of history, for it contains bas-reliefs by means of which is constructed the life of the ancient civilization (Candee, *Angkor The Magnificent*, p. 219).

Appleton made her second visit to Cambodia soon after the attack on Pearl Harbour when both Thailand and Indo-China were in the hands of the Japanese at the end of the Second World War, her first trip having taken place just before the war. She thought this time 'Everything will be different.' Looking at the Baphuon, she writes:

This did not seem empty at all. About it was a strange atmosphere; it was as though countless unquiet spirits haunted its stones (Nor was I alone in feeling this.) Now I understood the superstitious fears of the native Cambodians, and could believe we were looked upon by a myriad of eyes (Appleton, *East of Singapore*, p. 152).

She climbed to the top of the Baphuon, an exercise she thought resembled 'mountaineering'. Of the view from there, she writes:

From its height you see something of the forest which swallowed up the cities.

The teak trees below are two hundred feet high. The roots of others still clasp the topmost stones of the buildings, for although the trees themselves have been felled by the excavators, the roots could not be dislodged without pulling apart the masonry (Appleton, *East of Singapore*, p. 152).

CHAPTER 6

THE SPLENDOUR OF
ANGKOR WAT

Some power overcomes, some mysterious spell is cast, one can never look upon the ensemble of the Vat without a thrill, a pause, a feeling of being caught up into the heavens. Perhaps it is the most impressive sight in the world of edifices (Candee, Angkor The Magnificent, pp. 62-3).

The 'Sun King'

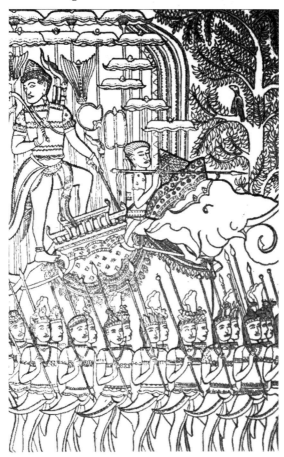

35 *Suryavarman II, Angkor Wat, early twelfth century (Gasrsti, The Dragon and the Lotus, 1927).*

Suryavarman II (the 'Sun King') was one of the most brilliant Khmer rulers and the rightful successor to the throne through his genealogy. But he became impatient with the ineffective rule of his aging uncle and deposed him in a victorious battle. This tempestuous, heroic beginning demonstrates Suryavarman II's shrewdness as a warrior, even when he was a young man. Soon after he became king in 1113, he led 20,000 troops to the coast of southern Vietnam, defeated the King of Champa and sacked the capital.

Besides his military achievements, Suryavarman II extended the territorial boundaries of the Khmer Empire into southern Laos and north-eastern Thailand, where he built imposing temples, signifying his omnipresence as sovereign of the empire.

With these accomplishments, it is not surprising that the great temple of Angkor Wat was constructed during his reign, or that it is the zenith of Khmer artistic achievement. Thousands of people, including: labourers to cut, transport and move sandstone to the site; artisans to draw the design; and carvers to chisel the stone, worked an estimated thirty years to build Angkor Wat.

The architects – mortals or gods?

The architects are unknown and speculations vary from realistic to fantastic. The only one with any historical documentation is an inscription that says when Angkor Wat was under construction the King bestowed the highest title possible on a Brahmin named Divikarapandita who was his chief advisor. Some historians think, therefore, that only the architect of the great temple would be given such an honour. Western travellers had other ideas as to who built Angkor Wat. Dickason did not know his name but called him 'the Michael Angelo of the Orient' (*Wondrous Angkor*, p. 46).

'The work of giants!' exclaimed Mouhot when he saw the temple in 1850. And then he wondered:

Was this incomparable edifice the work of a single genius, who conceived the idea and watched over the execution of it? One is tempted

to think so; for no part of it is deficient, faulty, or inconsistent (Mouhot, *Travels in Siam, Cambodia and Laos*, vol. 1, p. 301).

Sitwell thought:

It was the work of some human being of tremendous and forgotten importance who when he disappeared forever from the human scene left this giant structure of stone behind him in the lotused waters (Sitwell, S., *Great Temples of the East*, p. 38).

Halliburton learned of yet another possibility from the Thais:

The Siamese [Thais], who are believed to have driven the Khymers from Angkor Vat, insist it [Angkor Wat] was built by divinities, because human beings could not have been powerful enough or inspired enough to do it. You may not be inclined to believe this legend from seeing pictures or reading descriptions of Angkor...but when you last look upon Angkor in reality, you believe anything (Halliburton, *The Royal Road to Romance*, p. 299).

The largest temple in the world

The name 'Angkor Wat' means 'the city which is a temple', although 'Wat' ('temple' in Thai) was probably added in the late fifteenth or sixteenth century in the post-Angkorean period, after Cambodians converted to Theravada Buddhism. According to Guinness Book of Records, Angkor Wat is the largest religious structure built in stone in the world. Even after seeing it over fifty times, I am, still, astonished at the immense structure. Read what Halliburton thinks of its size:

Angkor [Wat], built by gods for a fabulous vanished empire, in the might of its dimensions, in artistry, in purity, in magnificence, and above all in preservation, surpasses anything Greece or Rome or Egypt has ever seen. The most amazing archaeological site in the world. It stands, and is perhaps destined to stand, the noblest monument raised by man (Halliburton, *The Royal Road to Romance*, pp. 198-9).

The size, scale and something else about the temple puzzled Andrew Graham:

[I have] Never been able to sort out my impressions of Angkor Vat or to get it into proportion in my mind. It's like nothing else, and there's something about it, apart from its sheer size, which I can only describe as profoundly disturbing (Graham, *Interval in Indo-China*, pp. 112-3).

The temple fills a sacred space of some 210 hectares (500 acres) with dimensions of 1,500 metres or nearly one mile from east to west and 1,300 metres or eight-tenths of a mile from north to south. Three rectangular enclosures, a wall and a moat comprising a perimeter of 5.5 kilometres (3.5 miles) surround the central area. Starting at the centre of the temple, each enclosure becomes progressively larger and the laterite wall, still larger, follows. Then, the magnificent moat (200 metres; 660 feet wide) with steps leading to the water encloses the entire temple.

And such a moat! Over six hundred feet wide, and encircling a space nearly three miles around. Surely fitting for a temple of such extravagant splendor. Indeed, it is more than merely a moat; it is a natural sacred basin; for lotus-flowers encumber its shallows and offer up incense to the gods of the High Penetralia (Hervey, *King Cobra*, p. 55).

Angkor Wat – an earthly Mount Meru

Symbolically, Angkor Wat, as an earthly symbol of the mythical Mount Meru, is in complete harmony with the universe. The symbiotic relationship between the micro-cosm on earth (Angkor Wat) and the macrocosm in the heavens (Mount Meru) is essential for the prosperity of the kingdom and the welfare of the people. According to the Hindu myth, Meru is the exact centre of the universe and separates earth from the heavens. Chains of mountains divided by oceans, surround Meru and the Ocean of Infinity encloses the mass. This layout – gradu-ated enclosures, large areas of sacred space, a surrounding moat – reflects the Khmer's architectural earthly interpretation of Mount Meru.

Ponder visited Angkor Wat in 1936 and, while he probably did not understand its symbolism, he clearly sensed the sacred space of the temple:

At whatever hour of the day or night you choose to visit it, to get the true 'feel' of the place you should have no company but your own...go to it alone, and you will find it in very truth a temple of the spirit: permeated with that essence of the divine that is the fount of all true faith, whatever the name by which men call their gods (Ponder, *Cambodian Glory*, p. 46).

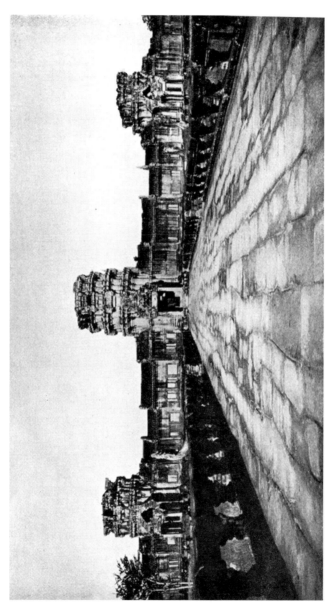

36 Angkor Wat, early twelfth century (Casey, 1929).

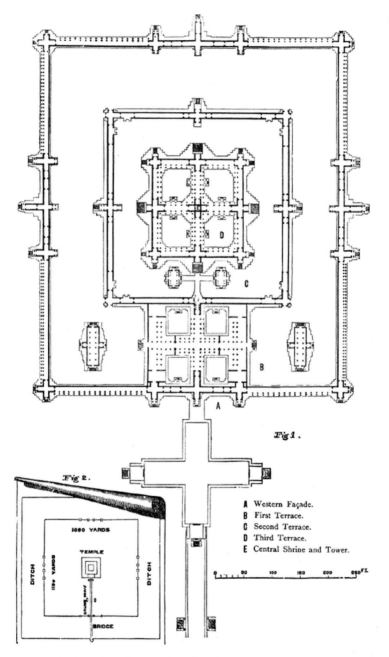

Fig 1.

Fig 2.

1080 YARDS

TEMPLE

1100 YARDS

DITCH

DITCH

CAUSE-WAY

BRIDGE

A Western Façade.
B First Terrace.
C Second Terrace.
D Third Terrace.
E Central Shrine and Tower.

0 50 100 150 200 250 FT.

Map 5 Plan of Angkor Wat by John Thompson, 1886.

CHAPTER 6: THE SPLENDOUR OF ANGKOR WAT

Here at last! The entrance to Angkor Wat

There is no such monument in the world...One doesn't describe an Angkor [Wat]. He stands and gazes at it in silence and amazement' (Casey, Four Faces of Siva, p. 59).

The western entrance is marked by a short flight of stairs leading to a cross-shaped sandstone terrace of elegant proportions. Six sculpted lions (two in each cardinal direction except the east) accentuate the terrace. They crouch fearsomely, always ready to attack intruders. The terrace, formed from massive sandstone blocks, leads to an impressive causeway that is 76 metres (250 feet) long and 12 metres (39 feet) wide.

That causeway, unrolling magnificently across the moat, plunging through the great outer portico and past the gardens to the temple itself, is one of the glories of Angkor-Wat (Hervey, King Cobra, p. 55).

The causeway...is an oddity of engineering...The slabs were cut in irregular shapes, which meant that each had to be chiselled to fit the one adjoining. The effect as seen under the noonday sun...is like that of a long strip of watered silk (Casey, Four Faces of Siva, p. 200).

The elaborately decorated western entrance comprises three towers (one in the centre and one on each side) with porches, a composition that derives its inspiration from an Indian form. The towers were originally the same height but the upper portions have collapsed so, today, the heights vary (Plate 41, p. 132). They form part of an expansive covered gallery (the first enclosure) with over 1,400 square columns and an entrance at each end with the moat in front (Plate 43, p. 134). The whole makes up the western façade of Angkor Wat.

Any architect would thrill at the harmony of the façade, an unbroken stretch of repeated pillars leading from the far angles of the structure to the central opening which is dominated by three imposing towers with broken summits (Candee, Angkor The Magnificent, pp. 67-9).

The three towers of the western entrance are accessed by a short flight of stairs, whereas the two entrances at the ends of the façade are on ground level, causing architects to speculate that they were passages for elephants, horses and

carts. When Candee saw the end towers in 1925 she quipped: '...architecture made to fit the passage of elephants is an idea most inspiriting.'

The view from the western entrance looking towards the east reveals several key features of Khmer architecture. The ingeniousness of the design is such that from the western entrance the temple looks like a mass of stone on one level. It is only as you move closer to the central area that the imposing height of Angkor Wat becomes apparent. The causeway leading to the entrance is nearly twice as long as the first enclosure and these proportions create an ideal sense of scale and balance (Plate 41, p. 132). 'Just the approach to Angkor Wat is on a grander scale than anything in the living world' (Sitwell, S., *The Red Chapels of Banteai Srei*, p. 43).

The western façade is a fine example of the recurring theme of symmetry in Khmer architecture, what you see on the left is replicated on the right. The columns take the eye in a continuous line in both directions along the façade and display the Khmer's brilliant use of repetitive elements to create a sense of harmony (Plate 43, p. 134). Looking eastward towards the temple, the whole evokes feelings of awe and admiration of the genius of Khmer artisans.

The architects of the great temple were masters of their craft, but first of all they were close students of the human eye. They set out to build not only a tremendous pyramid, but an ensemble which would instantly seize upon the vision of one who entered through the West Gate and carry it irresistibly in a direct, unwavering line to the climax of the central tower (Casey, *Four Faces of Siva*, p. 201).

The renowned Five Towers

Raising our eyes, the great temple seized us. Sitting in majesty across a flooded space, it claimed us. It held out spirited arms and embraced us. The soft morning air blowing from its grandeur baptized us into a new worship. The light glowing on its five distant towers illuminated our consciousness, our very souls. We stretched out our arms and stepped towards it in ecstatic forgetting of physical sense (Candee, *Angkor The Magnificent*, p. 63).

The western entrance connects to another, similar cause-

way except that it does not cross a moat. This one is even longer than the first and extends 150 metres (350 feet) in length and 9 metres (30 feet) in width. The celebrated view of the lotus-bud shaped towers of Angkor Wat – one in the centre and one in each of the four corners – a total of five towers symbolizing the five peaks of Mount Meru is seen at the far end of this causeway (Plate 42, p. 133).

These five stone flowers which crown Angkor Wat grew more and more beautiful as the days went on. At first, when the weather was sultry, they were heavy and black and still; but after rain they soared alive into a sky which no longer oppressed them and turned to a light, diaphanous silver grey. I would see them at the end of a vista, from some other part of the jungle, or reflected clearly in the waters of their moat at sundown. I would come upon them unexpectedly from a hundred different angles, and always with a fresh shock of delight. They were ever-present, watching over all the forest. Some-times I would see all five at a time, sometimes four, sometimes three. Sometimes two would seem to grow together and then, as I moved, detach themselves, the smaller opening out like a Japanese flower in water. As I walked away more towers would grow up and hide themselves in turn behind their fellows. My favourite view was from the north. From here the temple seemed too steep to be credible; its three cones rose immaculate, unhidden by the jungle trees. I would sit and watch them in the evening by the water-gate as the young priests came down to bathe and wash their yellow robes and the grey buffaloes wallowed in the muddy water (Balfour, *Grand Tour*, pp. 306-7).*

The auspicious naga (serpent)

One knows at once he is filled with attributes quite other than those which made a snake a thing of horror. He is majestic more than fearsome. He raises a fan of seven heads with such grace that the long body trailing after seems to undulate with natural effort (Candee, *Angkor The Magnificent*, pp. 69-70).

The serpent ('naga') was a popular decorative theme in Khmer art through its symbolic association with water and because of its role in the mythical origins of the Khmers. The Khmers believed that sometime long ago a Brahmin from a far-off land called India sailed along the coast of the Gulf of Thailand and when he reached the shores of Cambodia he saw a naga princess. He was captivated by her beauty and married her. Her father, the King of the Nagas, gave the land of Cambodia to them as her dowry.

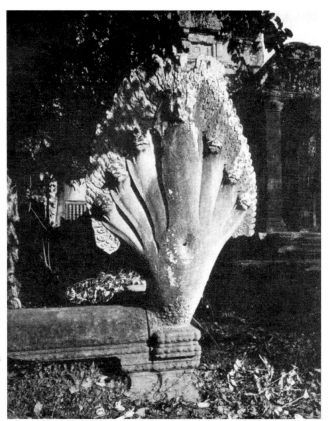

37 *A serpent with multiple heads at the front of a balustrade (de Beerski, 1923).*

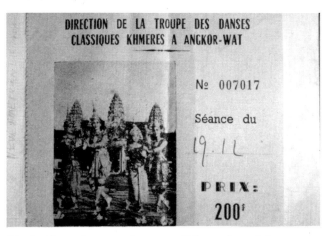

38 *A ticket stub to a performance of Khmer classical dance at Angkor Wat (1968).*

The prolific use of the naga as a decorative element on the sacred temples would, hopefully, ensure enough water for the prosperity of the kingdom.

The balustrade along the causeway leading to the Terrace of Honour looks like the scaly body of a serpent ('naga'), supported by short columns. At six intervals along this causeway the balustrade is intercepted on each side by a set of stairs leading to the ground level. At the bottom of the stairs the serpent raises its body and spreads its multiple heads in the shape of a fan (Plate 37). Lewis is one of the few who do not find the serpents appealing:

The causeway which leads into Angkor Vat is, or was, flanked at exactly spaced intervals by pairs of nagas—seven-headed serpents. I do not find seven-headed serpents particularly decorative, and much prefer the lions couchants of which there many hundreds. However, they represent the serpent beneath which Buddha sheltered. They are, therefore, in essence, protective; and it is necessary to have as many as can be fitted in. I think that it is an aesthetic advantage that the majority of them have been broken and are missing (Lewis, *A Dragon Apparent*, pp. 227-8).

The Terrace of Honour

The Terrace of Honour stands majestically in front of the central entrance to the upper levels of Angkor Wat as a fine example of the Khmer's aesthetics of beauty. The terrace is in the shape of a cross and supported by columns.

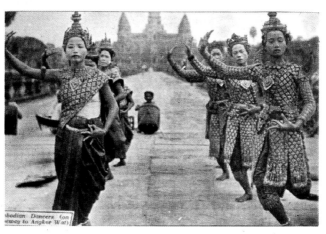

39 *A performance of Khmer classical dancing at Angkor Wat (Dickason, 1937).*

Steps to the north, south and west of the terrace lead to
an open space. Sculpted lions crouch on the steps and
serve as guardians of the terrace. This terrace was the
venue for performances of the royal ballet troupes who
enacted scenes from the Ramayana and other popular
epics in Hindu mythology (Plates 38; 39). My favourite
account of a performance on the Terrace of Honour
comes from Hervey who intertwines fantasy with reality.
Torches burn, celestial nymphs caper on the terrace and
chanting priests descend from the sacred central tower:

*The second night at Angkor (and I was not asleep and dreaming) the
Apsarases came down from the walls and danced on the cruciform
terrace where nearly a thousand years ago they danced before the
emperors of the Khmers.*

*On the veranda of the sala I received the first hint that it was to
be a night of enchantment. In the darkness toward Siem-Reap ap-
peared a swarm of lights, dancing like drunken stars. Nearer they
came, accompanied by the murmur of many tongues.*

*"The torchbearers are coming now," said a voice at my side; "the
dance will begin soon."...*

*We descended into the midst of those dancing flames, into a shiv-
ering orange glare burdened with dragons of sweet smoke. There
were full fifty torches, all carried by little Cambodian boys, whose
half-naked bodies gleamed like copper. What a procession they made,
trailing off toward the causeway! I followed with a wild beating in
my throat, drunk with the scent of burning gum.*

*Beneath the dipping, swaying torches the causeway became a
concourse of living splendor. The little boys chattered and laughed,
splashing fire upon the stones; now and then a bat hurtled up to-
ward the rising moon...I knew if I looked behind I should see a
person dark and jeweled, his body anointed with sandal and musk, a
girdle of gold about his waist, and a dazzling pointed head-dress
flaunting up from his caste-marked forehead; followed by slaves and
saffron-powdered women, all treading upon jasmine-flowers scat-
tered before them by dancing bayaderes.*

*At last the cruciform terrace was reached. There, at the very
entrance of the temple, was a great circle of natives. The little boys
filtered in among them, planting their torches on the flags against
inclining sticks. A place was made for us, and as we sat down there
came a clashing of barbaric music. This music rose from an orchestra
half hidden in the crowd on the other side of the terrace. Tom-toms,
primitive viols, and a long instrument that resembled a xylophone.*

*In the wake of the music came a low rumble, like the applause of
the gods. The sound of approaching chariots?—or thunder? A pas-
sionate vein of lightning grew livid in the sky, and the palms shud-
dered.*

In the glare of the torches, I could fancy these dark people were

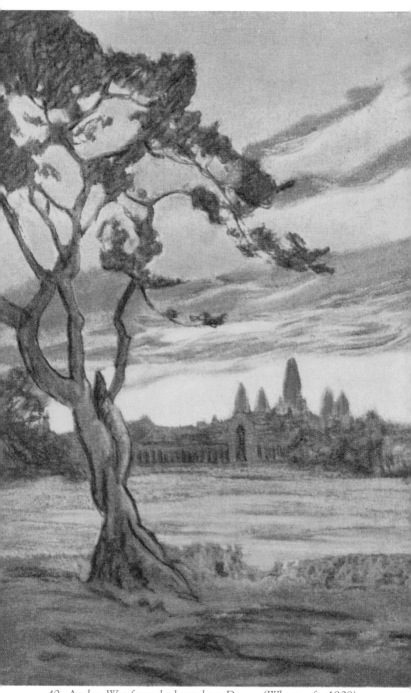

40　*Angkor Wat from the bungalow. Dawn. (Wheatcroft, 1928).*

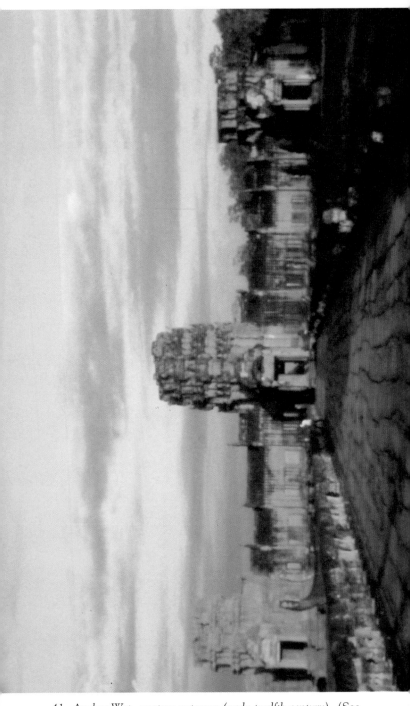

41 Angkor Wat, western entrance (early twelfth century). (See p. 125.)

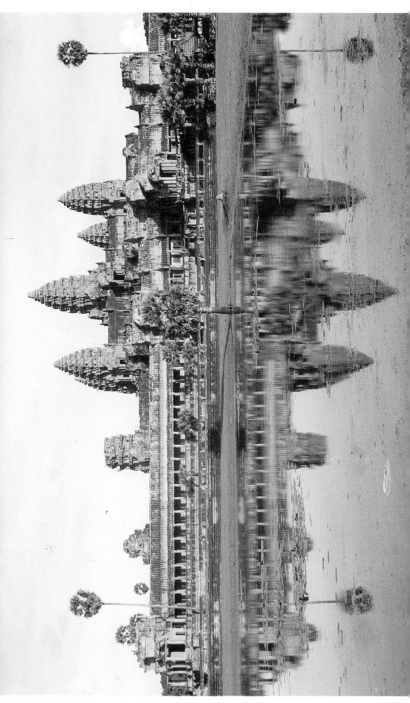

42 *The five towers of Angkor Wat (early twelfth century) and
their reflection in the pond.* (See p. 127.)

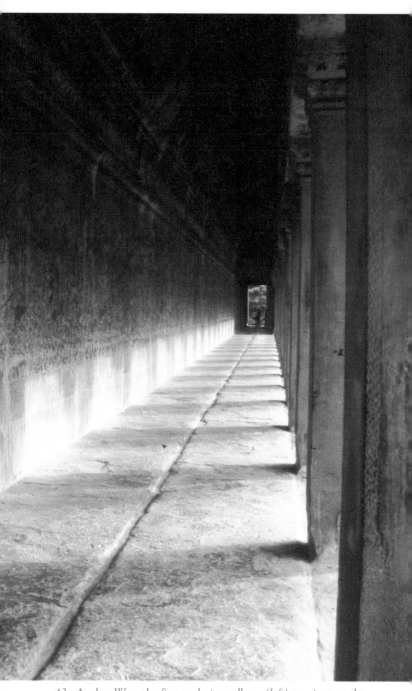

43 Angkor Wat, the first enclosing gallery; (left) carvings on the wall; (right) square pillars (early twelfth century). (See p. 125.)

marked with spots of vermilion or yellow; and to make the illusion complete, several bonzes appeared above the stairs and hovered there, saffron-robed pontiffs awaiting the advent of the sacred dancers.

With no more than a soft clash of anklets to announce them they came, seeming to emerge magically from the gloom of the temple, and advanced into the center of the circle.

"They are from Siem-Reap," my host whispered.

But I knew better; they were the Apsarases, made mortal for an hour.

They were eight, divided into double lines of four facing us. Their features were moon-white, their lips red with the stain of bits of Chinese paper. Above these etiolate faces tapered gilded head-dresses. They who were attired as men wore jackets drawn tight to the mold of their bodies; from their shoulders curved extravagant epaulets; while brocaded sampots were wrapped about their thighs and given dignity by embroidered panels. Over all was the glisten of jewels, of gold thread...The dancers who represented princesses were draped in sampots that hung in pleated folds from the shoulders. Their throats were aflame with collars of jewels; and jewels flashed from their belts, from their arms, fingers and ankles. Their splendor, kindled by the torchlight, left me a little breathless.

At the first fluid pulse of music a tension stiffened their bodies. In perfect harmony each dancer stood poised on one foot, the other leg bent, toes upturned, and moved up and down on flexing knee, while the arms thrown out of joint at the elbows, described bewildering angular gestures that became liquid and melted into other gestures equally bewildering. Thus they stood, fearlessly balanced, while their bodies undulated and their limbs flowed into motions incredibly barbaric. Fingers were bent backward over hands, hands over arms in attitudes seemingly impossible. All seen in the shivering ghostlight of the torches and set to that wild jungle music made doubly savage by the cadenced clash of anklets.

After the dance they faded into the temple; no doubt to become stone again on those glorious friezes.

The moon mourned above the moat, weeping among the wind-stirred lilies. But the fractures of lightning were more frequent, and in the west a tumble of clouds poured down like black hydrangeas.

Suddenly, accompanied by a mad rumble of drums, a mailed figure leaped into the circle of the torches. This dancer was the King of the Garudas. She wore a hideous mask that tapered into a cone, and there was a fire of jewels on her exaggerated epaulets, on her tight girdle and dark sampot. From a moment she crouched on bent knees in the exact pose of the Tevadas, shoulders twitching, body undulating, and sword uplifted. Then she whirled about the terrace in angular gyrations. It was a dance terrible and grotesque, done with such artistry I knew she could be none other than the première danseuse; the Tevada who nearly a thousand years ago danced before the secret splendor of the penetralia. The torchlight seemed to cling about her, kindling in the jewels of her costume and drawing

added fire from her body.

With another crash of drums she vanished.

Often now the towers stood out in black relief as lightning veined the sky, and the palms shivered in successive gusts of wind.

Into the center of the terrace marched the eight dancers, led by the King of the Garudas. This time it was a fragment of the Ramayana they told in supple postures, in the gliding rhythm of trained muscles and unjointed limbs. Hands curved and unfolded; toes were upturned impertinently; rippling muscles made poetry emphasized by the impassive pallor of whitened faces. They were dancers of another century; the sacred courtezans of Angkor, resurrected and reveling on the terrace of their own tomb.

From the near-by forest, where the wind was dancing in the foliage, came quick, stealthy rustles, as though a ghostly army was astir, drawn from its grave by this echo of dead grandeur.

And then, the lightning cracked the sky with a last shattering blow, and the rain came down like a dark glistening curtain descending prematurely upon an incredible performance. The torches were guttered. The orchestra was drowned in the splashing of great drops. Where the dancers had been was a confusion of running figures.

A hand caught mine and led me down from the terrace, then disengaged itself mysteriously, leaving me to hurry blindly across the causeway; a drenched refugee fleeing from a dream.

The next morning I went early to the Wat; and they were there on the walls again, those stone Apsarases, smiling their distant, celestial smiles, as though they had never come to life for an hour to make real the dream of one who had travelled leagues—perhaps centuries!—to gaze upon their loveliness (Hervey, *Travels in French Indo-China*, pp. 70-4).

Windows, balusters, and shafts of light

Directly in front of the Terrace of Honour, windows cut through thick blocks of sandstone extend the entire length of the Gallery of Bas-Reliefs. The open space of the window is filled from top to bottom with five or seven finely turned, stone balusters that give texture and depth to the gallery. Each balaster is a series of symmetrical rings that could only have been achieved with a turning tool (Plate 44). The shape and design of the balusters undoubtedly derived from an earlier Indian-influenced woodworking tradition, but the skill of the Khmers to execute the form in stone is extraordinary. Light frolics joyfully between the balusters creating an ever-changing interplay of shadows on the courtyard.

To illumine the unfolding of the bas-relief, which covers all the inte-

rior wall of the gallery, windows at intervals open on to the surrounding park, and admit an attenuated light, made green by the foliage and palms. Very sumptuous windows, too, framed with carvings so delicate that one might think lace had been overlaid on the stone. They have annulated bars, which look like little columns of wood, elaborately turned by lathe, but are, in fact, of sandstone, like the rest of the walls (Loti, *Siam*, p. 84).

The Gallery of Bas-Reliefs

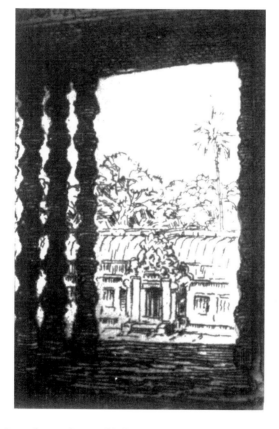

44 *A window with turned balusters, Angkor Wat (early twelfth century).*(Candee, H.C. New Journeys in Indo-China, Siam, Java, Bali, *1927*.)

> *Oh, the graceful and exquisite carvings scattered in profusion everywhere! These scrolls, these traceries of leaf and flower— how inexplicable it seems—resemble those which appeared in France in the time of Francis I and the Medicis. For a moment one might be tempted to believe, if it were not an impos-*

sibility, that the artists of our Renaissance had sought their models on these walls, which, nevertheless, in their days had been slumbering for three or four centuries, in the midst of forests, quite unsuspected by Europe (Loti, *Siam*, p. 101).

The Terrace of Honour leads to the Gallery of Bas-Reliefs, the second enclosure at Angkor Wat. It comprises 1,200 square metres (3,900 square feet) of sandstone carvings that extend from top to bottom of the inner wall at a height of two metres (seven feet). Themes for the carvings draw inspiration from Hindu literature, religious texts and warfare of the Angkor period. Details of war tactics are sufficient to reveal types of weapons used in hand-to-hand combat (Plate 45). The scenes are alive with action, drama and emotion, executed with consummate style, a characteristic that is synonymous with Khmer art.

Dazzling rich decoration—always kept in check, never allowed to run unbridled over wall and ceiling; possess strength and repose, imagination and power of fantasy; wherever one looks [the] main effect is one of "supreme dignity" (Sitwell, O., *Escape With Me!*, p. 91).

The execution of the shallow carving is extraordinary. It is bas- or low relief chiseled from fine-quality, hard, grey sandstone. 'If a symphony can be conceived in stone, surely

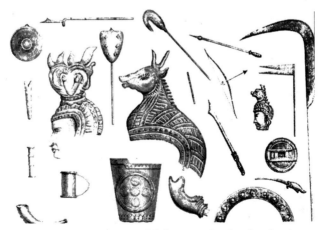

45 A drawing of weapons and helmets used in hand-to-hand combat at Angkor depicted on a relief at Angkor Wat (Mouhot, 1864).

the Khmers created delirious music on the walls of Angkor Wat' (Hervey, *Travels in French Indo-China*, p. 63). Halliburton saw the carvings at Angkor Wat in the early 1920s and found them unmatchable in world art:

The Egyptians might have raised this vast pile of stones in place, but only the Khymers could ever have executed the carvings. Every inch of the wonderfully-wrought structure is covered with finely-chiselled decorations. The splay of each window, the facing of each door, is a masterpiece with an individual design unapproachable for delicacy and grace. Kings and cobras, smiling deities and dancing figures, riot over wall and tower. There is no mechanical ornamentation, but dash and reality to everything. The fancy of the decorator has been given free play, yet more perfect blending of detail could not be conceived. However, I cannot do justice to the stones of Angkor— only a Ruskin or a Chateaubriand could, and either would fill many volumes in the task (Halliburton, *The Royal Road to Romance*, p. 301).

I include three scenes from the Gallery of Bas-Reliefs, which are the ones most frequently written about by early travellers to Angkor and also my favourites.

The Battle of Kurukshetra is an episode from the Mahabharata that appears in an action-packed drama on the west gallery, south side (Plate 46). It is the final hours of a fierce battle between rival enemies, the Kauravas and the Pandavas, who are cousins. They are fighting over the

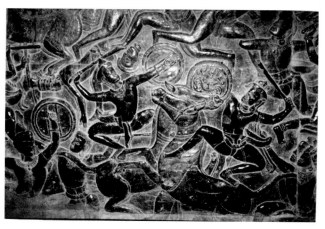

46 *A carving on the west wall (south side) of the Gallery of Bas-Reliefs, Angkor Wat depicting the Battle of Kurukshetra, from the Hindu epic, Mahabharata (early twelfth century).*

possession of family land in Kurukshetra, a province in India. Maugham captures the action of this scene superbly:

You have long lines of soldiers marching into battle, and the gestures of their arms and movements of their legs follow the same formal design as that of the dancers in a Cambodian dance. But they join battle and break into frenzied movement; even the dying and the dead are contorted into violent attitudes. Above them the chieftains advance on their elephants and in their chariots, brandishing swords and lances. And you get a feeling of unbridled action of the turmoil and stress of battle, a breathlessness, an agitation and a disorder, which is infinitely curious. Every inch of the space is covered with figures, horses, elephants, and chariots; you can discern neither plan nor pattern, and only the chariot wheels rest the eye in this chaos. You cannot discover a rhythm. For it was not beauty that the artists sought, but action; they cared little for elegance of gesture or purity of line; theirs was no emotion recollected in tranquillity, but a living passion that brooked no limits. Here is nothing of the harmony of the Greeks, but the rush of a torrential stream and the terrible, vehement life of the jungle. Yet there are not a few that are withal as lovely as the Elgin Marbles, and when you look at them you would be dull indeed if you were not caught by the rapture that pure beauty affords. (Maugham, *The Gentleman in the Parlour*, pp. 219-20).

And here is Halliburton's version of the battle:

There are hundreds of fighters in armour with shield and sword, on foot, on horseback, hundreds more in chariots and on elephants, yet not one figure is passive. It is a battle. Each army sweeps against the other, and the clash in the centre is terrific. Men are piled on one another, struggling in groups, in pairs, with clenched teeth, in agony, in fury, in despair, in triumph; arrows and spears fly thick and fast; the officers urge on their followers; the trumpeters sound the charge; the horses and elephants rear and tremble with excitement; the dead and dying are piled on the ground to be trampled by succeeding waves. At the rear deep ranks of reinforcements, cheering and hurrying, are marched forward into the slaughter. There is action, action, and carnage and the roar of battle. One's eyes stare at this realism; one's heart beats faster in sympathy with this mortal combat. Yet all this is in stone—cold, silent, colourless stone. Some day the artistic world will recognize the Khymers as the greatest artists that ever lived—though perhaps they never lived. Perhaps they were angels as the Siamese insist, descended from Heaven to carve this superhuman work (Halliburton, *The Royal Road to Romance*, pp. 302-3).

The Battle of Lanka is a scene derived from another Hindu epic, the Ramayana, and is depicted in the west gallery, north side. The Ramayana is especially popular in Southeast Asia and appears often in narrative scenes on the reliefs of temples at Angkor. The story carved in stone at

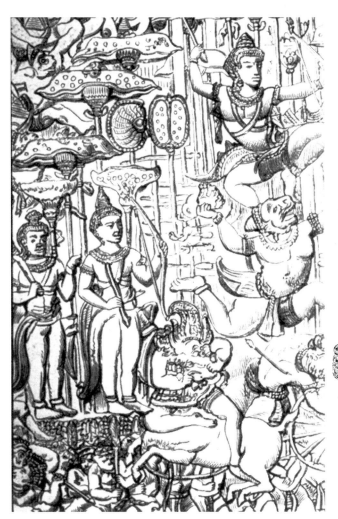

47 A drawing of a relief carved on the west wall (north side) of the Gallery of Bas-Reliefs at Angkor Wat depicting a scene from the Hindu epic, the Ramayana; (right) Rama (the hero) standing on the shoulders of Hanuman, the King of the Monkeys (after Delaporte, 1880).

Angkor, though, has several variations from the Indian version, suggesting that it is based on the Reamker, the Khmer story of the Ramayana. The Battle of Lanka is a dramatic episode in the long saga when Sita, the beautiful wife of Rama, is abducted by the demon king, Ravana, and the army of monkeys joins forces with Rama to go to the island of Lanka (Sri Lanka) to try to get

her back (Plate 47).

Turn the corner into the western gallery and they are at it again in a climax of fury, Rama and his monkey friends against the forces of the wicked. The wicked have chariots and horses, lions, elephants and all the panoply of war. The apes have little more than their teeth, but they go at it with the utmost good heart. They hurl themselves through the air, landing on men's backs, on the necks of horses, scratching, biting, and by sheer weight of numbers bear them down. Apes and men are locked together on the ground, wrestling, clawing, limb twisted about writhing limb. One giant monkey is strangling a lion with its hands and biting through the throat of a second. Another has gripped an agonized elephant by the trunk, while a friend chews at its leg. The King of Ceylon, Ravana the ravisher, sweeps through the frenzy in a lion-drawn chariot; above him the long banners stream like flames. Rama, bow in hand, balances on the shoulders of the ape-king, Hanuman; below him a monkey orchestra discourses wild music with drums and gongs, yelling. Seventy yards of it, six feet high, one packed, tangled mass of figures, smiting, stabbing, biting tearing. It is thrilling, breathless, a delirium of savagery. One can almost hear the clash of weapons, the roar of chariot-wheels, the shrieks of the monkeys, the groans of the dying; the very panels seem to vibrate with the whirling fury of it (Garstin, *The Dragon and the Lotus*, p. 177).

The Churning of the Ocean of Milk is a panoramic scene found in the east gallery, south side (Plate 48). Like the two previous episodes, its origin lies in Hindu mythology. The visual representation of the story centres on the theme of dualism, the eternal struggle between the gods and the demons, or good and evil. The Hindu god, Vishnu, as the preserver, is a key figure in this episode. His role is to keep a constant vigilance on the two poles of existence, represented by the gods and the demons in this scene. When Vishnu learns of an imbalance on earth between good and evil he descends to earth in a different form and offers his assistance in trying to reconcile the discrepancy.

The huge body of a scaly serpent stretches horizontally across the entire length of the panel. A mythical mountain supported by the Hindu god, Vishnu, in his incarnation as a tortoise and a tall churning stick define the centre of the scene. The body of the serpent coils around the stick and then extends to the left and right and is held by eighty-eight gods on one side and ninety-two demons on the side. Fish and other sea creatures swim in the ocean below, and, above, apsaras soar through the skies.

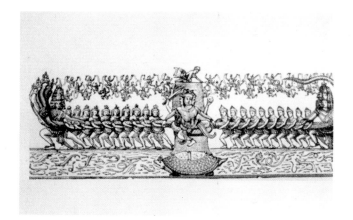

48 *A drawing of a relief carved on the east wall (south side) of the Gallery of Bas-Reliefs at Angkor Wat depicting the Churning of the Ocean of Milk with the gods and the demons pulling the body of a serpent; Vishnu in his incarnation as a tortoise serves as the base for the pivot of the churning stick (early twelfth century) (after Delaporte, 1880).*

The gods and demons have churned the ocean for 1,000 years, without success, trying to yield an elixir that will render them immortal and incorruptible. Also, the pivot, Mount Mandara, is sinking. So Vishnu, the preserver, comes to the rescue and descends to earth in the form of a tortoise and offers the back of his shell as a support for the mountain. So, the gods and demons churn for another 1,000 years, pulling rhythmically, first in one direction and then in the other. Finally, their efforts are rewarded. The churning yields not only the elixir but also many treasures, amongst them are the three-headed elephant Airavata, the goddess Laksmi and the beautiful apsaras.

Benson writes a humourous version of the Churning myth:

Naga, one day before history began, went to sleep coiled carelessly round a mountain, and there was found by a group of idle giants. They divided into two teams and, taking hold of Naga's head and tail, began a tug-of-war. One imagines poor Naga waking up and saying "Hey, fellers, that's enough—no, I mean seriously, this is beyond a joke . . ." And his protests were reinforced from all sides. For the mountain round which Naga was coiled happened to be the one on which heaven and earth were balanced. The put to, pull fro

in the tug-of-war twirled the mountain this way and that. Seldom are the true gods seen in attitudes of such impotent indignity as this frieze shows—thrones reeling, crowns askew, divine legs and arms sprawling in an effort to regain balance. Really it might be the twentieth century! But the waters under the earth are in still worse case. A crimped chaos vividly expresses the turmoil. Crocodiles, sea-horses, newts, axolotls and plain whiting are seen bursting in two, even when they remain intact they are upside down, and their expressions—down to that of the smallest eel—will suggest their intense astonishment and discomfort. At each end of the frieze a company of men and horses applauds the heartless game. There is a demon coach, too, with a great shouting mouth and gesturing arm, giving the word—"Pull, boys, pu-u-ll . . . Good Lord, what are yer arms made of—treacle. Now pull like hell, altogether, boys . . . by God you've got'em . . ." One imagines that Naga, now in retirement in a suburb of the Seventh Heaven, can never go into his club without seeing his fellow-members smiling behind their hands, remembering that day... (Benson, *The Little World*, pp. 286-7).

The sacred ascent

Ahead the pyramid of the temple mounts skyward, not in the fashion of the Egyptian pyramids, which are definitely geometrical in design and achieve their effect by sheer overpowering mass, but in three ornate stages suggesting the terraces of Babylon and Assyria. One is conscious instantly of a strange combination of delicacy, finely wrought detail, and terrific immensity, a conception that is peculiarly typical of the Khmer arts (Casey, *Four Faces of Siva*, pp. 200-201).

From a distance Angkor Vat is deceiving. We had the impression of a building that rises straight from its foundation. Nothing could be more misleading (Legendre, *The Land of the White Parasol*, p. 288).

The height of Angkor Wat becomes apparent as you begin the ascent from the second to the third level. A covered walkway flanked by columns connects the two levels. the columns are beautifully inscribed in Sanskrit and Khmer (Plate 49). Translations of these inscriptions have revealed a wealth of information about the temples such as the date construction began, the names of the donors and the donations they made, military achievements of the king, and so on.

The covered passage is in the form of a cross with four, square ponds, paved with sandstone at the intersections (Plate 50). Stairs lead from the raised passage down to the

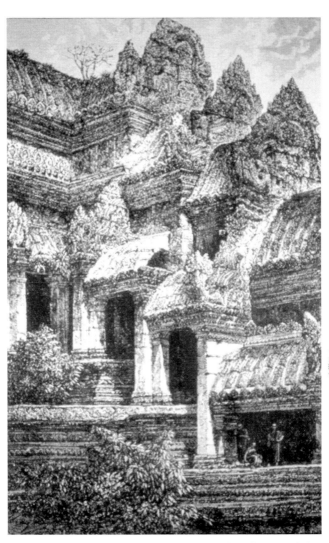

49 *A drawing showing the graduated levels of Angkor Wat (after Delaporte, 1880).*

ponds, which probably served a ritualistic function, perhaps related to lustral water used for sacred ceremonies and rites. These stately ponds are dry but I hope, someday, to see them filled with water freshly dropped by a tropical rain.

The steep stairway leads to the heart of Angkor Wat. Loti undoubtedly had this vista in mind when he wrote

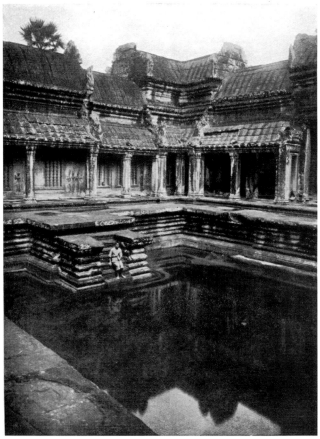

50 Angkor Wat, sacred pond (Casey, 1929).

about the ascent in 1901:

But a sun of fire glares on the last staircase, which is twice as high as the preceding one, and the steepest of all, the staircase which leads to the topmost platform and seems to climb into the sky. And, truly, this progressive doubling of height, from one stage to another, is a notable architectural discovery for increasing the size of the temple by an illusion from which it is difficult to escape. I experience it this evening as I experienced it this morning under the dark rain clouds: it is as if the dwelling of the gods, in measure as you approach it, flies before you, soaring into the air (Loti, *Siam*, p. 103).

The ascent gets higher and higher, up one set of stairs, followed by another one, and then you reach the stone-paved courtyard surrounding the massive third enclosure that supports the five towers on the top level. In contrast

to the richness of the Gallery of Bas-Reliefs, the decoration in this area is subdued with just two alternating themes – windows with balusters and female divinities – covering the four walls of the gallery surrounding the sacred third level. The combination of these elements reveals two classic Khmer architectural hallmarks – symmetry and repetition.

The apsaras – heavenly females

These millions of gracious figures, filling you with such emotion that the eye is never wearied, the soul is renewed, and the heart never sated! They were never carved by the hands of men! They were created by the Gods – living lovely, breathing women!

These heavenly females inspired writers even before Mouhot penetrated their hiding-place in 1859. The words above come from a Cambodian poet, Pang, writing in the 16th-17th centuries (partly translated by Aymonier in *Textes Khmers*, 1878).

Ethereal female divinities delicately carved in sandstone standing alone, in twos, threes or more adorn the undecorated space between the windows and face the sacred, upper level. These females number some 1,700 and are, perhaps, the most frequently photographed decorative element at Angkor Wat (Plates 51; 52). These exquisite, sensuous creatures are widely known as apsaras but are actually devatas, or female divinities, who stand ever-ready to serve, to please the gods. Dressed in luxurious attire and bejeweled with gold and precious gems, these females radiate the epitome of beauty as viewed by the Khmers. To Ponder the heavenly females were:

Visions of perfect grace with lotus blossoms in their hands;…dead maidens whose youth and charm have never died, left behind with us here to prove the grace and beauty of a vanished race! (Ponder, *Cambodian Glory*, p. 247).

Let's look at one of these celestial nymphs in detail. She stands gazing from the wall with the desire of sacred sexuality wearing a filmy, ankle-length skirt clinging to her legs and held in place with a belt inlaid with precious gems.

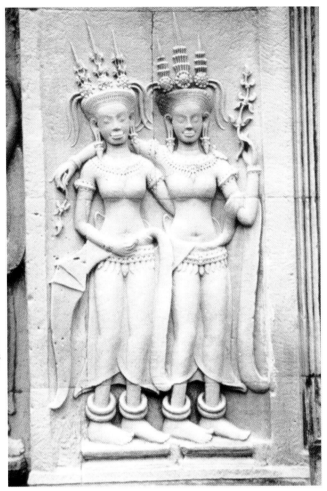

51 *Two female divinities with elaborate headdresses and jewellery, carved on the wall of the second level at Angkor Wat (early twelfth century).*

Her bare upper torso exposes taut, swelling breasts and a flat abdomen – a female at the peak of her physical beauty. Intricately worked bracelets adorn her ankles, wrists and upper arms – all in pairs, one in reflection of the other. She wears a sumptuous necklace of gradu-ated strands with dangling pendants, shaped like jasmine blossoms, the largest one pressed against her cleavage. Pierced earlobes hold heavy, yet delicately worked, ear-

rings. A headdress with spires like the towers of the great temple itself sets off her upswept hair. Read on for Loti's reaction to these lovely females:

Oh! the adorable creatures here and there upon the walls, as if to afford a respite to the eyes from the long battle; holding in their hand a lotus flower, they stand two by two, or three by three, calm and smiling beneath their archaic tiaras. They are the divine Apsaras of the Hindoo theogonies. How lovingly the artists of old have chiselled and polished their Virgin-like breasts!...What has become, I wonder, of the dust of the beauties from whom their perfect bodies were copied? (Loti, Siam, pp. 74-5).

Lewis writes on their anatomical features:

Within the Vat miles of goddesses and heavenly dancing girls, dehumanized and amiable, posture in bas-relief round the gallery walls. They are all exactly of the same height and physique, hands and arms frozen in one of the dozen or so correct gestures. Since Khmer art is never erotic—and one remembers de la Rochefoucauld's 'where ambition has entered love rarely returns'—they do not exhibit the development of breast and hip which is so characteristic of similar figures in Indian art (Lewis, A Dragon Apparent, pp. 228-9).

After Loti left Angkor, the apsaras came to life, quite unexpectedly:

The divine Apsaras, who have been used for centuries to be thus burnt with rays, smile at me by way of adieu, without losing their ease or customary gracious irony. As I took leave of them I little thought that within a few hours, by the lavish caprice of the King of Pnom-Penh, I should see them again, one night, at the evocation of

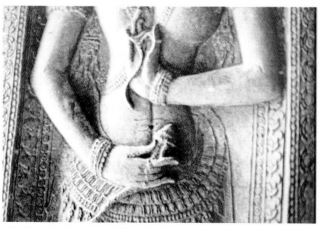

52 *Details of the graceful hands of an apsara*

the sound of old music of their times, see them no longer dead, with these fixed smiles of stone, but in the fullness of life and youth, no longer with these breasts of rigid sandstone, but with palpitating breasts of flesh, and coifed in veritable tiaras of gold, and sparkling with veritable jewels…(Loti, *Siam*, p. 128).

The sacrosanct uppermost level

Casey, standing in the courtyard, surrounded by female divinities and looking up at the top level where the most sacred image of the temple is housed, turns back eight hundred years and imagines a living Angkor with a ceremony taking place:

It is no ruin. The carvings on the galleries are complete. The roofs still turn the rains. The walls are as solid as they were when the Khmer masons put them there without binder or cement. And one cannot but feel that only a few hours ago it was palpitating with life. The torches were burning about the altars. Companies of priests were in the galleries chanting the rituals. Dancing-girls were flitting up and down the steps…That was only an hour or two ago, monsieur…it cannot have been more (Casey, *Four Faces of Siva*, p. 62).

The top level consists of a square base 60 metres (197 feet) long and 13 metres (43 feet) high. Twelve sets of stairs with forty steps each give access to the top level. Looking up from the bottom of the stairs, the climb seems formidable (Plate 53). 'The ascent of the great flight of stairs leading up to the platform is a toilsome task, for the steps are steep and narrow and slippery, but the view will compensate for the fatigue,' (Bleakley, *A Tour in Southern Asia*, p. 68). From the top, you can see all the elements that make up the architectural plan of Angkor Wat, the view is panoramic and the sunsets are memorable.

The stately central sanctuary stretches 42 metres (137 feet) above the upper level and is surrounded by a tower in each of the four corners. From the summit, the view is a spectacle of beauty and symmetry befitting the Khmer's architectural genius for creating harmonious proportions. Sitwell brings this view to life better than anything else I've read:

The traveller, climbing up steps that are more vertiginous than ever, to the central sanctuary, finds, when he reaches the summit, little to

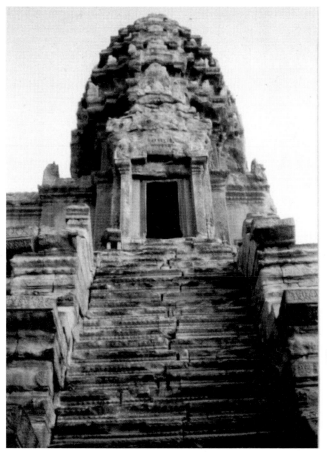

53 *A flight of steps leading to the top level of Angkor Wat (early twelfth century).*

see within, albeit the view of the courts and corridors of the temple below, and of the encircling jungle beyond, is incomparable...That which must chiefly impress him, as he looks down upon the elaboration of open space and mass, of sunlight and shadow, will be the sense of finely balanced proportion manifest throughout this gigantic and splendid edifice. Though permeated by a love of dazzlingly rich decoration, this is always kept in check, never allowed to run unbridled over wall and ceiling, as so often in other equatorial systems of architecture: it possesses strength and repose, as well as imagination and a power of fantasy. Here, gazing up at the lofty towers, or down, over fountain, court and corridor, terrace and paved esplanade, over the crossing lines of a thousand gabled roofs and exquisitely and boldly sculptured details, the main effect is one of supreme dignity: and next he will feel how curiously and fortunately combined in this great relic are ruin and survival. Almost whole—by far the least

injured of the temples—so that nothing has been lost by decay, it has yet disintegrated just sufficiently to produce in the heart of the onlooker an overwhelming sense of age and past glory (Sitwell, O., *Escape With Me!*, pp. 111-12).

Bats, bats and more bats

Watching bats roosting in the cavernous interiors of Angko Wat or departing at night to gather food or smelling the potent odour of bat dung evokes colourful descriptions from early travellers. 'The stench of bats assails the nostrils. They festoon the ceiling above an impassive Buddha as with black drapery, and make you catch your breath' (Appleton, *East of Singapore*, p. 157).

The temple now is deserted save for Buddhist priests and sightseers, and millions of bats that defile the floor and pollute the air with the gagging smell of their bodies—besides, these, there is nothing alive in a temple where once a million men bowed before their gods (Childers, *From Siam to Suez*, p. 11).

Borland, writing in 1933, begins with a description of the bats flying out of the temple after sunset and ends with an anecdote:

Climb to the top floor at sunset, and though it is a long steep pull you will be amply rewarded. Here no ugly factory chimneys or other disfiguring marks of civilization and progress mar the scene. Only the jungle is visible as the sun retired with true Oriental pomp and splendor. Here and there an independent palm, admiring itself in the Angkor moat, stands out blackly against the crimson golden sky. At once the stillness is disturbed by a flapping sound as thousands of bats pour out like black smoke from the five tower-tops. The towers empty simultaneously and each one has a leader who decides where his followers will feed that night. One squadron flies north while another goes west, but whatever direction they take they all go into the jungle to feast on wild figs and cherries till daybreak, when they return to their respective towers to sleep.

Poets would leave the majestic scene at this point and carry home their vast emotions unspoiled, but somehow things do not happen that way in real life. Just as the spectacle reached its climax, Plim stepped right in the center of an oozy bat hole full of slippery, black goo, and had to descend quickly from the heights to the grass below, where we could see him vigorously scuffling and tramping about in the semi-obscurity. "Bat hole!" has not become a standard warning for any unpleasantness underfoot (Borland, *Passports for Asia*, pp. 83-4).

Like Borland, Balfour experienced the bats at Angkor Wat at night:

The moon was all but full as I went to take leave of the Angkor Wat. I fancied that by moonlight it would be at its grandest and most majestic.

The moon was behind a cloud as I approached, and the temple reared up ahead of me, dark and frightening. Only a light like a star, far up in the topmost shrine, relieved the darkness. Not a soul was inside, and I groped my way amid the fetid smell of bats. Someone has described the Angkor Wat as a splendid nightmare. I had disagreed: it had not struck me as sinister. But now that I saw it unmasked by the darkness it seemed to take on a different character. An awful gaunt, huge emptiness reigned: it was like the unbeliever's conception of death. It was no ghost feeling that frightened me, as in a funeral vault which is inhabited by the spirits of the dead; here were no spirits but a void, a vacuum. The place was dead, like an untenanted house. It was as though it had been built for certain gods but those gods had never taken possession: not from displeasure but simply because they did not exist. Its nothingness, its monumental futility seemed to symbolize the tragedy of a people who had backed the wrong god.

I sat at the top of the temple for an hour, quite alone in its emptiness. The jungle below seemed to mock at the Angkor Wat, invisible now in the night, which had flaunted itself so nobly by day. The bats made play in its belfry. The crickets tittered. The moon smiled sardonically. A beetle croaked at it like a cuckoo in blasé cynicism, now from one tower, now from another, and his laugh was hollow, like the devil's (Balfour, *Grand Tour: Diary of an Eastward Journey*, pp. 312-13).

Greenbie writes about the bats inside, rather than outside, the temple:

Over and over again I returned to Angkor-Wat alone. I shrank from the intimacy with the millions of bats that dwell within its chambers. They cling to the dark domes and mutter and chatter and keep up their nervous musings all day long at the least disturbance, protesting man's presence, while they drip a nasty stench that assures them full possession of their conquered sanctuaries. Toss up a little stone into the night above, and they kick up a rumpus that makes you retreat instinctively. But the instant the sun drops below the horizon they pour out in great clouds to prey upon such things as bats relish in the jungle (Greenbie, *The Romantic East*, p. 169).

Whether or not Loti's experience with the bats is entirely true, it makes for lively reading:

Horror! the vault here sinks towards us, or at least the quivering black stuffs which seem to be suspended from it…They descend so as to touch our hair; we can feel the wind they make like a vigorous fanning…Hairy bodies moving very rapidly long hairless wings…It was these, then, that uttered those cries above, like so many rats…We are beset from all sides…enormous bats, in a cloud, in an avalance, maddened, aggressive,…they threaten to extinguish our little mockery of a light. Quick, let us escape, make for the doors; the temple obviously ought not to be profaned in the solemn hours of the night (Loti, *Siam*, p. 75).

Angkor Wat the invincible

The great wat has withstood nature and man for over eight centuries and seems destined to live for eternity as a legacy of the art and civilization of the Khmers. This chapter ends with excerpts of two journeys to Angkor separated by fifty years. But, regardless of the interlude, the thread of Angkor Wat is unbroken and the cycle of time continues eternally. The year is 1872. Members of the Mekong Exploration Commission are inside the temple. A fierce storm arises. It's an eerie account that sends chills down your spine:

Barely in the shelter of the closest gallery than I hear the wind rushing through the monument with the noise of thunder resounding and all the echoes in this old building, suddenly woken up, rumbling and moaning dully. The flashing lightning illuminates the entire temple with an immense and sinister glimmer and displays its towers still proudly braving the rage of the elements. But every day this assault, which it has withstood without batting an eyelid for centuries, seems to become too heavy for it. Its broad coat of stone, torn up by the years, provides passage to the storm and the raging storms penetrate even the most sheltered corner of the galleries. Little by little the wind recedes, the rains continue their slow work of destruction alone and, through the openings of the archways, it falls in streams pressed along the columns of moss. All the noises from outside are absorbed by the immense murmuring which is formed by the waterfalls which from archway to archway, from gallery to gallery, from terrace to terrace, come to fall in waterfalls in the interior courtyards (Garnier, The French in Indo-China, p. 23).

The storm is over. Hervey picks up the thread:

The rain had ceased, the sky was gray, overcast with a burnished haze; a reflection that seemed to run fluid from the west where the clouds were smoky gold. It was like some weird crepuscular light. In it Angkor-Wat was fabulous and pagan. The moat, drinking in the sunset, was tawny metal while the towers of the temple, great irregular tiaras crowning those bewildering terraces, seemed chased in old gold upon the rain-colored sky.

As I watched, the light died from it, swiftly, like the last breath from a living thing, and then it was dead stone, its towers ghosts that haunted the dusk.

In the roadway, a bullock cart creaked by; gleaming half-naked figures seemed to glide past with spectral litheness. Across the way, the broken obelisks of Angkor-Wat stood dark beneath a single ascending star (Hervey, King Cobra, p. 54).

If nothing else remained of all their works it [Angkor Wat] would be enough to mark them as one of the greatest races that time has produced (Casey, The Four Faces of Siva, p. 197).

CHAPTER 7

ANGKOR THOM, THE OPULENT CITY

Angkor Thom is undeniably an expression of the highest genius. It is, in three dimensions and on a scale worthy of an entire nation, the materialization of Buddhist cosmology, representing ideas that only great painters would dare to portray…Angkor Thom is not an architectural "miracle"…It is in reality the world of the gods springing up from the heart of ancient Cambodia… (Boisselier, The Symbolism of Angkor Thom, p. 3).

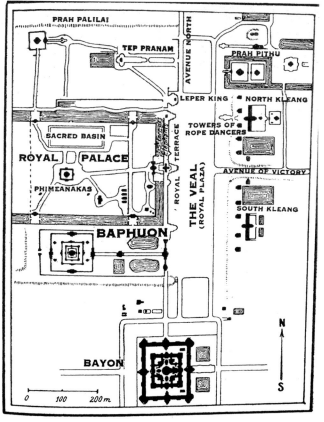

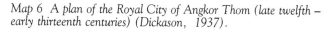

Map 6 A plan of the Royal City of Angkor Thom (late twelfth – early thirteenth centuries) (Dickason, 1937).

Angkor Thom ('Great City'), the religious and administrative centre of the powerful Khmer Empire, supported a population of some one million people and was larger than any contemporary city in Europe (Plate 55, p. 159; Map 6). Even though Angkor was in decline at the end of the thirteenth century, according to the Chinese emissary Zhou Daguan, the royal city was still a dazzling spectacle:

At the centre of this kingdom rises a Golden Tower [Bayon] flanked by more than twenty lesser towers and several hundred stone chambers. On the eastern side is a golden bridge guarded by two lions of gold, one on each side, with eight golden Buddhas spaced along the stone chambers. North of the Golden Tower rises the Tower of Bronze [Baphuon], higher even than the Golden Tower: a truly astonishing spectacle, with more than ten chambers at its base. A quarter of a mile further north is the residence of the King. Rising above his private apartments is another tower of gold. These are the monuments which have caused merchants from overseas to speak so often of 'Cambodia the rich and noble (Chou Ta-Kuan, *The Customs of Cambodia*, p. 2).

Gateways to the Royal City

An 8 metre (26 feet) high wall with a circumference of 1.9 kilometres (3 miles) extended in a square around the city, which was surrounded by a moat (width = 100 metres; 328 feet). Five causeways, each with an entry tower, stretching across the moat and give access to the city, one each on the north, south and west sides of the enclosing wall and two on the east side.

Natives have given a name to each of them. The southern is called the "Gate of the Lake"; the eastern are those of "Victory" and of "The Dead"; the western, the "Gate of the Spirit Kao"; the northern, the "Gate of the Spirit Nok," (de Beerski, *Angkor, Ruins in Cambodia*, p. 56).

The 'Gate of Victory', the additional entrance at the east, is in direct alignment with the Royal Palace.

The "Gate of Victory," under which we are about to pass, might at first sight be mistaken for the entrance to a cavern overhung with creepers....

Through the gloom then we approach the "Gate of Victory," which at first seemed to us the entrance of a cave. It is surmounted, nevertheless, with monstrous representations of Brahma [mistakenly identified], which are hidden from us by the entwined branches,

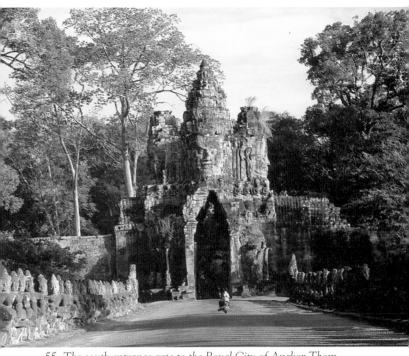

55 *The south entrance gate to the Royal City of Angkor Thom (late twelfth – early thirteenth centuries).* (See p. 155.)

56 *A copy of the so-called Leper King on the terrace of the same name (late twelfth century).* (See p. 170.)

57 *The original so-called Leper King; now in the National Museum, Phnom Penh (late twelfth century).* (See p. 170.)

58 *Cambodian children making an offering to the Leper King.* (See p. 171.)

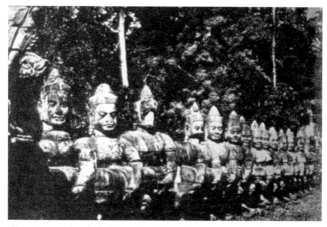

59 A row of gods holding the body of a serpent that forms a
balustrade across the causeway leading to the entrance of the Royal
City of Angkor Thom (late twelfth – early thirteenth centuries)
(Greenbie, S., The Romantic East: India, Indo-China, China
and Japan, 1930). (See p. 157.)

their power and strength when she crossed the causeway
in 1930:

*Any city abandoned to the jungle for unknown reasons would be
fascinating. When it is approached by causeways of demons and
giants leading up to colossal god-faced gateways, it becomes irresist-
ible. Huge stone guardians are still on the lookout for people without
toes, for it was an old Khmer custom to chop off the big toes of
criminals, who were thus easily identified forever after and not al-
lowed to enter the royal city of Angkor Thom* (Borland, Passports
For Asia, p. 81).

The Royal Palace and the Palatial Square

The king, his officials, military officers, priests, astrono-
mers and all others in his service lived inside the city, which
comprised an area of 360 acres (145.8 hectares). The struc-
tures within the city were built of wood and have all per-
ished, so you can only imagine the former grandeur of the
royal palace. Envision the king's residence as an immense,
rectangular structure supported by massive solid teakwood
columns. The façade is intricately carved with auspicious
signs of mythical creatures interwoven with tropical floral
motifs. Fragments of these tiles are scattered on the grounds
of Angkor Thom today and remind us of the former

royal dwellings of the once great centre of the Khmer Empire. Here is Candee's vision of the palace:

It is rather an enclosure, a large space about six hundred and seventy-five yards deep and two hundred and eighty wide. Around this space was built an enclosing wall pierced by two gates on both north and south, as well as by the grand gate of entrance in the centre of the Terrace on the east. A second enclosing wall was built inside this. Within the vast space thus protected were erected all the buildings made necessary by custom for royal living, which means for the accommodation of all the royal wives and children and for the enormous number of dancing girls and attendants who amused the king during the days and nights when he abstained from his favourite pursuit of war (Candee, *Angkor The Magnificent*, p. 180).

The fervent activity of Angkor Thom in its prime is gone today. Instead, the area is tranquil, cool, shady and ideal for strolling or sitting amidst the trees and pondering the former glory of Angkor. Aged trees and jungle have replaced the residences of royalty and administrators who served the king. Monkeys and squirrels scamper about the grounds and elephants plod along the roadside. Numerous stone structures are found amongst the jungle and include the Terrace of the Elephants, the Terrace of the Leper King, Phimeanakas, the Bayon, Baphuon and others. It is possible to bring the Royal Palace area to life once again through a combination of imagination, architectural remains and the one surviving firsthand account of the thirteenth century and to envision it as a vital capital of the Khmer Empire eight hundred years ago. Borland helps us do this:

Though the palace is gone, it is easy to imagine a glittering Khmer king on the Royal Terrace, upheld by garudas and elephants, reviewing his troops or watching cruel but gloriously spectacular games in the vast open square in front of him. The Cambodian army is still on parade around the walls of the Bayon and Angkor Wat (Borland, *Passports for Asia*, p. 81).

Hervey applies his imagination and sees the Royal Square in the twelfth century, alive with activity presided over by the king:

When he [the king] went about the city, he carried the sacred sword which the god Indra is reputed to have bequeathed to the Khmer emperors. What processions they must have been! Courtiers announcing the royal advent with conches and cymbals; then the soldiers, followed by priests; and last, surrounded by courtesans and

dancing-girls, by troops and officials, the king himself, carried in a jeweled palanquin and shaded by the numerous golden umbrellas to which his rank entitled him (Hervey, *Travels in French Indo-China*, p. 96).

Briggs pictures a celebration of a victorious battle taking place in the Royal Square:

Let us picture the return of the Khmer army after a victorious campaign at the beginning of the Thirteenth Century. The fleet sails up the Great Lake and the Siemreap river to the Avenue of Victory, the warriors disembark and march down the Avenue to the Royal Square, where the King, sitting in the pavilion of the Royal Terrace, reviews them: Caparisoned elephants, prancing horses, infantrymen in serried ranks, armed with pikes and crossbows, banners flying, marching to the measured cadence of cymbals—all this is pictured in the bas-reliefs of an earlier date. That night, without doubt, the populace was feasted, while bands played gaily. Games and spectacles of all kinds filled the Plaza for days, and doubtless the spellbinders of that day assured the people of the unconquerable plight of the Khmers, protected by their never-failing and all-powerful gods (Briggs, *A Pilgrimage to Angkor*, pp. 64-5).

For Candee, the palace area was:

One of the most alluring sights of Angkor, one of the dream-places where one must come again and again and live in imagination the life that made brilliant the court of the powerful Khmers from the ninth to the thirteenth when their star set (Candee, *Angkor The Magnificent*, pp. 129-30).

The Royal Square, in front of the Terrace of the Elephants, was where troops and processions marched, festivals and ceremonies took place and where people came daily to bear their grievances to the king, who presided over the events from on top of the terrace facing the Royal Square. He sat in a wooden pavilion with a canopy made of silk imported from China and embroidered with gold and elaborately carved. Zhou Daguan gives the earliest existing account of a New Year celebration held in the Royal Square:

In front of the royal palace a great platform is erected, sufficient to hold more than a thousand persons, and decorated from end to end with lanterns and flowers. Opposite this, some hundred and twenty feet distant, rises a lofty scaffold, put together of light pieces of wood, shaped like the scaffolds used in building stupas [temples], and towering to a height of one hundred and twenty feet. Every night from three to six of these structures rise. Rockets and firecrackers are placed on

top of these—all this at great expense to the provinces and the noble families. As night comes on, the King is besought to take part in the spectacle. The rockets are fired, and the crackers touched off. The rockets can be seen at a distance of thirteen kilometres: the fire-crackers, large as swivel-guns, shake the whole city with their explosions. Mandarins and nobles are put to considerable expense to provide torches and areca-nuts [for chewing betel]. Foreign ambassadors are also invited by the King to enjoy the spectacle, which comes to an end after a fortnight (Chou Ta-Kuan, Notes on Customs of Cambodia, p. 29).

Hervey gives his impression of the Royal Square when he saw it in 1928:

This morning we rode straight under the Gate of Victory, past the torn pyramid of Bayon, and into the great public square. There was a certain glory in that spacious stretch of green, thrice brilliant in the violent downpour of sunlight. Immediately it gave me a feeling of imperial vastness. On the left, stretching for more than three hundred yards and plumed with the ragged planes of tall trees, was what Kim Khouan [Cambodian guide] pronounced the Terrace of Honour. It was one great length of friezes, broken by five stairways; an intricate mass of sculpture that stencilled the brain with an array of Garudas, lions, gods and processions of howdahed elephants. (Hervey, *Travels in French Indo-China*, p. 84).

Northcliffe saw a procession in the Royal Square in 1921:

The great procession commenced at three o'clock to the minute—in terrific heat. We sat in a small temple, which was the Grand Stand. The whole pageant was an exact reproduction of the bas reliefs on the walls of the temple; Princes, Princesses, mandarins, the King himself, all gorgeously arrayed in wonderful silks, and carried in tall palanquins—dazzling in the sunshine. "La Favourite," the before-mentioned damsel of nineteen, loaded down with gems, was a great attraction to the ladies. There were fools with quaint gesticulations— royal dancers by the hundred—the Ministers of State—Brahmins— the whole ending up with fifty magnificently caparisoned elephants...I can't remember half of it, but I shall never forget the spectacle (Northcliffe, *My Journey Round the World*, chpt. 23).

Today only monks live within the enclosure of the royal city of Angkor Thom where modern temples juxtapose ancient ones and monks clothed in vibrant orange robes stroll meditatively on the grounds. Nuns, in white robes with shaven heads, sit along the east entrance to the Bayon, sometimes selling flowers, candles and incense so visitors can make merit by presenting an offering to the Theravada Buddhist images in the temple that have replaced the original ones. So, while the temples inside the royal city

are not active places of worship as they once were, a sense of religious zeal still prevails.

Phimeanakas

Phimeanakas ('celestial or aerial palace'), the king's private temple for worship, is located within the enclosure of the royal palace (Plate 60). The superstructure of the temple has collapsed but when Zhou Daguan saw it a golden pinnacle adorned the top giving it the name 'Tower of Gold'. Construction of Phimeanakas began in the middle of the tenth century but subsequent kings made additional changes to the original structure and layout. Cambodians believe that a serpent-spirit with nine heads lives at the top of the temple. Every night, the spirit appeared disguised as a woman and the king was obliged to go to the top of the tower where she lived and spend a part of every night with her. If the king missed even one night, not only would he die but also his royal lineage to the Khmer throne would cease. Today Phimeanakas is cleared and visitors can walk around the temple on the ground level or climb to the top for a stunning view of the palace area and Bakheng hill:

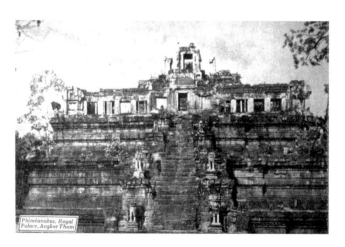

60 *The eastern entrance to Phimeanakas temple (tenth – eleventh centuries) (Dickason, 1937).*

We were now within the walls of Phimeanakas. Deep courts wildly overgrown with jungle-grass; vine-wrapped stones piled in grandeur; and where the path ran into high foliage a pyramidal ruin of reddish stone, ridged and serried, with trees growing up from its parapets past dead windows and bursting in terrific green above roofless chambers. "It is the temple of Phimeanakas," said Kim Khouan...At one time there must have been numerous other buildings about it. Now only broken walls and fallen rock kept visible the memory of spacious royal dwellings (Hervey, *Travels in French Indo-China*, pp. 84-5).

Two rectangular, paved ponds, north of Phimeanakas, served as bathing areas for the men and women in the service of the king. The pond for the men, to the west, is carved with two tiers of lively mythical water creatures. Srah Srei ('the women's bath'), near the north-eastern side of the enclosing wall, is the smaller of the two ponds. It is without decoration except for laterite steps leading from the ground to the water level. De Beerski envisioned it as a place where women kneel on the edge:

And fill little baskets with the stagnant water. They laugh and chat, and after the liquid has run out of their receptacles they look in them attentively and, with the tips of their fingers, take a few grains of shining dust...it is gold. The precious metal lies in infinitesimal quantities in all the sand that forms the soil of the province, and although it has no real commercial value through its rarity, the magic mineral is like a vague reflection of the invaluable wealth once amassed by the Khmers (de Beerski, *Angkor, Ruins in Cambodia*, p. 150).

Terrace of the Elephants

The expansive Terrace of the Elephants (some 300 metres, 984 feet long) is intercepted by three sets of stairs leading to the top of the terrace in front of the Royal Palace (Plate 61). A long platform framed by a balustrade of sacred geese carved in stone forms the façade of the Royal Palace. The central stairway, leading directly to the east entrance of the wall enclosing the royal palace, is supported by majestic garudas, the mythical mount of the Hindu god Vishnu, which has the head of an eagle and the body of a human (Plate 62).

The façade of the elephant terrace is carved in laterite with a row of huge elephants and their mahouts ('trainers') in profile (Plate 63). 'All the pachyderms, almost

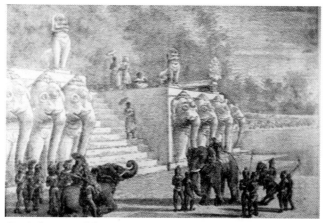

61 A drawing of the central stairway of the Terrace of the
Elephants (late twelfth century) (after Delaporte, 1880).

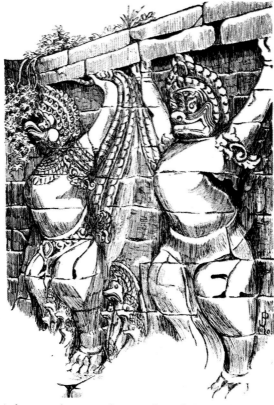

62 A drawing of two garudas carved in relief around the base of
the central stairway to the Terrace of the Elephants (late twelfth
century) (de Beerski, 1923).

life-size, are magnificent none the less, and the whole effect has an indescribable splendour' (de Beerski, *Angkor, Ruins in Cambodia*, p. 148). As you move closer to the terrace, the action intensifies and, although the surface of the laterite is worn, you can still sense this activity. An elephant carrying a slain deer, another one fighting with its trunk, a tiger clawing at a smaller elephant. Candee sees this panorama as a parade of elephants:

They are no smaller than the beasts one rides and sees lumbering down the road. But most of all is the unusualness of the great procession— totally unlike other decorations, not conventionalized at all, but a picture of life (Candee, *Angkor The Magnificent*, p. 164).

Whereas de Beerski sees the elephants on a hunt and brings it to life with all the accompanying gore and action:

An Imperial hunt in the sombre forests of the realm. There are the formidable elephants which have given a name to the structure.

The forest in which they travel is impenetrable to all but tiny creatures, able to squeeze their smallness between the fissures of the undergrowth, and to the biggest animals, which crush chasms for their passage in the virgin vegetation. The elephants are ridden by servants and princes, and tread as quietly as if they were on an excursive promenade. Their steps of even length have no respect for any obstacle.

The princely hunters, at ease in the slight howdahs, look on more than they act. Sometimes a noble aims an arrow or brandishes a spear, but the pachyderms themselves do most of the killing. Be it a bull they have reached, the wrinkled trunks, with finger-like endings, coil round its neck and press and squeeze—we can almost hear the bones crack and see the strongly built ruminant fall shapeless; be it a stag, the same trunks are stretched out again, grab the antlered beast, and we can imagine them lift it and throw it against a trunk, where its ribs would be broken, limbs rent, and blood would flow on the grass. The same thing happens to boars and gazelles, and it is easy to bring back to mind the picture of the models continuing their march, with tusks red and soiled by bits of skin, torn fur or dripping gore, their feet pounding victims into the slime and leaving a track of crushed plants and slaughtered game.

Some details are especially vivid: a tiger snarls savagely and plunges its claws in the tough muscles of an elephant, but, pressed by a pair of the enormous mounts, it gasps for its last breath in a final roar. An imaginary sinto [lion] rears up, but the elephant it attacks is equal to the danger and accepts the challenge. After a carnage the fine animals pluck a branch and brush away the dust from their heads. In one place a tribe of savages attempts to make them retire, but the futility of their

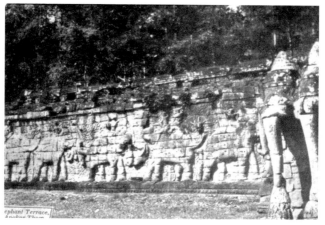

63 *The façade of the Terrace of the Elephants (late twelfth century) (Dickason, 1937).*

wish is appalling; they pay dearly for their rashness and are killed.

The true feeling of hunting is there—the brutal action of destroying lives for pleasure, of attacking agile creatures to pit one's skill against theirs. One even perceives almost a hint that the sculptors did not very much admire that particular kind of hunting in great battues, in which the human hunters are out of danger on moving fortresses, the elephants, and where the game has not a chance of escaping. The artists had a correct sense of attribution and show the elephants as the main factor in whatever success ensues. Moreover, we conceive how cruel is man, who captures the intelligent brutes, born for peace, and changes them into instruments of death (de Beerski, *Angkor: Ruins in Cambodia*, pp. 147-8).

Wheatcroft also thinks the elephants were on a hunt:

Every animal is magnificent in character and realism so that certainly each owner would unhesitatingly pick out his own beast. A gorgeous procession abounding in life; some of the elephants carry not only masters on their backs together with their pets, but their trunks hold the game that has been killed, such as deer and other animals (Wheatcroft, *Siam and Cambodia*, p. 60).

Terrace of the Leper King

The Terrace of the Leper King is to the east and aligned with the Terrace of the Elephants. The façade is a dramatic spectacle of carved male and female figures set in horizontal registers spanning the entire height of the wall. The name 'Leper King' refers to a stone sculpture of a male figure situated on the top platform of the terrace

sitting in a posture known as 'royal ease' with his right
leg tucked under him in a kneeling position and his left
leg raised at the knee. Splotchy white lichen gives a
leper-like appearance to the image. The one in place
on the terrace today is a copy (Plate 56, p. 159). The
original Leper King is in safe-keeping and displayed in
the centre of the courtyard at the National Museum of
Phnom Penh (Plate 57, p. 160). Dickason thought the
image of the so-called Leper King was

*brought here for some especial purpose from a neighboring temple, it is
notable in that it is totally naked and has no sex. Khmer art, unlike the
Hindu, is always chaste, never vulgar'* (Dickason, *Wondrous Angkor,*
p. 114).

De Beerski, who saw the original image of the Leper
King in situ in 1922, thought it was a masterpiece:

*The stone monarch is absolutely naked, his hair is plaited and he sits in
the Javanese fashion. The legs are too short for the torso, and the
forms, much too rounded, lack the strong protuberances of manly
muscles; but, however glaring are his defects, he has many beauties,
and as a study of character he is perhaps the masterpiece of Khmer
sculpture. Whilst his body is at rest his soul boils within him...His
features are full of passion, with thick lips, energetic chin, full cheeks,
aquiline nose and clear brow...his mouth, slightly open, showing the
teeth, and the eyes seeming to gloat over the shame of a fallen and
hated foe* (de Beerski, *Angkor, Ruins in Cambodia,* p. 175).

The origin of the name 'Leper King' continues to baffle
scholars. The long-held theory that Jayavarman VII was a
leper has no historical support. Some historians suggest
that it is the white and black lichen on the image, par-
ticularly on the fingers and toes of the image, which gave
it the name 'The Leper King'. Another idea for the name
is that inscriptions state that the king built over one hun-
dred hospitals throughout the kingdom, but there is no
indication that he was a leper. The image may represent
Kubera, Hindu god of wealth, or possibly Yasovarman I,
who were both allegedly lepers. The name is also associ-
ated with a legend that tells of a minister who refused to
prostrate before the king, so the king hit him with his
sword. Venomous spittle fell on the king, who became a
leper and was known as the Leper King. The most widely
accepted theory is based on an inscription that appears on

the statue carved in characters of the fourteenth or fifteenth century, some one or two hundred years after the date of the image. These suggest that the image represents Yama, the Hindu god of judgement and death. If this is so, the terrace may have been used for cremations. Even though the meaning of the name is uncertain and the statue in place is not the original one, worshippers today still honour the Leper King through offerings of flowers and incense (Plate 58, p. 160).

The Bayon (Plates 64; 65)

'We stand before it stunned. It is like nothing else in the land' (Candee, *Angkor The Magnificent*, p. 126). 'I do not think it too rash to say that the Bayon is the oddest building in the world, only rivaled by the Church of St. Basil in Moscow' (Gorer, *Bali & Angkor*, p. 197).

At whatever hour one visits the Bayon, the central temple of Angkor Thom, and especially by moonlight, the visitor is conscious of a sense of other-worldliness, almost as though the people who built it came from another planet' (Wellard, James, *The Search for Lost Cities*, p. 90).

'The Bayon dominates the whole town, and willingly or not most people succumb to its strange attraction,' (Wheatcroft, *Siam and Cambodia*, p. 62). 'It envelopes you in a whirl of artistic sensations and every stone is worth a prolonged study,' (de Beerski, *Angkor, Ruins in Cambodia*, p. 88).

The Centre of the Universe

At the beginning of this century, it was unknown that the Bayon is situated at the exact centre of Angkor Thom because it was enshrouded in jungle. 'This mysterious monument of complicated plan, with deep courts like wells and dusky galleries, alone of Khmer buildings, had no containing wall—its walls were those of the city itself' (Brodrick, *Little Vehicle*, pp. 165-6). The absence of an enclosing wall was a puzzlement until the precise location of the temple was known, then it became clear that the wall of the city of Angkor Thom

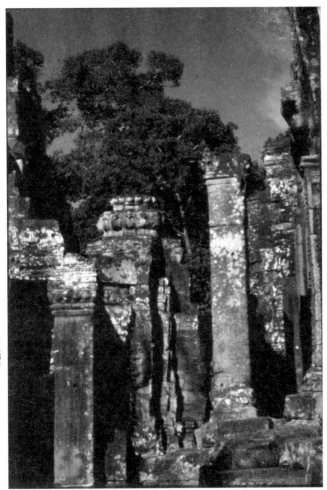

64 *The Bayon temple*

enclosed the temple and all other structures within the city. It was first thought to be a Hindu temple and then in 1925 the discovery of a sandstone lintel with an image of a standing Avalokiteshvara, a deity worshipped in Mahayana Buddhism, revealed its true religious affiliation. Subsequent archaeological work determined that the Bayon was built on top of an earlier monument and underwent a series of changes at a later date. Even after clearing, though, the date, layout and purpose of the Bayon remained obscure.

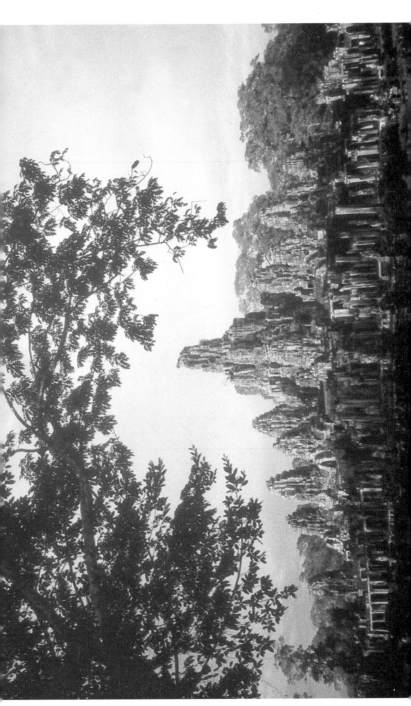

65 Bayon temple (late twelfth – early thirteenth centuries).

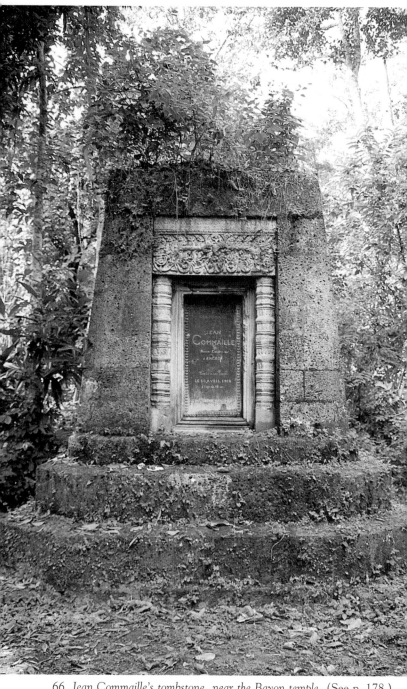

66 Jean Commaille's tombstone, near the Bayon temple. (See p. 178.)

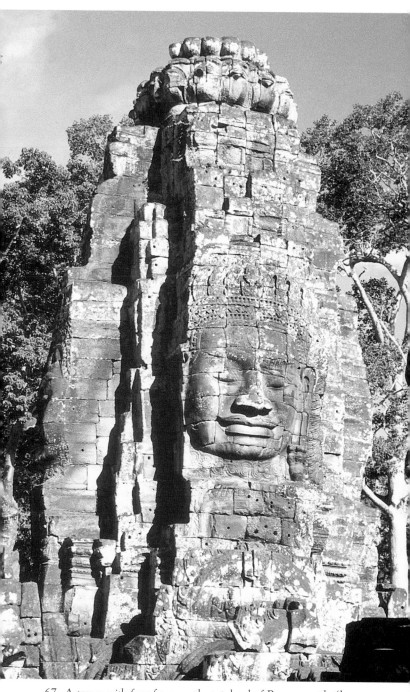

67 A tower with four faces on the top level of Bayon temple (late twelfth – early thirteenth centuries). (See p. 178.)

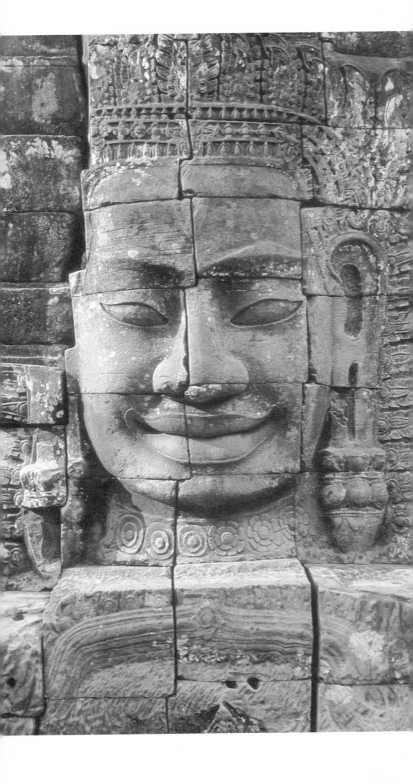

The Bayon is a mélange of crowded spaces, galleries, columns and stairs superimposed on other parts. According to the report of the Mekong Exploration Commission who saw the Bayon in 1866, the Cambodians called the Bayon 'Preasar ling poun' ('the pagoda in which one plays hide and seek'). Anyone who has walked through the Bayon will agree this is an apt name. De Beerski pondered:

Shall I walk for ever, always in the Bayon, till I fall of exhaustion? Fresh rooms gape before me; nowhere do I meet the slightest resistance. I inspect passages and cloisters, chapels and nooks at my wish, but never finding an opening to the outside, shall I die, lost here? (de Beerski, Angkor, Ruins in Cambodia, pp. 66-7).

The architectural composition of the Bayon is grandiose and imposing, if not comprehensible. From afar, the Bayon looks like a square structure with a multitude of scattered stalagmites (Plate 65, p. 173). Only as you move closer does the distinctive form of the temple become apparent. Santha Rama Rau and a group of French soldiers arrived at the Bayon in the wee hours of the morning before the moon descended, following a gala farewell party for the soldiers who were being sent to the front the following day. When they came face-to-face with the Bayon they:

Stopped—stopped talking, laughing and singing, stopped walking— and stared back, caught for a moment in the fugitive magic of the dead Khmer empire. The towers were lichened, decaying, but still rising with astonishing authority above the steamy muddle of the jungle (Rau, East of Home, p.83).

Peter Hauff, a Norwegian, went to Indochina in 1893 when he was a young man and worked with a trading company in Saigon. He subsequently married a Laotian woman and remained in the East for twenty-five years. During that time he made four trips to Angkor and had a memorable experience on his first visit in 1911. Walking alone at the Bayon temple amidst the maze of coloured galleries and dark passages, he fell into a well:

I had some difficulty getting out, having hurt myself rather badly. I had sprained a hand and was bleeding profusely. At the far end of the

← 68 A detail of a face on a tower at Bayon temple (late twelfth – early thirteenth centuries. (See p. 179.)

tunnel-like passage, which went through the building from side to side,
I was lucky to find Mr. Commaille, supervisor of excavations. He
explained that the well I had fallen into was an old treasure chamber,
emptied long ago. I was very glad to meet a European. He helped me to
bandage my arms and I stayed with him a week. Mr. Commaille had
previously conducted archaeological research in Egypt, and he gave me
many interesting explanations of Angkor. He had published an excellent
book about Angkor and is very enthusiastic about these ruins. He
once said: "All the ruins of Egypt, the Pyramids included, could find
room on the space occupied by Angkor Wat alone," (Asmussen, *Lao*
Roots, pp. 103; 105).

Jean Commaille, the Frenchman who looked after Peter
Hauff, was appointed the first curator of Angkor in 1908.
While distributing the payroll to workers at the temples
he was murdered in 1916 and buried near the Bayon tem-
ple. A tombstone commemorates his contribution to the
preservation of Angkor (Plate 66, p.174).

The third and top level has a circular central sanctuary
with a lotus shaped pinnacle. The circular shape was rarely
used by the Khmers as an architectural form and adds to
the uniqueness of the Bayon. A maze of galleries, court-
yards and steps link the various levels. The overall appear-
ance of the interior is one of dim lighting, narrow walk-
ways, low ceilings and congested space.

The staring eyes

An extraordinary feature of the Bayon, and one that as-
tounds nearly all who see it, both past and present, is fifty-
four towers, each one in the form of four gigantic faces,
one in each cardinal direction (Plate 67, p. 175). It is
generally accepted that the faces on the towers symbolize
Jayavarman VII and signify his omnipresence. Regardless
of their symbolical meaning, the faces are an innovation
of architecture of the Bayon period and representative of
the total revamping of the capital carried out by the king
at the end of the twelfth century. 'They are an eternal
reminder that all things must pass away, but that nothing
wholly passes,' (Norden, *A Wanderer in Indo-China*, p. 286).
Read Loti's reaction when he saw the faces of the Bayon:
I raise my eyes to look at the towers which overhang me, drowned in

verdure, and I shudder suddenly with an indefinable fear as I perceive, falling upon me from above, a huge, fixed smile; and then another smile again, beyond, on another stretch of wall,...and then three, and then five, and then ten. They appear everywhere, and I realize that I have been overlooked from all sides by the faces of the quadrupled-visaged towers...They are of a size, these masks carved in the air, so far exceeding human proportions that it requires a moment or two fully to comprehend them (Loti, *Siam*, pp. 70-71).

Let's move closer and look at the features that reflect the subtle 'smile of Angkor', (Plate 69). Each face is distinguished by: a broad forehead, downcast eyes, wide nostrils, thick lips curling upwards at the corners and a hint of a moustache (Plate 68, p. 176). De Beerski philosophizes on their meaning:

No better mask can be put on to a face than that of a smile. Slightly curving lips, eyes placed in shadow by the lowered lips utter not a word and yet force you to guess much. Certain smiles can mean everything, but never say it frankly. Naturally I do not pretend that a child's smile, or even that of some men and women are not plain and hearty; but I am now thinking of the expression of some Mona Lisa or complicated offspring of civilisation and learning. Primitive and simple creatures cannot smile enigmatically; it is only those beings who knowing much and scorning more, hide their imparts great contempt, great scepticism, in many cases deep-rooted misanthropy, and all that is enforced in a smile.

Smile, and you will never be known...Smile, and you will keep to yourself the depth of your own self...Smile, and others shall have some dread of you, in their complete ignorance of your powers of love or hatred...Smile and be a microcosm of God; for what is God, but mystery.

God, mystery...parallel words, both carried to your heart by one glance cast at a single gigantic head. Godliness in the majesty and the size; mystery in the expression; both oozing like moisture from it. If you look at the idol attentively the arch of the lips will seem to become more accentuated and the dents at the corners of the eyes to deepen. The divine irony that is found in him for a moment rapidly changes into passion or forgetfulness as your own thoughts wander. He has power over all; no one can face him with indifference or, however cloyed, help being struck by some novel freshness and distant glow of spiritual existence.

One finds at one time that he has the disturbing sneer of sadism, at another the chilling disdain of overwhelming superiority, or else the annoying hypocrisy of absolute egotism. Always, however, pure goodness is non-existent, and one feels that his ideas can only range between controlled wildness and unlimited culture of evil (de Beerski, *Angkor, Ruins in Cambodia*, pp. 124-5).

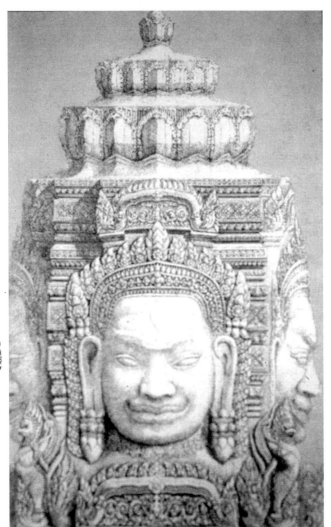

69 *A drawing of a face on a tower at Bayon temple (after Delaporte, 1880).*

Daily life revealed

The reliefs carved on the inner wall of the exterior and interior galleries of the Bayon are as distinctive as the towers with faces. The interior gallery depicts episodes from Hindu mythology whereas the exterior gallery enacts scenes of daily life such as markets, fishing,

festivals with cock fights and jugglers and historical scenes with processions and battles, the major one being between the Khmers and the Chams in 1177. The themes of these reliefs are a marked departure from any others carved on the temples of Angkor. They are more deeply carved than those at Angkor Wat and the stone is more porous, so the carving is not as crisp. Candee writes on the textural differences between the carvings at Angkor Wat and those at the Bayon:

Here the carvings stopped me wide-eyed, open-mouthed. Not like those of my first love, Angkor Vat; no, those are far more gracious and lovely, of more sophisticated art, but these hold one by their quality of directness. They do not lure by elegant suggestions of aristocracy among men and exclusiveness among gods, but by direct simplicity. They have homely human things to tell and they tell them without affectation (Candee, *Angkor The Magnificent*, p. 139).

And here is Gorer's view of the reliefs:

No part of the surface of the Bayon is bare of sculpture. Every stone is alive with dancing apsaras, offering flowers to the passers-by. And the covered galleries are tapestried with bas-reliefs, of indifferent artistic execution but of the greatest anecdotal interest. Both their workmanship and their interest ally them to similar Egyptian reliefs; they satisfy our curiosity but not our aesthetic senses. On the walls of the Bayon the sculptors have recorded, rather naively, the ordinary scenes of their epoch to portray the human head in profile and three-quarters face; but they have even less sense of proportion and perspective than the Egyptians, so that a man's head is as big as his trunk, and a fish in the sea bigger than a boat which should be above it, but which is actually below, so that the fish swims in the sky...

The Bayon sculptors have the advantage over the Egyptians of being able to portray the human head in profile and three-quarters face; but they have even less sense of proportion and perspective than the Egyptians, so that a man's head is as big as his trunk, and a fish in the sea bigger than a boat which should be above it, but which is actually below, so that the fish swims in the sky (Gorer, *Bali & Angkor*, pp. 198-9).

Greenbie imagines himself amongst the scenes on the reliefs at the Bayon:

The art of Angkor-Wat records the life of aristocracy; at the Bayon, it is the epitome of democracy. Here the life of the people is told in such full and complete detail that though not a word is found in writing to assist the archaeologist, even the untrained traveler can make out the story of happenings of a millennium ago. Here one may hunt with the huntsmen on elephants, breaking their way through the jungle like so many drills of living flesh, one may disport oneself with jolly women

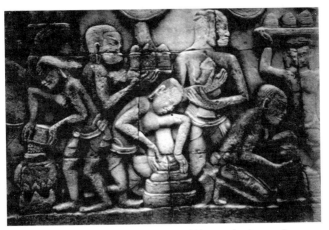

70 *Preparing a feast, Bayon, late twelfth – early thirteenth centuries.*

on the waterways, one feasts and dances with the kings and their courts, and fasts with the priests, plays with the boys on the stone flags of the pavements. The fears, the hopes, the achievements of the race were lift behind realistically in these carvings on the walls...(Greenbie, *The Romantic East*, p. 174).

For those interested in warfare methods and weapons used by the Khmers, de Beerski gives a detailed account of these aspects as revealed on the reliefs of the Bayon, which depict the intensive war between the Khmers and the neighbouring Chams from southern Vietnam in the late twelfth century (Plate 71).

The Bayon was built at a time when struggles never stopped, civil wars, conquest or defence against invading foes; the tread of armies continually shaking the foundations of the town...the triumphs of victorious generals or anxiety of departing forces continually making the public feeling waver from hope to despair, from glory to gloom. The blasts of trumpets, which disturbed the city eleven centuries ago, have an everlasting echo in the horns placed for all eternity on the lips of stone warriors. There were thousands of soldiers in Angkor-Thom; there are thousands at the present day, petrified in the huge fane. The first panels I came across dealt with combats, and many more as exciting in the tale they have to tell show the heroism of the formidable forces which kept under the yoke of their iron rule the vast plains encompassed by the mountains of Siam, China and Champa, and by the ocean.

I have already noted the soldiers, not very tall in stature, but broad-chested and muscular, with a very light sarong and ropes round their shoulders and over their breast. They have no headgear and

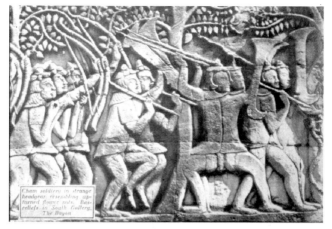

71 A scene carved on the wall of the outer gallery of reliefs at Bayon temple depicting a battle between the Khmers and the Chams from southern Vietnam (late twelfth – early thirteenth centuries) (Dickason, 1937).

their hair is cut short. Nearly always armed with lances or javelins they carry a long shield or else a small round one. The officers or lesser rank are either on foot or on horseback, and have as a weapon a sort of narrow hatchet fastened at the end of a bamboo handle and which the woodmen still use and call "phkeak." Generals and princes ride on elephants, on which are fastened embroidered cloths and rich howdahs. Mercenaries or vassal tribesmen were incorporated in the armies; they are distinguished by short bears, and some of them, at any rate, could be Chinamen with strange helmets, in layers and openwork.

War elephants had tiaras on their heads sometimes, or a cap in leather or other heavy material, in which two round holes were cut for the eyes. Horses were ridden without stirrups, and the saddle was a simple covering of wool or cotton. Standards and flags were very numerous and gorgeous, with dog-tooth edges, flaming pennants and complicated patterns; some consisted of a small figure of Garuda, Vishnu on Garuda, a dancer, or yet a monkey, probably in bronze. Stout nets fastened to long staffs were carried before important nobles to stop arrows, stones and such light missiles.

This was not all, and by the inventions contrived for the army one perceives how very important fighting was—how it called upon the country's men, resources and intelligence. Some of the massive elephants carried a pair of baskets, in which two archers were posted—sharp-shooters, no doubt, who from their elevated position could mark and slay commanders and nobles. Other elephants were loaded with heavy catapults, also worked by two men; similar instruments, exactly like enormous crossbows, were rolled on wheeled barrows and probably used in sieges or for the defense of fortified camps. Perhaps the most ingenious device was thus composed: a platform

*provided with a step was raised on strong wheels and concealed behind
an enormous shield, big enough to cover two warriors from head to
foot; these men stood on the platform, one foot on the step, ready to
spring up suddenly, throw their javelins and drop once more behind the
protective shield; their left hands were probably holding on to a bar of
metal, which steadied their balance on rough ground. A few of their
brothers-in-arms pushed the machine forward.*

*The splendid troops above described are very often found in fierce
battles, and the courage they display is only what might be expected.
In one case they are fighting rebels; the belligerents on either side
have the same facial type and the same uniform. In the end the
faithful soldiers bring back the heads of the revolted generals to an
important Brahmine, possibly the king's guru. But to judge the full
valour of the Khmers, as it is given us to understand by the Bayon's
bas-reliefs, one must see them pitted against their hereditary foes,
the Chams* (de Beerski, *Angkor, Ruins in Cambodia,* pp. 107-9).

The Apsaras dance

Pillars around the exterior gallery of the Bayon are carved
with endearing apsaras in pairs or threes. These sensuous
dancers are poised gracefully on a lotus pod with both legs
folded back in opposite directions, one arm extended up-
wards and the other tucked into the body (Plate 72).

Wheatcroft brings these celestial dancers to life better
than any other account I've read:

*On the lower levels of the Bayon is life of a very different kind, light-
heartedness pure and simple in the troupes of dancing Apsaras. On
every side of every square pillar on the ground floor of the temple are
three Apsaras dancing with the completeness of movement of a swim-
ming frog. Apsaras dancing round the windows of shrines and round
the shrines too. Their gaiety is infectious and takes no need of the
great faces. They might not even know they are there. With en-
chanting poses of fingers and toes, and a rhythm of movement that
brings music to the ear, they dance upon their lotus flowers. Their
dress is of jewels and crowns, and there is a suggestion of wings
about the lower parts of their bodies—wings not growing from the
shoulder blades, as we Westerners imagine them. With all their move-
ment, wonderful to relate, they almost always manage to keep their
crowns straight as they dance in bowers of branching arabesque!
Not all the ladies dance, some are motionless, standing quiet with
fascinating smile, doubtless waiting for their turn to dance. They are
worshipping figures too, and many others and everything except the
wonderful faces of the super-world is on quite a small scale*
(Wheatcroft, *Siam and Cambodia,* pp. 63-4).

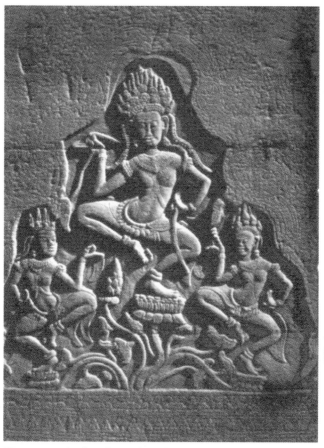

72 Apsaras ('celestial nymphs') dancing on lotus pods carved on a pillar at Bayon temple (late twelfth – early thirteenth centuries).

Recollections of Bayon

I close this chapter with several accounts of the effect the Bayon had on travellers. Although some are rather long, each one offers a perceptive view of what for many is the most spectacular temple of the Angkor group.

Loti recalls his experience at the Bayon when a fierce storm arose. The passage begins on a spooky note:

And then, suddenly, the rare birds that were singing become silent: and, suddenly, too, we are aware of a deeper obscurity. And yet the hour is not late. There must be something more than the thickness of the overhanging verdure to make the pathways seem so dark. A general drumming on the leaves announces the advent of a tropical

deluge. We had not seen that, above the trees, the sky had suddenly become black. The water streams, pours in torrents upon our heads. Quickly, let us take refuge over there, near to that large, contemplative Buddha, in the shelter of his roof of thatch.

The involuntary hospitality of the god lasts for a considerable time, and there is in it something inexpressibly mournful in the mystery of the forest twilight, at the fading of the day.

When, at length, the deluge abates, it is time to take our departure if we wish to avoid being overtaken by the night in the forest. But we have almost reached Bayon,...celebrated for its quadruple-visaged towers. Through the semi-obscurity of the forest trees we can see it from where we stand, looking like a chaotic heap of rocks. We decide to take the risk and go to see it.

Through an inextricable tangle of dripping brambles and creepers, we have to beat our way with sticks in order to reach the temple. The forest entwines it strictly on every side, chokes it, crushes it; and to complete the destruction, immense "fig-trees" are installed there everywhere, up to the very summit of its towers, which serve them as a kind of pedestal. Here are the doors; roots, like aged beards, drape them with a thousand fringes; at this hour when it is already growing late, in the obscurity which descends from the trees and the rain-charged sky, they are deep, dark holes, which give one *pause. From the first entrance that we reach, and were sitting in circle as if for some council, make their escape, without haste and without cry; it seems that in this place silence is imposed upon everything. We hear only the furtive sound of the water as it drips from the trees and stones after the storm.*

My Cambodian guide is insistent that we should depart. We have no lanterns, he tells me, on our carts, and it behoves us to return before the hour of the tiger. So be it, let us go. But we make up our mind to return, expressly to visit this temple so infinitely mysterious.

Before I leave, however, I raise my eyes to look at the towers which overhang me, drowned in verdure, and I shudder suddenly with an indefinable fear as I perceive, falling upon me from above, a huge, fixed smile; and then another smile again, beyond, on another stretch of wall,...and then three, and then five, and then ten. They appear everywhere, and I realise that I have been overlooked from all sides by the faces of the quadrupled-visaged towers. I had forgotten them, although I had been advised of their existence. They are of a size, these masks carved in the air, so far exceeding human proportions that it requires a moment or two fully to comprehend them. They smile under the great flat noses, and half close their eyelids, with an indescribable air of senile femininity, looking like aged dames discreetly sly. They are likenesses of the gods worshipped, in times, obliterated, by those men whose history is now unknown; likenesses from which, in the lapse of centuries, neither the slow travail of the forest nor the heavy dissolving rains have been able to remove the expression, *the ironical good humour, which is somehow more disquieting than the rictus of the monsters of China.*

Our oxen trot smartly on the return journey, as if they, too, realised that it was necessary to escape before nightfall from this soaked and steaming forest, which now becomes dark almost suddenly, without any interval of twilight. And the memory of those over-large old dames, who are smiling yonder behind us, secretive above the heaps of ruins, continues to pursue me throughout the course of our jolting, rocking flight through the bush (Loti, Siam, pp. 68-71).

This is Halliburton writing on the Bayon:

Of the remaining buildings the Temple of Bayon is in a class of interest by itself. Mutilated, overthrown, the lodgment for a forest of trees and vines, it is still the most original and fantastic temple in the world. Formerly it contained fifty-one towers, each faced near the top of all four sides, with a great carved countenance of Brahma eight feet high. Although many of the faces are lost, a number remain, and the sight of them, looking calmly out to the four quarters of heaven as passive as Sphinxes, is weird and wonderful. The cracks and yawns in the joints of the stones upon which they are carved give each of them a different and contorted expression, some wry, some smiling, some evil. Lianas have crept across the eye of one; lichens and moss have blinded another. They peered at me from the treetops; they pursued me with their scrutiny like a bad conscience, no matter where I tried to escape. Stamped with the wisdom of a thousand years, they seemed to read my puny soul and mock the awe of them that rested there.

Slowly and wonderingly I climbed about these fabulous ruins. The sun set beyond the western jungle-tops, and before I realized that day had gone twilight enveloped me. Every bird became hushed; the faintest breeze seemed to hold its breath. Not even a cricket broke the pall of silence that sank upon this mighty corpse. From the shadows, death and oblivion crept forth to seize the city from the retreating sunshine; ghosts drifted beside me as I moved and dreamed through the gathering darkness. Loneliness—loneliness—in all this stupendous graveyard of man and monument, I stood—the only living human being (Halliburton, The Royal To Romance, pp. 306-307).

And now an impression from Sitwell who writes an evocative account of the Bayon:

Many visitors will be watching at this time for the great ceremonial sortie from Angkor Vat of the bats inhabiting it, which, suddenly collecting each evening from every nook and roof and dome in the immense building, combine into a dark cloud of leathery wings and fly three times round the temple: but actually to stand here, on one of the upper terraces of the Bayon, and merely to observe the shifting lights and colours of the tropical sunset play among these turrets, affords a spectacle infinitely more interesting and remote from experience. With every modulation they reveal new faces, or change the features and expression of those at which you are looking. They attain, now, to a numerical and problematic beauty, like that of a recurring decimal, that has no end, but goes leaping away into infin-

ity, behind it trailing the indivisible progeny so soon to become itself. Never will you be able to penetrate beyond the barrier of repetition, a similarity that yet alters as you attempt to focus it. No longer architecture, this temple has become a vast, prophetic poem, a vision such as was granted to William Blake. From here nothing else exists, except in the sky, in which the evening star is now beginning to appear, and the moon, so clearly belonging to the same world as these crags: nothing else exists, even though the dying glory of the sun still rests upon the stones, throwing back its heat, and upon the jungle, whence come up to meet you on the scented evening air cries and chattering, and the sound of scuffling and branches crackling, which serve to emphasise the death and stillness, wherein only dreams can live, of this great building' (Sitwell, O., *Escape With Me!*, pp. 119-20).

Those who have seen the Bayon will see it again, perhaps in a different light, and those who have not seen it will have a better vision of its appearance through Maugham's words:

It surprised me because it had not the uniformity of the other temples I had seen. It consists of a multitude of towers one above the other, symmetrically arranged, and each tower is a four-faced, gigantic head of Siva the Destroyer. They stand in circles one within the other and the four faces of the god are surmounted by a decorated crown. In the middle is a great tower with face rising above face till the apex is reached. It is all battered by time and weather, creepers and parasitic shrubs grow all about, so that at a first glance you see only a shapeless mass and it is only when you look a little more closely that these silent, heavy, impassive faces loom out at you from the rugged stone. Then they are all round you. They face you, they are at your side, they are behind you, and you are watched by a thousand unseeing eyes. They seem to look at you from the remote distance of primeval time and all about you the jungle grows fiercely. You cannot wonder that the peasants when they pass should break into loud song in order to frighten away the spirits; for towards evening the silence is unearthly and the effect of all those serene and yet malevolent faces is eerie. When the night falls the faces sink away into the stones and you have nothing but a strange, shrouded collection of oddly shaped turrets (Maugham, *The Gentleman in the Parlour*, p. 224).

The Bayon is the whole Cambodian nation turned to stone; from the summit of the central tower to the level of the ground all the qualities and vices, all the greatness and baseness which distinguished that race are disclosed (de Beerski, *Angkor, Ruins in Cambodia*, p. 128).

CHAPTER 8

BEYOND THE GATES OF THE ROYAL CITY

If the dead city [Angkor Thom] contains numerous beauties, all the wilderness outside its walls owns as many treasures...even more. As soon as Angkor-Thom is left behind, in every direction, along tracks clear or hardly traced, some stellas, fallen stones and buildings prove that the Khmers not only toiled in the capital, but surrounded it with structures sometimes rivalling or surpassing the Bayon in size and majesty (de Beerski, *Angkor, Ruins in Cambodia*, p. 178).

Angkor Vat, the finest effort of this lost civilization, has been pictured so often in Occidental magazines that it is generally believed to be the only work of the Khmers still existing. As a matter of fact it is only one temple in an uncountable group (Casey, *Four Faces of Siva*, p. 64).

After Angkor Wat one might go away expecting nothing more. But the wonders of Angkor are only at their beginning (Sitwell, S., *The Red Chapels of Banteai Srei*, p. 53).

Remains of Jayavarman VII's extensive building campaign outside the gates of the royal city (Plate 73) are particularly visible in the north and include two large monastic complexes, Ta Prohm built in honour of his mother and Preah Khan, dedicated to his father.

But when I came riding in a circus chair to Angkor, only such temples as Prah Khan, Ta Prohm and Ta Som gave any idea of what the city must have resembled on its rediscovery. Nothing could better express forgotten civilization or a palace of sleeping beauty than the conflict of trees and masonry visible in these temples (Parsons, *Vagabondage*, p. 147).

Preah Khan

Preah Khan, the Beguiler, the Romancer, and theaterist...it is an entrancing mystery deep in the jungle, soft and alluring in the twilight made by heavy verdure, accessible only to the ardent lover of past days who is gifted with agility...They may have been courtyards where high priests gathered and guardians slept, but they are not walled bowers over which the trees extend to heaven's blue...It all seems a wondrous mass of beauty tossed together in superb confusion (Candee, *Angkor The Magnificent*, pp. 274-81).

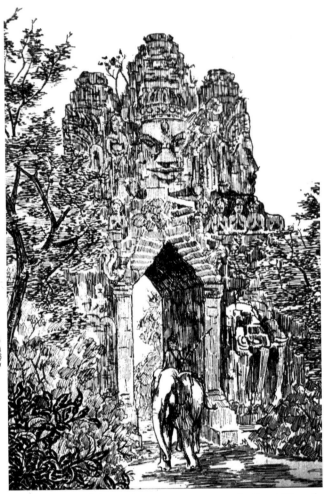

73 A drawing of the northern entrance gate to the Royal City of Angkor Thom (late twelfth – early thirteen centuries) (de Beerski, 1923).

Although Ponder visited many temples at Angkor his thoughts returned again and again to Preah Khan. 'My mind would not leave the Prah Khan. It was as if I had seen a very lovely woman and all paled before her' (Ponder, In Asia's Arms, pp. 48-9).

Preah Khan ('the sacred sword') was a Mahayana Buddhist complex built by Jayavarman VII in the late twelfth century in honour of his father. The temple served as both

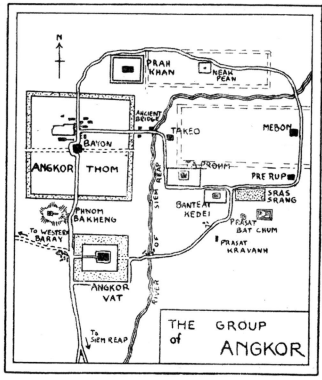

Map 7 The group of Angkor, (de Beerski, 1923).

a monastery and a teaching centre. The Preah Khan group included the North Baray (a large reservoir that is now dry) and two smaller temples, Neak Pean and Ta Som. The name of the temple means 'sacred sword', a weapon with a long history in Khmer tradition, dating at least to the late ninth century, when Jayavarman II left his successor a sacred sword, the 'Preah Khan'. Jayavarman VII probably used Preah Khan as a temporary residence during the time he was rebuilding the capital after it was sacked in 1177 by the Chams.

Jayavarman VII built Preah Khan as a Mahayana Buddhist temple but his successors added shrines dedicated to Hindu deities so, today, alongside its Buddhist foundations, you see peripheral Hindu structures, those dedicated to the Hindu god Vishnu in the west and to Shiva in the north. *The Pra Khan of Angkor is a ruin so extensive, so desolate, that it*

seems to be the product of high explosive rather than ambitious ver-
dure; but a ruin whose beauty, triumphant over chaos, has led sci-
ence to attempt here a work of restoration (Casey, *Four Faces of*
Siva, p. 167).

When Casey saw Preah Khan he wrote: 'One cannot see
the builders in what is left of Pra Khan, but only the de-
stroyers, grim, relentless, and terribly efficient,' (Casey, *Four*
Faces of Siva, p. 171). Today the World Monuments Fund
(WMF), which manages the Preah Khan Conservation
Project, is changing the image and is restoring the temple
'as a partial ruin'. One side has been cleared and structures
propped to make it accessible and safe for visitors, whereas
the other side has been left in a state of ruin. The decision
by the WMF to restore only half of the complex allows for
an interesting comparison by the visitor today. On one
hand, you see the temple with stones collapsed and sur-
rounded by jungle; on the other hand, cleared galleries
and open walkways give a sense of what Preah Khan prob-
ably looked like when it was an active, living monastic
complex.

A moat and four enclosing walls surround the vast com-
plex, which comprises 140 acres (56.7 hectares). The in-
terior included the living quarters of the monks and those
who served the temple, and a labyrinth of shrines, pavil-
ions, halls and chapels.

It is probable that had we known the feats of strength necessary for
viewing this tumbled mass, we would have prepared for it by three
months or more of physical training. Prah Khan is not revealed to
the lazy... (Candee, *Angkor The Magnificent*, pp. 236-7).

A grand processional way at the east (also one at the west)
flanked on the left and right sides by a row of stone lan-
terns signals the importance of the temple. Each lantern
is a vertical pedestal supported by a mythical monster with
upraised arms; a niche above bordered by a flame motif
originally contained an image of the Buddha seated in
meditation. Many of the images of the Buddha were deci-
mated and others adjusted to represent praying ascetics in
the late thirteenth century when Hinduism replaced
Mahayana Buddhism.

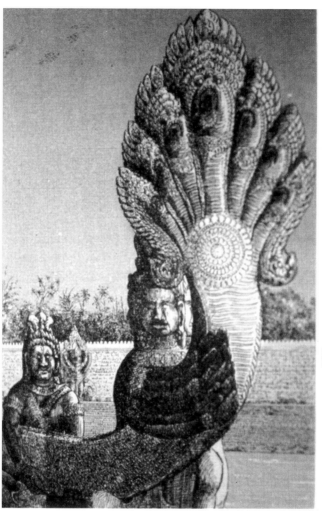

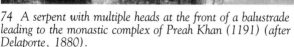

74 A serpent with multiple heads at the front of a balustrade leading to the monastic complex of Preah Khan (1191) (after Delaporte, 1880).

The processional way leads to a causeway, paved in stone, that spans a moat. A row of gigantic images – gods on the left and demons on the right – holding the body of a huge, scaly serpent or *naga* flanks the causeway (Plate 74). This composition is the same as that found at the entrances to the royal city of Angkor Thom. In front of you is the main entrance to the temple, marked by a large central tower with huge guardian figures on each side, four smaller en-

trances to the left and right and an expansive raised terrace.

The terrace of the principal entrance of Prah Khan is more like one's forgotten childish dreams of the doorway to a Magician's palace than anything that the mature Western imagination could possibly conceive. It was only a race that had learned a superb architectural technique without forgetting how to believe in fairies, that could ever have achieved such a combination as this majestic portico, with its dark, imposing galleries, and the terrifying stone giants, so startlingly lifelike, that stand on guard at each side, looking as though they had marched straight out of a tale by Hans Andersen (Ponder, *Cambodian Glory,* p. 312).

You are now at the enclosing wall to the Preah Khan complex and standing in front of one of the temple's outstanding artistic features, a giant sandstone image of a garuda holding the body of a *naga*. This mythical beast, the mount of the Hindu god Vishnu, has the torso of a human and the wings, claws and beak of an eagle and stands mightily in a frontal position with arms upstretched supporting the wall enclosing the most sacred part of the temple. Spectacular images of a garuda in grey sandstone, spaced some thirty-five metres apart, adorn all four sides of the enclosing wall formed from reddish-coloured laterite, providing a dramatic background and colour contrast for the garudas. The World Monuments Fund has declared the garuda their symbol of Preah Khan. De Beerski expounds on the garuda:

In his heavy shape we must not look for lightness only and delicacy; he is not the air of poets—transparent, languid, meek and delicate— no, his is the strength of the great element, marvellous, but not always innocent. He possesses the head of vultures, with the eyes reputed to be the acutest in nature, and with the power of smell which is able to notice, in spite of wide distances, the odour of carrion; he has also wings of the same rapacious bird of prey unmatched by any others; in the lofty regions of the clouds he glides, and remains suspended to the stars by a thin thread, which allows him never to tire, to reign where all is vapour, and trace vast circles in emptiness. His arms and hands are those of men—the most useful implements we possess, for few things are more ionderful in nature than the palm and the five fingers attached to it, which strike or hold, caress or strangle, create music on instruments, and fashion thoughts or, at least, lastingly inscribe them; and they are shown there to personify the power of air to strike or caress, to sing or murmur, to hold or to liberate. Finally his body and legs are those of tigers: suppleness incarnate, grace in flesh, and crushing power turned

into limbs, abdomen and breast. They are the velocity of the wind, the sudden leap of storms and the grace of clouds (de Beerski, *Angkor, Ruins in Cambodia*, pp. 145-6).

The Hall of Dancers is a vaulted, airy space near the east entrance and preceding the central sanctuary. Its majestic beauty and graceful cross-shaped form give the Hall of Dancers an elegant appearance. Expansive lintels exquisitely carved with a row of *apsaras* dancing rhythmically give their name to this hall. The location and plan of the terrace suggest it may have been a sacred space where offerings were made to the king. Today, with the revival of the Khmer Royal Ballet dance troupe, performances take place in this hall on special occasions (Plate 76, p. 201). I hope you are lucky enough to be there when this beautiful spectacle happens and then, for a few minutes, you can sense the beauty and majesty of Preah Khan and the glory of Angkor in the late twelfth century.

Today the environment at Preah Khan is not one of intense activity as when the temple was a religious centre of monastic learning in the late twelfth century. It is tranquil and you see trees, wildly untamed and free in all directions. The World Monuments Fund is dedicated to preserving a serene environment and is developing nature walks and paths through the jungle connecting the main temple with the smaller ones. Bleakley appreciated the beauty of the jungle at Preah Khan in 1928:

Prah-Khan, a stupendous mass of stonework…It is a beautiful ruin, rendered more beautiful by its environment…The soft light that flickers through the trees casts green and golden shadows upon the grey stones. Moss and lichen and flowery creepers have spread their many-coloured embroideries over the carved lintels and graceful archways. Leafy bushes nod and rustle from the crevices of tall towers. All around there is the solitude of the primeval jungle (Bleakley, *Tour in Southeast Asia*, pp. 75-6).

Candee found the temple pleasantly tranquil and discovered 'delicious spots in which to stay still at Preah Khan'. And here is de Beerski's description of Preah Khan:

The vegetation has imprisoned the temple with indescribable violence [Plate 77, p. 202]. The most monstrous of all its agents are the gigantic fici of soft wood, with whitish slender trunks, only divided into branches at a great height. Their roots are so broad and so

strong that, when the wind destroys one of them, it does not uproot it, but breaks it in half. The roots of the ficus are unquestionably the most grasping of all plants; they cannot be torn away, even the smallest; they have become a part of the stone; indeed they cannot resist knives, but pull, pull as much as you can, as long as you may, and the plants baffle you, and the inequalities of their bark open and laugh at your presumption. With writhing, tortuous, tenacious tentacles they clasp the achievements of men like octopuses their victims. The roots have an appearance which is almost muscular; their bends look like elbows and their ends like finger-tips; moreover they seem to feel their way and to move. They have a surprising manner of pressing themselves into the slightest fissure, of crawling beneath monoliths, and the havoc they have made is not to be reckoned. One comes to believe that their doings are guided by a brain, that their growth is commanded by a spirit. They have dislodged entire roofs; they have disaggregated entire shrines; they have poured down like streams of water; they have carried away numberless stones; they have caused whole towers to tumble. There are hecatombs of crushed erections leaning almost to the top of remaining turrets. The hand of ruthless man was no doubt very guilty, but that of nature beyond expression. Like a fury rejoicing in its conquest, in the kill, nature has closed its fist over the temple and squeezes, squeezes, squeezes, pitilessly and for evermore. It will not rest, one feels, until no stone shall stand. The fici, crowded together, struggle over the prey; their roots are mixed up, coiled, entangled like a brood of snakes on a half-strangled beast, breathing with difficulty. Prah Khan tries to defend its remaining parts; the sanctuaries, galleries and chambers in serried ranks attempt to frustrate the common foe, but they are no match, alas! for tropical flora, and plants, big and small, swarm over what is already a corpse. Humus has settled all round, and creepers have woven their tapestry. Dark ivy decks sandstone, laterite and trunks without discrimination; vines tie tendrils in every noon; ferns, in broad bunches, emplume a withered tree or a pedestal. Lianas balance in swooping garlands or hand loosely like the long and thin tresses of dryads. The monuments are pierced with wide gaps, besetting in their look of dismay; the sandstone is worn away by humidity, gnawed in slabs; the laterite, ruddy or black, is spongious and a world of tiny cells; mosses and lichens and mildew flourish abundantly and dazzle by the patterns they display, patterns which give to every chapel the vagueness and softness of pointilliste paintings.

Well, nature has been frightfully harmful; yet may we complain?...With inimitable perfection it has preserved the atmosphere of the temple and adapted its forms to it. The tall trees are full of majesty; the undergrowth has the mystery of sculptured detail. Pictures, masterly in composition and colour, charm the eye at every step: a portico in the midst of banyans; a gate opening on to a nest of verdure; a colonnade which has become a shrubbery, windows through which appear boughs of tender green; a cornice crowning

thick bushes, or, on the contrary, walls with a coping of new grass. Besides, the undefinable intricacy of the foliage is a glorious wreath of eternal freshness laid on the relics of an art, on the tomb of a nation…Wherever a stone has fallen, O infinite poesy, a flower grows! And, as if it wishes to intensify the beauty of the scene, the sun, like Jupiter when he visited Danaë in her brazen jaul, reveals his wealth in a shower of gold (de Beerski, *Angkor, Ruins in Cambodia*, pp. 223-5).

Reading Hervey's account of his visit to Preah Khan in the late 1920s, you can almost feel his perspiration, the dampness of his clothes and see the stinging in his eyes:

We had entered into a kingdom of twilight, a dank green twilight like the aqueous dusk close to the surface of the ocean, and the hush was vocal. The hot air seemed to rush out and inundate me. My lungs labored for breath. Strange rustles sounded a warning in the growths that sprang up breast-high on either side, and the stridulations of insects seemed to italcize the hidden menace. Deeper we went, crashing through limbs and grasping tendrils. I felt a sense of utter terror. I was drenched with perspiration; it stung the corners of my eyes and ran over my mouth. The smells of mossy stone, of wet earth, of decaying roots and innumerable varieties of fungi made the air close in with the effect of a palpitating thing that left a warm mucus over my lungs.

In the gauzy apparition of the forest appeared a wall and shattered pillars, all struggling out of verdant disorder. Dominating this ruin, their roots and limbs ghostly pale, were monstrous trees that seemed to dissolve overhead in that eternal green twilight. Some of the limbs were thrust cruelly into the walls; some of the roots sprayed out and imprisoned the pillars, looping down and slithering off into the gloom, as if to consort with other spectral, destroying things. In places, entire trees had broken through the crumbling ramparts or had seized upon some spot in the wall and shot up in vicious triumph. Ferns and plants with long tapering leaves took life in cornices and on the sills of empty windows. The moss was relentless in its desire to possess every inch of bare stone. Even the vines, generally so tender, seemed full of lust….

As we drew nearer the temple I could see the walls were extravagantly chiseled in lacelike designs, among which were figures of the Apsarases, or sacred courtezans, their carved bodies indistinct and smooth, like coins whose effigies are effaced. Kim Khouan moved ahead, stepping from rotted tree-trunk to crumbling pilaster, and climbing over the fallen walls. In the close hush our breathing was like scraping on dead husks. Dampness in the face, in the nostrils; the cling of sweaty clothes. And all about us that awesome tangle, into which rays of sunlight plunged, searching out the crawling green lava of ferruginous roots and giving livid emphasis to the piles of rock that lay dark-stained as with verdigris.

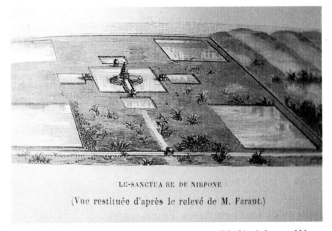

LE-SANCTUA RE DE NIRPONE

(Vue restituée d'après le relevé de M. Faraut.)

Map 8 A plan of Neak Pean temple (second half of the twelfth century) (after Delaporte, 1880).

The ruins seemed to stretch on interminably, like a vast drowned city. Its desolation was incredible. I remember the tragedy of broken columns in window-frames half crushed; battered-in parapets that lay beneath snarling roots; courtyards seeming sunk in fountains of plants; mold-green passages and chambers, dreadful as a subterranean prison; and over all, the dripping tallow of vines that melted down into dank twilight. In places, great trees lay felled in an agony of green, pressing deeper into the earth the stones that had fallen beneath them. Tower and rampart, gallery and colonnade, all lay in mute bondage—a terrible memorial to Angkor and its agonized surrender to the forest.

It is a ghastly punishment, the vengeance of the jungle (Hervey, King Cobra, pp. 79-81).

Neak Pean

Like a rich mirror, coloured by the stones, the gold and the garlands. This pool, of which the water is lit by the light of the golden prasat coloured by the red of the lotuses, shimmers in evoking the image of the sea of blood spilled by the Bhargara: on the interior there was an island taking its charm from the ponds which surround it, cleaning the mud of sin of those who came in contact with it, and serving as a boat to cross the ocean of existence (in Glaize, Les Monuments du Groupe d'Angkor, p. 212).

The small and unusual temple of Neak Pean (the 'coiled serpents') is located in the center of the baray that forms the group including the temples of Ta Som and Preah

199

75 *An image of a horse with humans clinging to its sides who were rescued from a shipwreck at Neak Pean temple (second half of the twelfth century) (Claeys, J.Y., Angkor, 1948).*

Khan. Originally, Neak Pean was only accessible by boat. It is set in a large, square, man-made pond bordered by steps and surrounded by four smaller square ponds (Map 8). A small circular island, with a stepped base of seven laterite tiers, is in the centre of the large pond, and forms the base for the shrine dedicated to Avalokiteshvara, a

bodhisattva of Mahayana Buddhism. The bodies of two serpents encircle the base of the island and their tails entwine on the west side. It is this configuration that gave the name of 'coiled serpents' to the temple. The heads of the serpents are separated to allow passage on the east. A blooming lotus surrounds the top of the platform, while lotus petals decorate the base.

A sculpted horse swimming towards the east with figures clinging to its sides dominates the central pond (Plate 75). The horse, Balaha, is a manifestation of the bodhisattva Avalokiteshvara, who postponed his own entrance to enlightenment and returned to earth to help mankind, this time in the form of a horse to rescue Simhala, a merchant, and his companions. Their ship sank on an island off Sri Lanka and female ogresses snatched them. The victims are holding on to the horse's tail in the hope of being carried ashore safely.

Four small chambers with vaulted roofs, one in each cardinal direction, back onto the main pond, then open onto four small ponds with steps leading to the water. The interior of the vault is decorated with panels of lotus and a central waterspout in the form of an animal or human in the centre. The four buildings served a ceremonial function, where pilgrims could absolve themselves of their sins. They anointed themselves with lustral water, which flowed from the spout connected to the central pond. Each water spout is different – an elephant head, a human head, a lion, and a horse. Alluding to the fine quality of workmanship on the human head, French archaeologists called it the 'Lord of Men'. When the ponds were filled with water Neak Pean 'must have seemed like a vast and beautiful fountain' (Casey, *Four Faces of Siva*, p. 171).

This small temple, unlike anything else at Angkor, obviously impressed early travellers because their accounts of it are extensive and bordering on the poetic. First, we hear from Candee, writing in 1925:

Neak Pean—the last word being pronounced 'Ponn', and the whole name signifies curved Nagas. Neak Pean is one of the temples that makes one dream of the olden days of luxury and beauty. It was

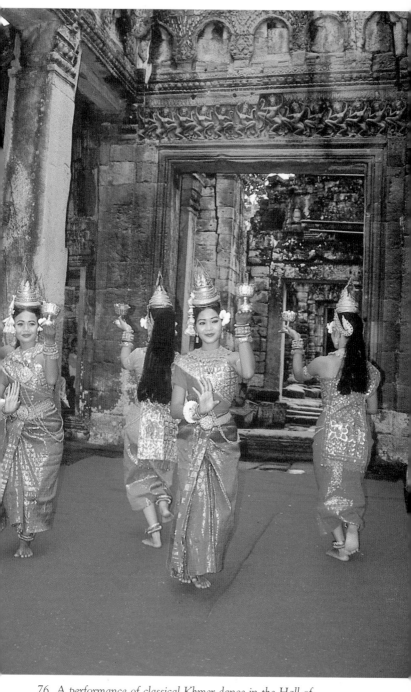

76 A performance of classical Khmer dance in the Hall of
Dancers at Preah Khan temple (1191). (See p. 194.)

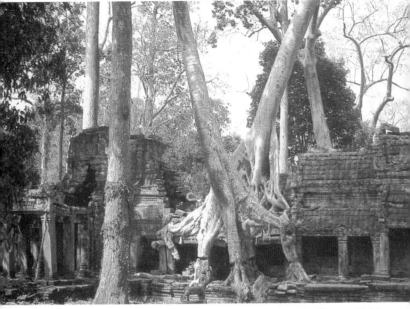

77 *The eastern entrance to Preah Khan temple (1191).* (See p. 195.)

78 *Srah Srang.* (See p. 207.)

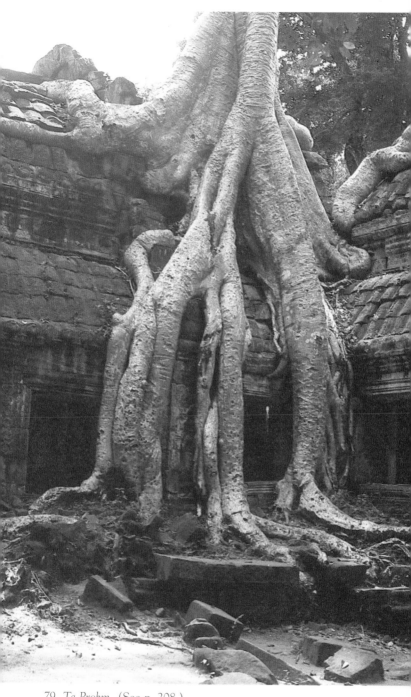

79 *Ta Prohm*. (See p. 208.)

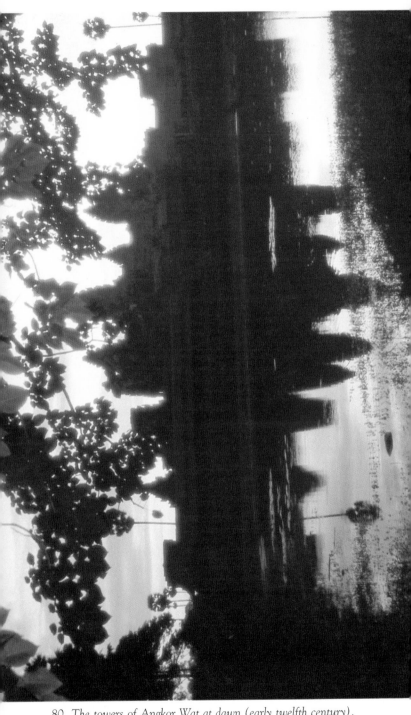

80 *The towers of Angkor Wat at dawn (early twelfth century).*
(See p. 215.)

worth while to live then and to be a woman among a race which has ever adored its women. It is to the overpowering temples of Civa that men and armies repaired; but it was at the tiny temple of Neak Pean that eager princesses laid their lovely offerings of wrought gold and pungent perfumes…Fancy it as it was in the old days. To begin with there was the artificial lake, a wide extent of water in the shallows of which floated the flowering lotus. In its exact centre—the surveyors of Angkor were expert—stood the exquisite miniature temple of one small chamber, the sanctuary, a temple as finely ornate and as well-proportioned as an alabaster vase. With art delicious this wonder was made to appear like a vision in the land of faerie. It floated upon a full-opened flower of the lotus, the petal tips curling back to touch the water. On the corolla of the flower, curved around the temple's base, were two Nagas whose tails were twisted together at the back and who raised their fan of heads on either side of the steps in front which mounted to the sanctuary. Thus they guarded the gem and gave gracious welcome to whosoever directed her light barque to draw close to this lovely heaven…On this circular pedestal of poetic imagination rested a square temple with four carved doors, one open occupying all the façade except for the square columns which flank it. Above rose the tower with pointed over-door groups of carvings, symbolic, graceful, inspiring. Each closed door bore the figure of the humane god Vishnu standing at full height, but lest he impress too strongly his grandeur in this dainty spot, the space about him is filled with minor carvings which vary on each door.

Within this lovely casket was a seated stone figure. The door was ever open, suppliants might at any time lay before Buddha their offerings and their prayers.

The chamber was too small to admit them and they stood without in a bending group, swaying toward the Naga-heads for support or salamming gracious salutations to the god of peaceful meditation. The golden boat floating beside the approach again…Rowers moved the shallop so slowly that the Naga-prow seemed to progress of its own volition. And so, the gods appeased, the spirits rose, and soft music spread over the waters in which the rich notes of male voices blended, and life went happily in the lovely twilight hour.

…Neak Pean stands hidden, but it stands in greater perfection than if it had not had the enveloping roots of the ficus to hold its stones from falling apart (Candee, *Angkor The Magnificent*, pp. 281-6).

The enormous ficus tree referred to by Candee once engulfed the shrine on the central island like a blanket and spread its branches so broadly that it shaded the entire island (Plate 81).

Brodrick thought that the small, unusual temple of Neak Pean was used for cleansing the soul:

Neak-Pean resembles nothing so much as one of the artificial lakes

81 *The central island of Neak Pean temple with a tree engulfing the sandstone tower (Dickason, 1937).*

of a French palace. The Khmer site reminds you at once of Versailles and of Fontainebleau. There is the same rich but not obtrusive wood fringing the lake. The whole thing is perfect in proprtion and the man-made stonework seems a natural part of the landscape, which lends itself admirably to enhance the beauty and pleasure of the 'Intertwined Serpents.' For all we can see this great basin was a holy well, perhaps even a miraculous well like that of St. Winifred in North Wales where 'Baron Corvo' fell so foul of the Catholic incumbent Father Beauclerk. In any case, Neak-Pean was doubtless the scene of water-rituals, and the layout of the lake indicates that it was intended as a copy of the Sacred Lake Anavatapta, fabled to lie in inaccessible recesses of the Himalayas and from whose waters four mighty rivers take their source. So, probably, at Neak-Pean men washed themselves and rid themselves of their ills, both of the body and of the soul while the Divine Pity of Avalokiteçvara, the deity of Boundless Light, was spread upon the worshippers.

The oval basin is bounded by a laterite wall and its waters at each of the cardinal points slip through great stone faces into rivulets carrying off the overflow while at each of the sluices rises a stone pavilion. These little structures command smaller, secondary basins fed through the stone faces, the first of a horse, the second of an elephant, the third of a lion and the fourth of a man whose great, grave spewing countenance shows an arching mouth, the Khmer smile rounded to a Khmer shout...splendid.

Neak-Pean appears to have been dedicated to Avalokiteçvara or Lokeçvara in his avatar, or incarnation, as Balaha, the Saviour-Horse, who, legend has it, rose from the waters before the steps of the little shrine on the central islet of the basin. This islet bore, until 1935, its tempietto strangled and embraced by a gigantic fromager (fig tree) whose saw-like, ridged, grey roots almost hid the sculpture of the sanctuary and of its pedestal adorned with lotus flowers and

the two intertwined snakes (giving their name to the place) whose heads rise on the eastern side.

But this tree lent the whole islet and lake so singular a charm that when a great storm stripped and split the tree, there was a general cry of dismay that one of the most evocatory and romantic of the Khmer monuments was maimed and made commonplace. However, in 1938, M. Glaize, the conservator of Angkor, decided to remove the remains of the fromager and to reconstruct the graceful, little sandstone shrine. Unfortunately, the basins fill up only during the rainy season, so then, when it is least convenient for the traveller to visit the place, then only, can you enjoy the full pleasure and edification of Neak-Pean (Brodrick, *Little Vehicle*, pp. 183-4).

Banteay Kdei

In the ruin and confusion of Banteai Kedei the carvings take one's interest. They are piquant, exquisite, not too frequent…they seem meant…to make adorable a human habitation (Candee, *Angkor The Magnificent*, pp. 249-50).

Across the road from the royal bathing place of Srah Srang, is the Buddhist temple of Banteay Kdei ('citadel of the cells'), another of Jayavarman VII's temples built in the late twelfth century. Originally, a gallery, a passageway and a moat surrounded a central sanctuary. An outer enclosing wall is bisected with towers comprised of gigantic faces, such as those as Angkor Thom.

Today, Banteay Kdei's poor state obscures the original layout but it offers pleasant, quiet surroundings for strolling and looking at the remains of carvings and reliefs of the period. Balfour saw parallels in the architecture and decorations of Banteay Kedei with Roman churches:

It is a relief to pass into the courts of the Banteai Kedei, with its corridors and vistas of square doorways still intact. There is a strong suggestion of Roman influence here as in all the Angkor buildings, in general conception, in the formalized, scrollwork carving of plinths and lintels, and in the pilasters of the square windows. It is curious to find sometimes the figure of a Buddha as the central figure of a decorative motif entirely classical in its effect. There must certainly have been commercial contact between East and West in the time of the Roman Empire, and this would bring with it artistic influence. The Romans had silk but no silkworms, and we may assume that they imported it from the East. What more natural, then, that some of the architectural inspiration of their Great Empire should filter through to inspire afresh the Khmers? (Balfour, *Grand Tour*, pp. 305-6).

Srah Srang (See Plate 78, p. 202.)

It was perhaps a chapel to Kama, God of Love. The spot would suit the temper of the strange power, terribly strong and yet terribly tender, of that passion which carries away kingdoms, empires, whole worlds, and inhabits also the humblest dwellings. Yes, it might be a fit abode for the human and superhuman feeling, impersonified in Eros, in Cupid, under a thousand names, but which keeps everywhere the same conformation and creates the same acts. Love could occupy this quiet nest embedded in water, whence he could fly at will over the earth and burn hearts and scorch men and women, freeze hatred, and also cause thoughts to rise high, to soar far to ask from the unknown the strength needed to adore God more than flesh. There is some inexplicable sensation that Kama rested there for some time after his travels-without-end. Is it the soft hues of water under a pitiless sky? Is it the perfect freedom from agitation, unforeseen amidst the thriving life of the jungle? Is it because one feels love to be a rest, a change from our clanging hubhub? And is it because this place has an inner appeal for tranquillity, doubly effective after all the disturbance experienced among the coolies?...At any rate, I recall on the sand, damped by murmuring ripples, many nooks in different countries I have seen, which gave me the same impression that love had come one day and had left there, when he went away, a part of his spirit; as if, in truth, that weird lust, neither a virtue nor a vice, for it kills as much as it generates, owns snug retreats in all lands, where it stops, where it roosts in the fashion of a migratory bird, volatile like it (de Beerski, *Angkor, Ruins in Cambodia*, pp. 189-90).

Srah Srang is a large man-made lake (700 by 300 metres; 2,984 by 984 feet) with an elegant landing terrace and stairs leading to the lake surrounded by greenery that 'offers at the last rays of the day one of the most beautiful points to view the Park of Angkor.' The stairs of Srah Srang are where the French archaeologists gathered at dusk, relaxing and talking about the day's work. The platform is of cruciform shape with serpent balustrades flanked by two lions. At the front there is an enormous garuda riding a three-headed serpent. At the back there is a mythical creature comprising a three-headed serpent, the lower portion of a garuda and a stylised tail decorated with small serpent heads. The body of the serpent rests on a dais supported by mythical monsters. Lewis also saw the lake at the end of the day:

My last daylight hours at Angkor were spent by the lake of Srah Srang. The Khmers were always digging out huge artificial lakes,

which, if the preliminary surveying had been correctly carried out, the temples and statues were erected according to accepted precedents round their margins or on a centre island, could always be declared to possess purificatory qualities. For this reason Srah Srang was supposed to have been a favourite royal bathing place, with its grand approach, its majestic flight of steps, flanked with mythical animals, and its golden barges (Lewis, A Dragon Apparent, p. 232).

Ta Prohm (See Plate 79, p. 203.)

The most beautiful spot in all the region of Angkor, Ta Prohm ("the Ancient Brahma"), legendary treasure-house of the Khmers and undisputed capital of the Kingdom of the Trees….Ta Prohm in the ensemble…must appear to be the abandoned toy of giants who tossed it here from an unbelievable height…Ta Prohm is beautiful in the chaotic melange of its trees and in the isolated glimpses of desolated gods who peer out of its walls through the infrequent clearings…The fromagers that are bringing Ta Prohm to its ignominious end are at present one of the chief agents in holding its walls and arches together (Casey, Four Faces of Siva, pp. 174-6).

'Grimm, or Hans Andersen, or any man who ever dreamed up legends never outdreamed this' (Elvin, *Avenue to the Door of the Dead*, p. 277). Ta Prohm has not been restored by archaeologists. Only paths were cleared for visitors and parts were strengthened structurally to stave off further deterioration. Its natural state allows visitors to experience a sense of the wonder of the explorers, when they came upon this monument in the late nineteenth century. Members of the Mekong Exploration Commission who visited Ta Prohm with Commander Delaporte in 1866 even mistook the huge tree roots for prodigious serpents. Shrouded in jungle, the temple of Ta Prohm is ethereal and conjures up a sense of romance and adventure. Trunks of trees twist amongst stone pillars. Fig, banyan and *kapok* trees spread their gigantic roots over, under and in between the stones, probing walls and terraces apart, as their branches and leaves intertwine to form a roof above the structures (Plate 82).

Imagine de Beerski sitting in a secluded corner at Ta Prohm writing this flowery prose:

Come back old days!, come back, old thoughts, to fill a new mind; come back! Charm my dreams and make everything live again. In this haven of romance fact is absent; then let imagination arrive and

beautify my soul by taking out of it some of the gloom my modern education has put there. Render me care-free, heedless, even reck-less, and place within my reach the nobility of ancient times.

So far modernity, speed, science have confined me in material-ism, and if I have wandered to such distant lands it is to forget…Help me, you jungle and you ruins! Make me forget!

And never, never is the call left unanswered, if only the heart is its source. It has oft been quoted that stones would have many won-drous stories to tell if they could but speak, and leaves and beasts if they could but whisper in the fashion of man (I, for one, have said it); but they do speak, they do sing, they do recite marvellous po-ems, and we can hear them if we wish (de Beerski, Angkor, *Ruins in Cambodia*, p. 152).

The impressive monastic complex of Ta Prohm was built in honour of Jayavarman's VII mother. According to an inscription found *in situ*:

Ta Prohm owned 3,140 villages; it took 79,365 people to maintain the temple, including 18 high priests, 2,740 officials, 2,202 assist-ants and 615 dancers. Among the property belonging to the temple was a set of golden dishes weighing more than 1,100 pounds (500 kilograms), 35 diamonds, 40,620 pearls, 4,540 precious stones, an enormous golden bowl, 876 veils from China, 512 silk beds and 523 parasols…(Cœdès, Angkor, *An Introduction*, p. 96).

A series of long, low buildings connected by passages and concentric galleries frame the main sanctuary of Ta Prohm, all on one level. A rectangular wall encloses the entire complex. The layout still seems haphazard today and some areas of the temple are impassable because it is essentially in a state of ruin. Much of the temple's fascination for the visitor, of course, lies in this disarray. The sumptuousness of Ta Prohm is its unique and acquired relationship with nature. Although parts of chambers, doorways, galleries, and enclosing walls define its parameters, Ta Prohm is mostly fallen stones, blocked passages, obscured carvings. The roots of a giant tree cascade over the roof of a gallery with such weight and intensity that the wall supporting the roof has collapsed. Across the courtyard the roots of another tree have spread with enough force to pry apart the sandstone blocks of the wall. But instead of destroying the wall, the roots add support and give stability. And so nature and man feed on one another. In a strange way they have become friends, supporting, protecting each

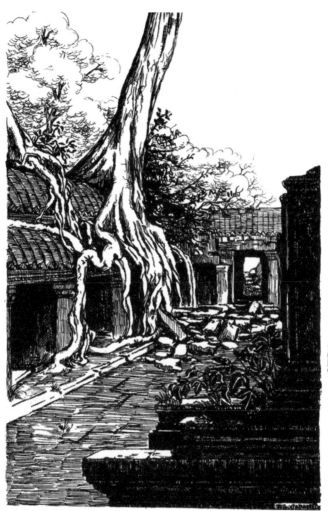

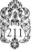

82 The roots of a tree growing over the roof of a gallery at Ta Prohm temple (mid-twelfth – early thirteenth centuries) (de Beerski, 1923).

other and simply growing old together.

According to legend, Ta Prohm had a divine origin through a miracle performed by the Hindu god Indra:

The hero of the story was a poor cripple, named Ta Prohm Kel, whose legs and arms were paralysed, and who just managed to crawl about the streets, begging a few coppers from the charitable. One day a horseman, who was really the god Indra in disguise, pulled up his horse in front of the cripple, where he sat in the dust, jumped off,

and threw the horse's reigns and a package to the poor wretch to hold. The god then disappeared; and the spirited horse, rearing up, straightened out. Struggling with the horse, Ta Prohm dropped the package on the ground, where it fell open, disclosing the insignia of royalty. These the miraculously cured cripple immediately donned, and sprang on the horse's back; whereupon it spread wings and soared with him into the air, and bore him away to the heavens. Ta Prohm became a great king, and built the huge stronghold called by his name (Ponder, *Cambodian Glory*, p. 308).

Lewis writes about Ta Prohm in colourful and lively prose. For me, he encapsulates the essence of the environment of the temple today in just two words, '*arrested cataclysm*':

The temple was built on flat land and offers none of the spectacular vistas of Angkor Vat, nor the architectural surprises of Bayon. It has therefore been maintained as a kind of reserve where the prodigious conflict between the ruins and the jungle is permitted to continue under control. The spectacle of this monstrous vegetable aggression is a favourite with most visitors to the ruins.

Released from the hotel bus, the thirty tourists plunged forward at a semi trot into the caverns of this rectangular labyrinth. For a few moments their pattering footsteps echoed down the flagstoned passages and then they were absorbed in the silence of those dim, shattered vastness and I saw none of them again until it was time to return.

Ta Prohm is an arrested cataclysm. In its invasion, the forest has not broken through it, but poured over the top, and the many courtyards have become cavities and holes in the forest's false bottom. In places the cloisters are quite dark, where the windows have been covered with subsidences of earth, humus and trees. Otherwise they are illuminated with an aquarium light, filtered through screens of roots and green lianas.

Entering the courtyards one comes into a new kind of vegetable world; not the one of branches and leaves with which one is familiar, but that of roots. Ta Prohm is an exhibition of the mysterious subterranean life of plants, of which it offers an infinite variety of cross-sections. Huge trees have seeded themselves on the roofs of the squat towers and their soaring trunks are obscured from sight; but here one can study in comfort the drama of those secret and conspiratorial activities that labour to support their titanic growth.

Down, then, come the roots, pale, swelling and muscular. There is a grossness in the sight; a recollection of sagging ropes of lava, a parody of the bulging limbs of circus-freaks, shamefully revealed. The approach is exploratory. The roots follow the outlines of the masonry; duplicating pilasters and pillars; never seeking to bridge a gap and always preserving a smooth living contact with the stone surfaces; burlesqueing in their ropey bulk the architectural motives which they cover. It is only long after the hold has been secured that

the deadly wrestling bout begins. As the roots swell their grip contracts. Whole blocks of masonry are torn out, and brandished in mid-air. A section of wall is cracked, disjointed and held in suspension like a gibbeted corpse; prevented by the roots' embrace from disintegration. There are roots which appear suddenly, bursting through the flagstones to wander twenty yards like huge boa-constrictors, before plunging through the up-ended stones to earth again. An isolated tower bears on its summit a complete sample of the virgin jungle, with ferns and underbrush and a giant fig tree which screens the faces of the statuary with its liana-curtains, and discards a halo of parakeets at the approach of footsteps.

The temple is incompletely cleared. One wanders on down identical passages or through identical courtyards—it is as repetitive in plan as a sectional bookcase—and then suddenly there is a thirty-foot wall, a tidal wave of vegetation, in which the heavenly dancers drown with decorous gestures (Lewis, *A Dragon Apparent*, pp. 230-2).

Ta Prohm was Ponder's favourite temple:

The strange, haunted charm of the place entwines itself about you as you go, as inescapably as the roots have wound themselves about the walls and towers…Everywhere around you, you see Nature in this dual role of destroyer and consoler; strangling on the one hand, and healing on the other; no sooner splitting the carved stones asunder than she dresses their wounds with cool, velvety mosses, and binds them with her most delicate tendrils; a conflict of moods so contradictory and feminine as to prove once more—if proof were needed—how well 'Dame' Nature merits her feminine title!

The paths by which the first explorers hacked their way in have been cleared, and the further advance of the forest checked; but the matchless temple built by Nature into the very fabric of that erected by man, has been left undisturbed under its canopy of mighty branches…The strange, haunted charm of the place entwines itself about you as you go, as inescapably as the roots have wound themselves about the walls and towers…The gods of these old haunted places are jealous gods, and keep their choicest delights for the solitary who pays them the homage of undivided attention. If you sit very still…

…They all have their own peculiar charm, these special playgrounds of the giant trees, and all of them are hard to leave. But it is to old Ta Prohm that you will find yourself drifting back again and again; back to that magical courtyard where the biggest of the big trees stand whispering together—a place that might be the setting for all the fairytales ever written; and one that you can never leave without feeling that you are turning your back upon some lovely, elusive, enchanted palace, where for an hour or two you had recaptured all the lost romance of childhood (Ponder, *Cambodian Glory*, pp. 304-306; 314-15).

And, finally, Loti's memorable account of Ta Prohm:

The "fig-tree of ruins" reigns to-day as undisputed master over Angkor. Above the palaces, above the temples, which it has patiently disintegrated, it flaunts everywhere in triumph its pale, sleek branches, spotted like a snake, and its large dome of leaves. At the beginning it was only a small grain, sown by the wind on a frieze or on the summit of a tower. But no sooner did it germinate than its roots, like tenuous filaments, insinuated their way between the stones, and proceeded to descend, guided by a sure instinct, towards the earth. And when, at last, they reached the earth, they quickly swelled, waxing on the nourishing juices, until they became enormous, disjoining, displacing everything, cleaving from top to bottom the thick walls; and then the building was irretrievably lost (Loti, Siam, pp. 67-8).

CHAPTER 9

REFLECTIONS

To see the Bayon in the late afternoon, with the light of the sun slanting against its fifty-odd massive towers, is to see one of the supreme creations of man (Michener, *The Mystery of Angkor*, p. 89).

The breaking of dawn at Angkor is a magical moment, as a temple emerges from darkness at the beginning of a new day (Plate 80, p. 204). The sun shining directly over a stone tower with the day at maturity has its own special effect. As the sun begins to descend, it radiates an iridescence and warmth on the brick and stone. Still later, as the sun drops behind the horizon a kaleidoscope of yellow, orange and red emerges, bringing a glorious climax to the day. Finally, the light of the moon shining on a temple is unforgettable. Whatever the condition of the light, the quality of the shifting rays on the stones of Angkor exhilarates your spirit and mesmerizes your senses. Greenbie observes:

The towers, for all their dignity and beauty, are uncertainties without a dash of sunlight at sunrise or sunset. As the sun rises higher, AngkorWat creeps down nearer the earth; as it sinks lower in the west, its spirit poises for a moment against the sky, and suddenly plunges off into the shadows (Greenbie, *The Romantic East*, p. 170).

In this last chapter I include selected excerpts that express the timeless interplay of light and shadow on the temples of Angkor.

My favourite comes from Ponder who writes an enjoyable passage of the shifting light and its effect on the entire plain of Angkor, from the black of dawn to the white of the moon:

To steal out of the Bungalow an hour before the dawn, and down the road that skirts the faintly glimmering moat of Angkor Wat, before it plunges into the gloom of the forest; and then turn off, feeling your way across the terrace between the guardian lions (who grin amiably at you as you turn the light of your torch upon them);

then clamber up the steep buried stairway on the eastern face of the hill, across the plateau and up the five flights of steps, to emerge from the enveloping forest on to the cool high terrace with the stars above you—is a small pilgrimage whose reward is far greater than its cost in effort.

Here at the summit is very still. The darkness has lost its intensity; and you stand in godlike isolation on the roof of a world that seems to be floating in the sky, among stars peering faintly through wisps of filmy cloud. The dawn comes so unobtrusively that you are unaware of it, until all in a moment you realize that the world is no longer dark. The sanctuaries and altars on the terrace have taken shape about you as if by enchantment; and far below, vaguely as yet, but gathering intensity with every second, the kingdom of the Khmers and the glory thereof spreads out on every side to the very confines of the earth: or so it may well have seemed to the King-God when he visited his sanctuary—how many dawns ago?

Soon, in the east, a faint pale-gold light is diffused above a grey bank of cloud, flat-topped as a cliff, that lies across the far horizon: to which, smooth and unbroken as the surface of a calm sea, stretches the dark ocean of forest, awe-inspiring in its tranquil immensity. To the south the view is the same, save where a long low hill, the shape of a couchant cat, lies in the monotonous sea of foliage like an island. Westward, the pearl-grey waters of the great Baray, over which a thin mist seems to be suspended, turn silver in the growing light, and gleam eerily in their frame of overhanging trees; but beyond them, too, the interminable forest flows on to meet the sky. It is only on the north and north-east that a range of mountains—the Dangrengs, eighty miles or so away—breaks the contour of the vast, unvarying expanse; and you see in imagination on its eastern rampart the almost inaccessible temple of Prah Vihear.

Immediately below you there is movement. The morning is windless; but one after the other, the tops of the trees that grow on the steep sides of the Phnom sway violently to and fro, and a fussy chattering announces that the monkeys have awakened to the new day. Near the bottom of the hill on the south side, threadlike wisps of smoke from invisible native hamlets mingle with patches of mist. And then, as the light strengthens, to the south-east, the tremendous towers of Angkor Wat push their black mass above the grey-green monotony of foliage, and there comes a reflected gleam from a corner of the moat not yet overgrown with weeds. But of the huge city whose walls are almost at your feet, and of all the other great piles scattered far and near over the immense plains that surround you, not a vestige is to be seen. There must surely be enchantment in a forest that knows how to keep such enormous secrets from the all-seeing eye of the sun?

In the afternoon the whole scene is altered. The god-like sense of solitude is the same; but the cool, grey melancholy of early morning has been transformed into a glowing splendour painted in a thousand shades of orange and amber, henna and gold. To the west, the

CHAPTER 9: REFLECTIONS

Baray, whose silvery waters in the morning had all the inviting fresh-
ness of a Thames backwater, seems now, by some occult process, to
have grown larger; and spreads, gorgeous but sinister, a sheet of
burnished copper, reflecting the fiery glow of the westering sun. Be-
yond it, the forest, a miracle of colour, flows on to be lost in the
splendid conflagration; and to the north and east, where the light is
less fierce, you can see that the smooth surface of the sea of tree-tops
wears here and there all the tints of an English autumn woodland: a
whole gamut of glowing crimson, flaring scarlet, chestnut brown,
and brilliant yellow; for even these tropic trees must 'winter'.

By this light you can see, too, what was hidden in the morning:
that for a few miles towards the south, the sweep of forest is inter-
rupted by occasional patches of cultivation; ricefields, dry and golden
at this season of the year, where cattle and buffaloes are grazing.

The forest still keeps almost all its secrets, even in this fierce illu-
mination. Not even the topmost tower of the Bayon, less than a
mile and half away; not a glimpse of the tremendous city wall just
below you; is vouchsafed by the relentless tide of jungle that has
submerged the whole kingdom of the Khmers. But there are just two
of its half-drowned victims that have succeeded in lifting their proud
heads high enough above the surface to be seen in the searching light
of the afternoon sun; almost due east, about four miles away, rises
the top of a grey pile that can only be the great pyramid of Pre Rup;
and much nearer, to the north-east, three towers that are part of the
noble crown of Ta Keo.

As for the Great Wat, which in the morning had showed itself an
indeterminate black mass against the dawn: in this light, and from
this place, it is unutterably magical. You have not quite an aerial
view—the Phnom is not high enough for that; and even if it were,
the ever-encroaching growth of trees on its steep sides shuts out the
view of the Wat's whole immense plan. But you can see enough to
realize something of the superb audacity of the architects who dared
to embark upon a single plan measuring nearly a mile square. Your
point of view is diagonal: across the north-west corner of the moat
to the soaring lotus-tip of the central sanctuary, you can trace the
perfect balance of every faultless line. Worshipful for its beauty,
bewildering in its stupendous size, there is no other point from which
the Wat appears so inconceivable an undertaking to have been at-
tempted—much less achieved—by human brains and hands.

But however that may be, even while you watch it, the scene is
changing under your eyes. The great warm-grey mass in its setting
of foliage, turns from grey to gold; then from gold to amber, glowing
with even deeper and deeper warmth as the sun sinks lower. Purple
shadows creep upwards from the moat, covering the galleries, blot-
ting out the amber glow; chasing it higher and higher, over the piled
up roofs, till it rests for a while on the tiers of carved pinnacles on
the highest towers, where an odd one here and there glitters like cut
topaz as the level golden rays strike it. The forest takes on colouring
that is ever more autumnal; the Baray for ten seconds is a lake of

fire; and then, as though the lights had been turned off the pageant is over…and the moon, close to the full, comes into her own, shining down eerily on the scene that has suddenly become so remote and mysterious; while a cool little breeze blows up from the east, and sends the stiff, dry teak-leaves from the trees on the hillside, down through the branches with a metallic rattle.

There is one more change before this nightly transformation-scene is over: a sort of anti-climax often to be seen in these regions. Soon after the sun has disappeared, and after-glow lights up the scene again so warmly as almost to create the illusion that the driver of the sun's chariot has turned his horses, and come back again. Here on Bakheng, the warm tones of sunset return for a few minutes, but faintly, mingling weirdly with the moonlight, to bring into being effects even more elusively lovely than any that have gone before. Then, they too fade; and the moon, supreme at last, shines down unchallenged on the airy temple.

It is lonelier now. After the gorgeous living pageantry of the scene that went before it, the moon's white radiance and the silence are almost unbearably deathlike: far more eerie than the deep darkness of morning with dawn not far behind. With sunset, the companionable chatter of birds and monkeys in the trees below has ceased; they have all gone punctually to bed; even the cicadas for a wonder are silent. Decidedly it is time to go. Five almost perpendicular flights of narrow-treaded steps leading down into depths of darkness are still between you and the plateau on the top of the Phnom: the kind of steps on which a moment of sudden, silly panic may easily mean a broken neck—such is the bathos of such mild adventures. And once on the plateau you can take your choice of crossing it among the crumbled ruins, and plunging down the straight precipitous track that was once a stairway—or the easy, winding path through the forest round the south side of the hill, worn by the elephants of the explorers and excavators. Either will bring you to where the twin lions sit in the darkness—black now, for here the trees are too dense to let the moonlight through; and so home along the straight road between its high dark walls of forest, where all sorts of humble, half-seen figures flit noiselessly by on their bare feet, with only a creak now and again from the bundles of firewood they carry, to warn you of their passing. Little points of light twinkle out from unseen houses as you pass a hamlet; and, emerging from the forest to the moat-side, the figures of men fishing with immensely long bamboo rods, from the outer wall, are just dimly visible in silhouette against the moonlit water (Ponder, Cambodian Glory, pp. 76-80).*

Casey's impression of dawn at Angkor:

The sky is hot now behind the towers. The mists are lifting from the lower galleries, disclosing the silhouette of the temple as vaguely unreal as an image on a shadow screen. The ghosts are gone, but their memory remains as the elephants come plodding across the causeway. The vastness of the pyramid seems to cover the horizon, and

for this moment, at least, the Khmers are alive again (Casey, *Four Faces of Siva*, p. 270).

Benson writing on daylight at Angkor:

Day comes up dull and hot, impaled on the horns of Angkor. By daylight the smart reasonable efforts of French preservers and renovators make their effect; by daylight the holy place is not too holy to be winked at by the rude eye of a Number One Brownie (Benson, *The Little World*, p. 285).

De Beerski's description of sunlight in the jungle reads like poetic prose:

The sun's rays, filling the sky with glamorous light, pass through the holes left in the foliage and as the latter moves, ever swayed by a light breeze, the shafts thrown by the flashing orb dance on the ground, skip quickly like wistful little spirits over the bark of trunks, suddenly make an orchid gleam like a twinkling star in the night of green, then recoil back to kiss the earth or a slender liana; and it appears that the sun is alive, that the shrubs are alive. Surya, the sun god, plays with nature, and this playfulness appeals as the games of untamed animals. In order to show his joy the emperor of heavens is brighter and sends more and more numerous his yellow, shining arrows, until he pierces everything; the plants smile in response and their colours become more crude, their odours more penetrating; the sun, excited by the game, casts terrible heat, and all things would retire before such an unforeseen vigour in our cold countries of Europe. But in this forest nature replies with equal strength, and, instead of cracking, burning, withering under the violent strokes, it appears to expand, to rise…Fresh boughs grow and lengthen, other flowers bloom into tender petals, and what would prove to be devastating fire in many regions is here a creative force (de Beerski, *Angkor, Ruins in Cambodia*, p. 59).

Most visitors, including myself, try to plan their schedule so that they reach the top level of Angkor Wat just before sunset. For me, the sun sets more gloriously at that point than anywhere else I know. Parsons watched the changing colour and shape of the sun from this vista and compared the real thing to a model she saw in the Paris Colonial Exposition in 1931:

On my last visit to this temple I sat and watched the sunset from the topmost shrine, which faces westward from the central tower. I looked out over the descending galleries, and the long causeway centred at this tower. The causeway leads out to the jungle, and a vista cut through the jungle in line with it stretches away forever to the feet of the setting sun.

I was listening to the sound of chanting. Priests with their yellow

robes drawn round them were gathered in the shrine repeating prayers that had been chanted here since Angkor was created. The same inflections of sound recurring in cycle formed into a rhythmic dance in the brain. There was nothing new, the chanting seemed to say, all things returned again to their beginning.

Sitting up here, I thought of those concrete steps that I had seen in Paris, put up for a temporary exhibition. I compared them with the steps below me now: great welts of stone that slaves had brought down the Siemreap river and set up here in the monument. They were token of the enormous energy behind the building of these temples, the same force, I believed, that had brought me to this place. And I saw why the flood-lighting at the exhibition had been golden, only gold wasn't really the right shade. Away and away the jungle stretches over flat country, and the sun has an uninterrupted view of the towers till it plunges into a green ocean of trees. By that time the light is vermilion.

And now the sun went down on Angkor. But it would come again tomorrow, when I would be starting back over the long road home. Would the road be empty, I wondered, now that ambition was fulfilled? But emptiness is a thing of mind, not space.

No, it certainly wasn't empty, the journey home (Parsons, Vagabondage, pp. 149-50).

Here is Harris's impression of sunset at Angkor Wat:

Angkor Wat, the great temple, stands revealed in all its glory. It is at evening that its effect is most impressive, when the stone, already red and green and grey, reflects the rays of the setting sun, when the courts are deep in shadow and it is twilight in the dim galleries. The temple is deserted except for a few Buddhist monks in their yellow robes who pass, scanty offerings in their hands, to the altar far above, where stands a statue of the Buddha. One of them carries a little lamp, a tiny wick floating in a glass of oil, and as they climb the great, steep stairways and pass along the windowed galleries, the little speck of light appears and disappears. A small boy, high up, plays some notes on a flute of cane. Then everything turns grey. A few birds fly back to roost in the holy precincts. The strange, sad smile of the statues of the Gods in the corridors fades away in the gloom, but, high above, the great central tower that covers the Holy of Holies still reflects the afterglow of the Western sky. But the sanctuary beneath it is empty—the Gods of Angkor are dead (Harris, East for Pleasure, p. 316).

Legendre's excerpt was written from the bungalow across the road looking towards Angkor Wat at night:

It was late when we arrived there and the tall beehive shaped towers were already casting long shadows over the stone flagged courtyards. As I stood thrilled by the majesty of the scene, four black lines, ribbons against the darkening sky, spread out from the four great towers to the corners of the world. They were bats of Angkor, the

CHAPTER 9: REFLECTIONS

last inhabitants of this ancient capital of the mysterious Khmer empire. Slowly the lights of the bungalow became glowing spots in the gathering darkness. They illuminated the cement, brick-bordered terrace, and the marble-topped tables around which the tourists sat drinking their aperitifs. Across the silver of the moat the moon lighted the entrance portal, with its turrets looking like pawns supporting a gigantic chess king. In the background the five towers of Angkor Vat rose to the sky shrouded in mystery. Above the wall surrounding the temple three palms stood tall and slender, their heads slightly bent as if paying silent homage to the glory of an empire long swallowed by the jungle (Legendre, Land of the White Parasol, pp. 285-6).

Benson has the following to say about moonlight at Angkor Wat:

Angkor Vat, by full moonlight, is heaped upon a line of dim moon-reflecting moat. Across the moat on a great causeway we go, feeling like shadows. Incredible stillness melodramatically succeeds thirteen hours' prosaic clatter (Benson, The Little World, p. 283).

And here is Childers, also writing on moonlight at Angkor Wat:

I have just returned from wandering through the temple alone. Far back in the inner sanctum, I heard the liquid notes of the bamboo xylophone, played in the native village, join with the low chant of the Buddhist priests and come softly over the lake. The great temple stretched away from me, its stones silver in the moonlight, its shadows hiding the brooding souls of millions of men dead for centuries...Long I sat listening to the xylophone and to the chanting. Long I peered at the ancient stones. And yet when I left the temple at midnight, the souls of the builders were still hidden in shadows (Childers, From Siam to Suez, pp. 12-3).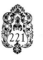

Loti visited the temple during the blackest hours:

It is in the dead of night, preceded by a Siamese torch-bearer, that I cross at last the threshold of the colossal temple of AngkorVat. It had been my original intention not to begin the pilgrimage before tomorrow at day-break; but I was tempted by the proximity of the temple, the stupendous mass of which seemed almost to overhang my frail lodging...

Outside, sudden peace, serenity of sky, and splendour of stars. We arrest the course of our flight to inhale deliciously; the air is fragrant with jasmine, and the tranquil psalmody of the monks, after those multitudinous cries, seems an exquisite music. All those tortured figures which peopled the walls, and all those contacts of horrible wings...Ugh! from what hideous nightmare have we escaped?

It is the enchanted hour of these regions, the hour when the brazier of the sun is extinguished, and the evil dew has not begun to shed its moisture. In the immense glade, defended by moats and

wall, in the middle of which the temple is throned, one has a feeling of complete security, notwithstanding the surroundings and the proximity of the great forests. The tigers do not cross the bridges of stone, although now the gates are never shut, and, save for some curious monkeys, the beasts of the forests respect the enclosed park where men dwell and sing.

And the long causeway is there, stretching before me, whitish in the night, between the dark tufts of the bushes scented with jasmine and tuberose. Without aim, I begin to wander slowly over its flagstones, getting further and further away from the temple, hearing less and less distinctly the song of the monks, which by degrees dies away behind me into the infinite silence.

I wander on and on until I reach the water-lilied moat, with its bridge guarded by the seven-headed serpents. On the further bank the forest spreads its high black curtain; it draws me to it, with its air of sleep and mystery. Without entering it, what if I went just so far as the edge of its tall trees, surcharged now with night, where so many sleepless ears must already have heard me. And cautiously I pass through the portico, making sure of each stone upon which, gropingly, I set my foot; in such darkness as this, the bridge is formidable to cross.

But I seem to hear light footsteps running towards me from behind. Are they men or monkeys? And before I have time to turn round I feel myself taken by the hand, but without any sort of roughness, the two human shapes appear, who seek to detain me. I recognise them at once—they are two of my worthy Siamese ox-drivers. What do they want with me? To understand one another we have no single word of any language in common. But they make clear to me by signs that it is foolhardy to proceed further; there are ambushes yonder, and there are beasts with teeth that bite. And I let them have their way and lead me back (Loti, Siam, pp. 73-77).

I end this anthology with travellers' reactions to leaving Angkor. Before Bleakley departed from the bungalow across the road from Angkor Wat in the 1920s, he opened the Visitor's Book and found it:

Filled with the lucubrations of tourists for a period of many years. Most of the entries have been written by Americans, who outnumber all other travellers. To many of these compositions footnotes have been appended by subsequent visitors...A certain Mr L_____ P_____ of Norwood in Massachusetts, who was staying at Angkor in December 1916, has inscribed the following eulogy:

> Leaving December 10th with many regrets.
> A Most Genial Host.
> A Competent Guide.
> Have twice visited Greece and Egypt,
> But have never seen such magnificence.

It is difficult to tear oneself away from Angkor. In addition to its

natural beauty and the interest of its antiquities the climate and the accommodation are so much superior to those of Saigon that there are many inducements to stay on indefinitely. The wise traveller will remain as long as he can spare time, and however long his visit lasts there will be something new to see every day (Bleakely, *A Tour in Southern Asia*, pp. 91-2).

I like Benson's account, written in 1925, because she captures the frenzy of what I witness today in visitors who fly to Siem Reap to see Angkor in one day, arriving in the morning and leaving the same evening:

In our final curtailed sight of Angkor we must dash irreverently about that stately miracle as no one ever dashed before. It is like a nightmare—Look here—look there—see that frieze—try not to forget the attitudes of that row of dancers—serene distortion—nine minutes for Angkor Thom—I don't think we need really stop to look at this gate—just drive slowly—oh, well, perhaps one ought to spare ten seconds, there's another four-faced Brahma—yes, drive on—look how the trees have grown up in the palaces—the trees, at least are leisurely guests—here's the Leper King's palace and his statue—(see the leprosy—no, silly, that's his moustache)—here's the Terrace of Elephants, they rollick chubbily round the frieze like little boys coming out of school—carved a thousand years ago, yet we don't have to make any complacent twentieth-century allowance for them—more strangled stone faces among the creepers—what impudence the monkeys and parrots have, chattering and chuckling about—would that gallery make a good snapshot?—ten minutes for breakfast and we must go. Have we seen Angkor or has the jungle given us a feverish dream? (Benson, *The Little World*, pp. 289-90).

Greenbie's feelings on leaving Angkor in 1930 are quite different from those of Benson. It was an emotional experience and even though he moves further and further away from Angkor, the memories linger:

In retrospect, I still feel the presence of that shrine of mystery and beauty, as the train rolls on to Bangkok. The dust of the road over the plains has only given it a more roseate setting, like dust in the face of the sun. The five stately towers, the long rows of buildings around it, the two little half-crumbled structures at either side of the causeway to Angkor Wat, the gates that stand with corridors like open arms to take you in—this is Angkor. It appeared like a lovely sunrise and disappeared as a glorious sunset, without high noon, dry noon, or day between. And now, over a year later, if a radiator sends a musty odor into the room, I see at once those towers and smell the dank presence of the bats who, when man destroyed himself, took possession of his palaces and places of worship (Greenbie, *The Romantic East*, p. 178).

Candee departs from Angkor on a practical note:

If sighs of regret at leaving were heaved at dawn it is not by me. Dawn is a still stark hour, a slow return to life that resents an early rising. The night before the heart is sad at leaving the riches of Angkor. At five A.M. there is emotion only for luggage, buckles, and hot coffee.

And yet, and yet, as the motor starts there is an anguished farewell look at the towers of Angkor Wat stamped black against the brightening sky, and one realises all too late the folly of leaving a love. Angkor is a great objective, the visit to the far-away city has been held in anticipation until it became a part of life. Now that it is over, and the long road lies through wet bogs and jungle without interest, life and travel seem without a purpose—sans but (Candee, New Journeys in Old Asia, p. 135).

And now Hervey writes of his last glimpse of Angkor:

The rain had ceased, the sky was gray, overcast with a burnished haze; a reflection that seemed to run fluid from the west where the clouds were smoky gold. It was like some weird crepuscular light. In it AngkorWat was fabulous and pagan. The moat, drinking in the sunset, was tawny metal while the towers of the temple, great irregular tiaras crowning those bewildering terraces, seemed chased in old gold upon the rain-colored sky.

As I watched, the light died from it, swiftly, like the last breath from a living thing, and then it was dead stone, its towers ghosts that haunted the dusk.

In the roadway, a bullock cart creaked by; gleaming half-naked figures seemed to glide past with spectral litheness. Across the way, the broken obelisks of AngkorWat stood dark beneath a single ascending star (Hervey, King Cobra, p. 54).

Loti climbs the steps of Angkor Wat for a final visit:

The sun is already low in the heavens and beginning to cast a ruddy light when my little train of ox-carts gets under way, leaving Angkor behind for ever, along the paved causeway, between the bushes clustered with the white bloom of the fragrant jasmine. Beyond the large pools choked with weeds and water-lilies, beyond the bridge, the last porticoes and the great seven-headed serpents which guard the threshold, the pathway of departure opens before us. It plunges under the trees which are ready at once to hide the great temple from us. I turn, therefore, to take one last look at Angkor. This pilgrimage, which, since my childhood, I had hoped to make, is now a thing accomplished, fallen into the past, as soon will fall my own brief human existence, and I shall never see again, rising into the sky, those great strange towers. I cannot even, this last time, follow them for long with my eyes, for very quickly the forest closes round us, ushering in a sudden twilight (Loti, Siam, pp. 128-9).

CHAPTER 9: REFLECTIONS

And now we hear from Maugham:

I came to the last day I could spend at Angkor. I was leaving it with a wrench, but I knew by now that it was the sort of place that, however long one stayed, it would always be a wrench to leave. I saw things that day that I had seen a dozen times, but never with such poignancy; and as I sauntered down those long grey passages and now and then caught sight of the forest through a doorway as I saw had a new beauty. The still courtyards had a mystery that made me wish to linger in them a little longer, for I had a notion that I was one the verge of discovering some strange and subtle secret; it was as though a melody trembled in the air, but so low that the ears could just not catch it. Silence seemed to dwell in these courts like a presence that you could see if you turned round and my last impression of Angkor was like my first, that of a great silence. And it gave me I know not what strange feeling to look at the living forest that surrounded this great grey pile so closely, the jungle luxuriant and gay in the sunlight, a sea of different greens; and to know that there all round me had once stood a multitudinous city (Maugham, *The Gentleman in the Parlour*, p. 222).

And so, in spirit, you need never say 'Good-bye' to Angkor. Its magic will go with you wherever Fate and the Gods may take you, to colour your thoughts and dreams until life's very end…the spirit of Angkor bites deep into the tissue of the soul…a part of its spirit goes with you, never to leave you while memory shall last (Ponder, *Cambodian Glory*, p. 316).

A legend passed on by descendants of the Khmers is mindful of the past and hopeful for the future:

In the forests are the ruins of our cities. In the valleys of the rivers and on the great dry plains are the bones of our people. Our kingdom is dust and ashes and desolation.

But our glory will return. Some day there will come from across the sea a man of a new race to take up the thread of our story, to restore our cities and make Angkor once more the marvel of the world (Casey, *Four Faces of Siva*, p. 91)

GLOSSARY

Angkor ('city or capital') An ancient capital in north-western Cambodia that was the main centre of the Khmer Empire from AD 802 to 1432.

anastylosis A method of restoring a monument by dismantling and rebuilding the structure using the original materials and methods.

Angkor Thom The 'great' city built in the late twelfth to early thirteenth centuries by Jayavarman VII, located north of Angkor Wat with the temple of the Bayon at its centre.

apsara A female celestial nymph; heavenly dancer.

Avalokiteshvara ('the Lord who looks down from above' with compassion) (see Lokeshvara).

baluster A small pillar (usually circular) commonly used in a balustrade or as a window bar.

balustrade A row of balusters supporting a railing.

banteay ('citadel') A temple with an enclosing wall.

baray ('lake') A large man-made body of water surrounded by banks of earth; reservoir.

bas-relief A sculpture in low relief with the figures projecting less than half the true proportions from the background.

bodhisattva ('Enlightened Being') In Mahayana Buddhism, a compassionate being who postpones his own nirvana and chooses to stay in the world to help those who are suffering.

Brahmin The priestly class in Hinduism.

Brahmanism The early religion of India that emanated from Vedism.

Buddha (the) A being who has attained enlightenment.

Buddhism A religion derived from the teachings of the Buddha with several philosophical schools and spiritual practices.

Cambodia A country in Southeast Asia bounded by Laos, Thailand, Vietnam and the Gulf of Thailand.

causeway A raised road or walkway across a body of water.

Champa An ancient Indianized state situated in an area corresponding approximately to present-day south and central Vietnam (c. second century to the fifteenth century).

Chenla (see Zhenla).

Cochin-China A region in south Vietnam that was a French colony between 1867 and 1945.

devata A deity living on earth or in a heavenly realm.

Funan A Chinese name for an ancient state located in the

lower Mekong basin that was a predecessor to Angkor; probably founded in the first century AD, and reaching a zenith in the fifth century; the state of Zhenla eclipsed Funan in the seventh century.

garuda A mythical creature with a human body and birdlike wings, legs and beak and the claws of an eagle with feathers on the lower body; the mount of the Hindu god Vishnu.

Hanuman A mythical being who is chief of the army of monkeys and figures prominently in the Ramayana.

Hinduism A religion and social system of the Hindus; popular in Cambodia from the first century to the twelfth century.

howdah A chair for riders carried on the back of an elephant.

Indo-China The area of Southeast Asia comprising present-day Vietnam, Cambodia and Laos; a name used by Europeans because the area was influenced by both Indian and Chinese cultures.

Khmer An ethnic group consisting of the large majority of Cambodians.

laterite A ferruginous (iron rich) rock that is abundant in Cambodia and north-eastern Thailand; a porous texture and reddish colour; used as a building material for foundations, bridges, roads, etc.

lichen A fungus and an alga symbiotically united; grows on the surface of stone, trees, etc.

linga A representation of the male organ of generation, a symbol of Shiva and his role in creation.

Lokeshvara ('Lord of the World') A name often used in Asia for the compassionate bodhisattva Avalokiteshvara.

Mahabharata One of the great Indian epics that describes a civil war in north India; many episodes carved on the reliefs at Angkor.

Mahayana Buddhism The 'Great Vehicle'; a school of Buddhism where Bodhisattvas figure prominently; flourished in Cambodia, particularly in the late twelfth – early thirteenth centuries.

Mount Meru A mythical mountain at the centre of the Universe and home of the gods; the axis of the world around which the continents and the oceans are ordered.

naga A semi-divine serpent; king of the waters; lives in the underworld beneath the earth or in the water; often depicted in Khmer art with seven or nine heads and a scaly body.

nirvana The 'Extinction' and final liberation from the cycle of rebirths; the goal of a Buddhist.

phnom A Khmer word meaning 'hill or mountain'.

prasat A Khmer word meaning 'temple'.

Rama The hero of the *Ramayana*; an incarnation of the Hindu god Vishnu.

Ramayana An Indian epic describing the story of Rama and Sita; episodes appear often on the reliefs at Angkor.

Sita Rama's wife and the heroine of the *Ramayana*.

srah A Khmer word meaning 'pond'.

superstructure The upper portion of a building that usually begins from the top of the walls; deviates in form from the basic structure.

Theravada Buddhism The 'Doctrine of the Elders' representing the traditional Pali heritage of early Buddhism.

Tonle Sap A freshwater lake in western Cambodia that is linked with the Mekong River by the Tonle Sap River.

tympanum A triangular space on the front of a pediment in Khmer architecture.

wat A Pali word meaning 'temple'.

Zhenla (Chenla) An ancient Chinese name for a state in Cambodia that was a predecessor to Angkor and flourished between the sixth and eighth centuries.

229

BIBLIOGRAPHY

An Official Guide to Eastern Asia: Trans-Continental Connections Between Europe & Asia: East Indies Including Philippine Island, French Indo-China, Siam, Malay Peninsula, and Dutch East Indies, vol. V, Tokyo, Japan (The Imperial Government Railways of Japan), 1917.

Appleton, Marjorie, East of Singapore, London, New York, Melbourne (Hurst & Blackett), 1942.

Asmussen, Fleur Brofos, Lao Roots, Bangkok (White Orchid Press), 1997.

Aymonier, Étienne, 'Edification d'Angkor Wat, ou satra de Prea Ket Mealea' Textes khmères, pp. 68-84, 1878.

Balfour, Patrick, Grand Tour, Diary of an Eastward Journey, London (John Long), 1934.

Bastian, A, 'A Visit to the Ruined Cities and Buildings of Cambodia' Journal of the Royal Geographical Society, vol. 35, pp. 74-87, 1865.

Beerski, P. Jeannerat de, Angkor, Ruins in Cambodia, London (Grant Richards), 1923.

Benson, Stella, The Little World, London (Macmillan & Co), 1925.

Bleakley, Horace, Tour in Southern Asia (Indo-China, Malaya, Java, Sumatra, and Ceylon, 1925-1926), London (John Lane, The Bodley Head Ltd), 1928.

Boisellier, Jean, 'The Symbolism of Angkor Thom' Siam Society Newsletter, vol. 4, no. 1, March 1988, pp. 2-5.

Borland, Beatrice, Passports For Asia, New York (Ray Long & Richard R. Smith), 1933.

Briggs, Larry, A Pilgrimage To Angkor, Ancient Khmer Capital, Oakland, California (The Holmes Book Co), 1943.

Brodrick, Alan Houghton, Little Vehicle, Cambodia & Laos, London (Hutchinson), 1940.

Campbell, James, 'Notes on the Antiquities, Natural History, &c. &c. of Cambodia, compiled from Manuscripts of the late E.F.J. Forest, and from information derived from the Rev. Dr. House, &c. &c.', Paper read at The Royal Geographical Society, June 27, 1859.

Candee, Helen Churchill, Angkor The Magnificent: The Wonder City of Ancient Cambodia, London (H F & G Witherby), 1925.

Candee, Helen Churchill, New Journeys in Old Asia: Indo-China, Siam, Java, Bali, New York (Frederick A. Stokes), 1927.

Plate, A. G., *A Cruise Through Eastern Seas, Being A Travellers' Guide to the Principal Objects of Interest in the Far East*, London (For the Norddeutscher Lloyd, Bremen), 1906.

Ponder, H.W., *Cambodian Glory, The Mystery of the Deserted Khmer Cities and their Vanished Splendour; and a Description of Life in Cambodia to-day)*, London (Thornton Butterworth), 1936.

Pym, Christopher, *The Road to Angkor*, London (The Travel Book Club), 1959.

Rau, Santha Rama, *East of Home*, London (Victor Gollancz), 1951.

Seton, Grace Thompson, *Poison Arrows, Strange Journey with an Opium Dreamer, Annam, Cambodia, Siam, and The Lotus Isle of Bali*, London (The Travel Book Club), 1938.

Sitwell, Osbert, *Escape With Me!, An Oriental Sketch-Book*, London (Macmillan), 1949.

Sitwell, Sacheverell, *Great Temples of the East, The Wonders of Cambodia, India, Siam, and Nepal*, New York (Ivan Obolensky), 1962.

Sitwell, Sacheverell, *The Red Chapels of Banteai Srei, and Temples in Cambodia, India, Siam and Nepal*, London (Weidenfeld & Nicolson), 1962.

Snellgrove, David, *Asian Commitment. Travels and Studies in the Indian Sub-Continent and South-East Asia*, Bangkok (Orchid Press), 2000.

Thomson, John, *Antiquities of Cambodia: Illustrated by Photographs, Taken on the Spot With Letterpress Description*, Edinburgh (Edmonston & Douglas), 1867.

Thomson, John, 'Notes of a Journey through Siam to the Ruins of Cambodia' An unpublished manuscript communicated to The Royal Geographical Society, London, 1866.

Thomson, John, *The Straits of Malacca, Indo-China and China or Ten Years' Travels, Adventures and Residence Abroad*, London (Sampson, Low, Marston, Low & Searle), 1875.

Vincent, Frank, *The Land of the White Elephant: Sights and Scenes in South-East Asia 1871-1872*, New York (Harper & Brothers), 1874.

Wales, H.G. Quaritch, *Towards Angkor: In the Footsteps of the Indian Invaders*, London (George G. Harrap), 1937.

Wellard, James, *The Search for Lost Cities*, London (Constable), 1980.

Wheatcroft, Rachel, *Siam and Cambodia: in Pen and Pastel with Excursions in China and Burmah*, London (Constable), 1928.

Zhou Daguan (see Chou Ta-Kuan).

INDEX

237

ABOUT THE AUTHOR

Dr Dawn F. Rooney is an art historian specializing in Southeast Asia. She is the author of six books and numerous articles on Asian art, including *Angkor. An Introduction to the Temples* (1994) and *The Beauty of Fired Clay: Ceramics of Cambodia, Laos, Burma and Thailand* (1997). She is a Fellow of the Royal Geographical Society and the Royal Asiatic Society; has lectured at art societies and museums in Asia, England and America; and has acted as guest lecturer on tours to China, Southeast Asia and Vietnam.

Dr Rooney has made over fifty trips to Angkor since it reopened in 1991, and divides her time between residences in Bangkok, London and San Francisco.